The LADY DI
Look Book

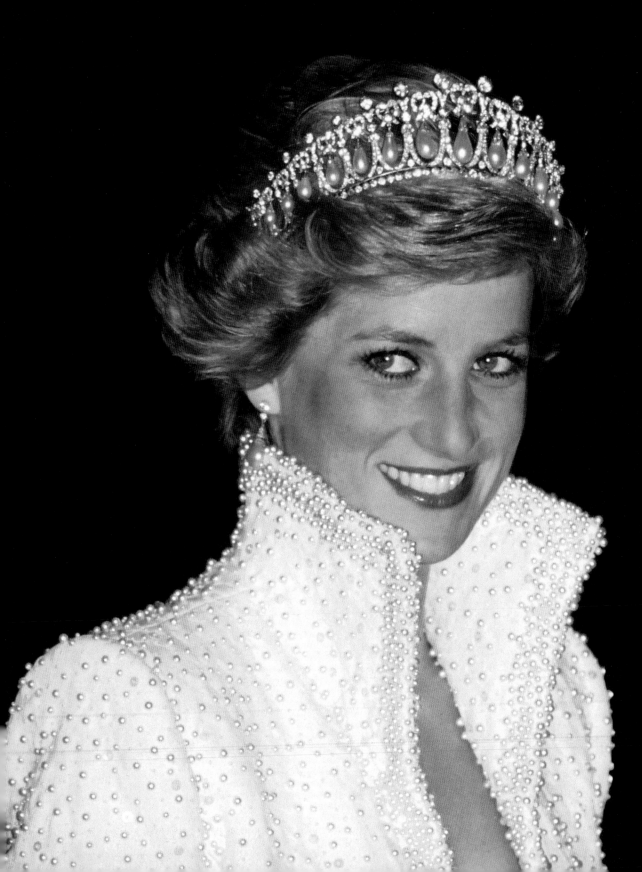

The LADY DI Look Book

WHAT DIANA WAS TRYING TO TELL US THROUGH HER CLOTHES

Eloise Moran

ST. MARTIN'S GRIFFIN
NEW YORK

First published in the United States by St. Martin's
Press, an imprint of St. Martin's Publishing Group

THE LADY DI LOOK BOOK. Copyright © 2022 by
Eloise Moran. All rights reserved. Printed in Germany.
For information, address St. Martin's Publishing Group,
120 Broadway, New York, NY 10271.

www.stmartins.com

Book design by Shubhani Sarkar, sarkardesignstudio.com

The Library of Congress Cataloging-in-Publication Data
is available upon request.

ISBN 978-1-250-83050-0 (paper over board)
ISBN 978-1-250-83051-7 (ebook)

Our books may be purchased in bulk for promotional,
educational, or business use. Please contact your local
bookseller or the Macmillan Corporate and Premium
Sales Department at 1-800-221-7945, extension 5442,
or by email at MacmillanSpecialMarkets@macmillan.com.

First Edition: 2022

10 9 8 7 6 5 4 3 2 1

For my mother,
Kaja

"I think every strong woman
in history has had to walk
down a similar path, and I
think it's the strength that
causes the confusion and
the fear. Why is she strong?
Where does she get it from?
Where is she taking it?
Where is she going to use it?"

—DIANA, PRINCESS OF WALES

CONTENTS

INTRODUCTION

DIANA: SACRIFICIAL LAMB TO REVENGE QUEEN viii

PART I

Diana's Eighties Looks

1

THE
BACHELORETTE
LOOK

2

2

THE
POLO LOOK

20

3

THE SLOANE
AND THE
CITY LOOK

60

A TRIBUTE TO FERGIE'S WILDEST HEAD ADORNMENTS 72

4

THE
REBEL REBEL
LOOK

76

5

THE
ROYAL DUTY
LOOK

88

6

THE
FAIRY PRINCESS
LOOK

124

PART II

Diana's Nineties Revenge Looks

7
THE FUCK-YOU DRESS REVENGE LOOK
156

8
THE ATHLEISURE REVENGE LOOK
188

9
THE CHIEF EXECUTIVE PRINCESS REVENGE LOOK
200

PRINCESS ANNE REVENGE LOOKS 242

10
THE OFF-DUTY REVENGE LOOK
244

11
THE SKI REVENGE LOOK
268

12
THE MR. WONDERFUL REVENGE LOOK
278

PART III

The Final Revenge, Then Peace, at Last

13
THE VACATION REVENGE LOOK
286

ACKNOWLEDGMENTS 310

RESOURCES 312

NOTES 315

PHOTO CREDITS 318

Diana

SACRIFICIAL LAMB TO REVENGE QUEEN

accidentally became a Princess Diana fashion researcher in the summer of 2018.

For the few years prior to that, I'd been getting over my own marriage breakup, waking up with miserable midtwenties existential dread, and working in a job that paid the bills but almost bored me to an early grave. I was waiting for something to come along that would finally ignite a sense of purpose in me and capture my complete, undivided attention. One sweltering summer evening in New York, while I was sitting in my Brooklyn apartment with my window A/C desperately chugging away, that finally happened.

I watched the documentary *Diana: In Her Own Words* on Netflix, and the next day at work, I couldn't stop thinking about it. I got lost inside an internet vortex of old Princess Diana articles and paparazzi photos. There was something magnetizing about Lady Di; her story struck a chord with me, and I was surprised at how connected I felt to, well . . . a princess. THE Princess. She was so relatable, so present. As the title of the documentary suggests, Diana posthumously narrates the entire program, edited together from a series of tapes that she had recorded in secret with a friend she'd had since her teenage years, James Colthurst, and that consequently informed Andrew Morton's writings in his infamous Princess Diana biography.

I had never had any kind of special interest in Princess Diana before. Of course, I was aware of her iconic status, especially since I grew up in London, but I was just five years old when she died. My only firsthand memory of the Princess was watching her funeral procession on TV with my mum and our elderly neighbour. I played on the rug in front of the television with my baby brother while the two of them sobbed and chain-smoked through the whole thing.

My research of Diana that day, and in the weeks following, drove me to my biggest *aha!* moment. Diana, princess or not, is just like us. Sure, it's not every day that we're plucked as teenagers from the obscurity of our parents' manor houses and placed in a semi-arranged marriage with the future king of England. She's like us because she went through the very human trials and tribulations many women face. Except she did it, I'm sure at times humiliatingly, in plain public sight. Every move she made, we watched and critiqued—we got a *Truman Show*–like view into this young woman's life. We witnessed her weaknesses, her pain, a betrayal, her growth, and, ultimately, her emancipation. Diana is not relatable because of her status but because most

women understand what it's like to trust and have it broken, to speak and not always be heard, to be doubted and disbelieved. Most of us, unfortunately, have also encountered a Charles, or a dreaded Camilla.

I created the Instagram account @ladydirevengelooks shortly after I began my research. What started as intrigue had developed into a bit of an obsession. I had read about Diana wearing a little black dress, later dubbed her "revenge dress" due to the strategic timing of wearing it the very same evening that Prince Charles admitted his marital indiscretions to Jonathan Dimbleby, a veteran British presenter and broadcaster, on national television. That LBD was just a starting point for me. As I dug deeper into my research, and through an infinite archive of paparazzi photos taken after this moment, I connected the dots: this look wasn't a standalone moment. It was part of a much larger, calculated wardrobe of nineties minimalist pantsuits, bold athleisure-wear, figure-hugging Versace minidresses, and Jimmy Choo strappy heels—the antithesis of her eighties poofy dresses, pleated skirts, and crisp oversized prairie collars. Princess Diana had a *fuck you* wardrobe—and a new, modern haircut to go with it.

My intention was to document her best postdivorce "revenge looks" and pair them with tongue-in-cheek captions (I was going through a breakup myself, so I had plenty of inspiration). I started with a photo of the smiling Princess in a green-and-blue bathing suit and a pair of Versace sunglasses and captioned it, *"The happy and healthy revenge look."* I began following five of my closest friends, added a few more photos with slightly more wicked captions, and suddenly the fun began. To date, I've pored over thousands of Princess Diana images and at the time of writing this, I have over one hundred thousand followers. Many of them, like me, are too young to remember Diana firsthand yet often express their adoration for her.

A part of Diana's story I found most intriguing is how little the public knew back then of her personal struggles—seldom did she give any interviews until 1995, when she sat down for the infamous *Panorama* interview with BBC journalist Martin Bashir. Recently, it was announced that Bashir falsified bank statements to gain access to Princess Diana and persuade her to do his interview. His faked documents played on some of her fears and suspicions and, according to family members, her paranoia. Unquestionably, the tactics the journalist used to secure his bombshell interview were deceptive, opportunistic, and indicative of a wider culture of exploitative journalism and a zero-boundaries media. I've watched the interview close to a dozen times and did

so again when the Lord Dyson report came to light in May 2021. What makes me most uncomfortable is how quickly certain individuals have seized upon discrediting Diana's actual words within the interview due to the nature of how it was obtained.

How the interview came to fruition is undeniably disturbing, but would Diana have wanted us to silence her now, all these years later? It seems to me that the Princess who had long been quieted, the woman who for years had sought to share her innermost thoughts and feelings via voice coaching and secret collaborations with her biographer, simply wanted to have her voice heard. There was an internal BBC investigation into Bashir shortly after the *Panorama* show aired, when concerns were initially raised about the questionable bank statements. During this inquiry, Diana handwrote a statement from Kensington Palace in defense of her interview: *"Martin Bashir did not show me any documents, nor give me any information that I was not previously aware of. I consented to the interview on Panorama without any undue pressure and have no regrets."*[1]

When watching the interview again, I got a strong sense (call it a woman's intuition) that the person who spoke in that hour-long interview spoke her truth—and I don't believe that anyone should have the right, back then or today, to argue with a woman's declaration of consent.

One of my favorite quotes from that notorious interview was this: *"I think every strong woman in history has had to walk down a similar path, and I think it's the strength that causes the confusion and the fear. Why is she strong? Where does she get it from? Where is she taking it? Where is she going to use it?"*[2]

We likely will never know what exactly happened, and of course we won't ever know what Diana was really thinking. There was and always will be an air of mystery to the Princess. After studying thousands of photographs of her, I get the sense that she reveled in the enigma around her—it was almost her superpower, a small fragment of privacy that no one could invade. A narrative that she could control and finally have a say in.

I believe that we can unravel this enigma by looking closely at Lady Di's clothes, alongside the known facts of her biography. If we look carefully, we can piece together a powerful story—one that's at first a little sad, then uplifting, ultimately heartbreaking, but overwhelmingly human. From the very start, Diana communicated surreptitiously through what she wore. At her first official royal engagement, she opted for a black taffeta strapless gown—from designers Elizabeth and David Emanuel—much to the dismay of Prince Charles, who told

her that black was only for people in mourning. She went against his objections, later saying in her secret tapes with Colthurst that she wasn't a part of his family yet, reflecting "black to me was the smartest color you could possibly have at the age of nineteen. It was a real grown-up dress."[3] She wore the dress, with its décolletage-baring neckline, and her stab at freedom was immortalized in the press the next day, accompanied by the headline, "Daring Di Takes the Plunge." This was perhaps the start of a track record for ruffling the feathers of royal courtiers—the "men in grey," as Diana called them.

Later in 1980, Diana wore her infamous black sheep sweater, made by British label Warm & Wonderful, a tongue-in-cheek and not-so-subtle choice for the nineteen-year-old who had been thrust full force into the strict codes of royal life. Then came the "I'm a Luxury" sweater by British knitwear label Gyles & George, known for their cheeky offbeat slogans and "witty knits." On the back, the sweater reads "Few Can Afford." To this day, almost forty years after she wore these knitted pieces, the Princess, the sheep sweater, and the cheeky slogan knit all seem to be inextricably linked. She was certainly both a black sheep and a luxury, daring yet delicate.

In the mideighties, roughly around the time she plucked up the courage to confront Camilla face-to-face, we witness the beginning of Diana's transformation. The hair was wilder, the shoulder pads bigger, the silhouettes more confident. She also had a thing for sequins and lamé, which earned her the nickname "Dynasty Di."

A standout Dynasty Di look for me was at the 1989 premiere of the film *Shirley Valentine*, when the Princess appeared on the red carpet in a figure-hugging Catherine Walker gown, mermaid-green sequins cascading down to her ankles. It was an extravagant look for a premiere, which, judging by the grin across Diana's face, she was certainly looking forward to.

The movie (coincidentally one of my favorites) is centered around a Liverpudlian housewife trapped in a world of domesticity and ennui, dealing with verbal abuse from her husband on a nightly basis. Shirley Valentine talks to her kitchen wall in the day, sharing her dissatisfaction with how her life has turned out: "I have allowed myself to lead this little life, when inside me there was so much more. And it's all gone unused. And now it never will be. Why do we get all this life if we don't ever use it?"

After a row with her husband, Shirley decides to join her friend on a vacation to Mykonos, where she meets a rugged Greek waiter named Costas and has a passionate fling (including some hot *sur* deck boat sex). One can't help but

wonder if Diana, sitting in her theater seat embellished in dazzling sequins, could relate to Shirley. I wonder if she smirked when Shirley delivered one of the film's most memorable lines: "I'm not sayin' he's bad, my fella. He's just no bleedin' good."

In 1994, two years after Charles and Diana's separation was announced publicly, we see Diana's inner transformation fully realized in the form of a little black dress known by most as her "revenge dress," exactly the dress that bonded me to her forever. Diana wore this infamously sexy dress, designed by Greek designer Christina Stambolian, to the Serpentine Gallery the night of Prince Charles's televised confession that he had been unfaithful with Camilla for the prior nine years of his marriage (although Diana intimated that Charles had been emotionally unfaithful throughout their entire marriage).

Once again, Diana stole headlines. It was the ultimate power move and the

"... It seemed like the whole world (minus the Windsors) were on Team Diana."

first step in the confident final chapter of her story. The Stambolian dress had an off-the-shoulder sweetheart neckline and was cut just above the knee. She wore it with sheer stockings that displayed her toned legs. Her head was held high, and she had a grin on her face. No more shoulder pads, just her naked shoulders, strong and stoic. Around her neck was a pearl and sapphire choker that she had worn at many official royal engagements during the eighties— inarguably a nod to her ill-fated marriage and past life, worn like a badge of honour, contrasted against a powerfully risqué ensemble which signaled a sense of an awakening and a new dawn. Her relief was palpable. Diana held her head high, in stark contrast to Prince Charles, who was quite literally hanging his in shame.

The next day, Princess Diana stole headlines yet again, something Charles had been jealous of while they were married. While people cringed at Charles's

televised admittance of his indiscretions (which he said with an irrepressible smirk, no less), Diana was applauded for her strength. Her popularity soared. She was reborn. That night she solidified her position as "queen of people's hearts." Those headlines weren't about to end anytime soon—it seemed like the whole world (minus the Windsors) were on Team Diana.

From the summer of 1994 onward, Diana's clothing continued to play an important role in the rewriting of her narrative. She became astutely aware of herself and loved the thrill of one-upping the last outfit. When I spoke to Jacques Azagury, designer of some of Princess Diana's most famous nineties dresses, he said, "She knew that every time she stepped out of the car there'd be a thousand people waiting for her to see what she was wearing, which dress, which shoes, which jewelry. She was aware and she didn't like to disappoint. She wouldn't disappoint. It was a big deal for her and she loved it." Her new fashion posse included an army of the world's design titans—Gianni Versace; Valentino and his cofounder, Giancarlo Giammetti; and Ralph Lauren—all of whom were known for their daring, form-fitting silhouettes and were largely responsible for helping the Princess communicate her newfound freedom. She wore power suits and accessorized with stylish briefcases and statement handbags from Gucci and Dior, while adding an all-American touch to her traditional Sloane Ranger style by incorporating varsity jackets, cowboy boots, Polo Ralph Lauren sweatshirts emblazoned with a "USA" logo, and gleaming white Nike sneakers to her day-to-day wardrobe. At official charity events, she sported sharply tailored skirt suits and shift dresses, while clutching a white Chanel Kelly bag, the intertwining *CC* turn lock held quite literally at arm's length.

It's been more than forty years since the world was introduced to a young kindergarten teaching assistant and nanny known to the press as "Shy Di," and the world still sits up and pays attention to any mention of Lady Diana Spencer. I've spent much time trying to get to the root of the Princess's lingering relevance. (Marilyn Monroe, once considered a style icon, seems light-years away from the sartorial interests of Millennials or Gen Z, for example.) People often ask me if I think the recent Diana revival will come to an end. My conclusion is this: the woman locked away in her ivory tower, fascinated by the "man on the street," positioned herself as just that: a regular woman, albeit in an unprecedented position that fate dished up for her. She could be the woman sitting next to you at the café sipping a cup of tea and eating a sandwich, as much as she could be the high-society lady you could find yourself reapplying your lipstick next to in the restroom at the Ritz. Her seamless blending of high

and low fashion and her approachable yet untouchable demeanor are perhaps the reasons behind her enduring relevance and why, all these years later, she's a modern-day muse for both luxury brands and streetwear designers—from London-based dress designer Alessandra Rich (a Kate Middleton favorite) to the late Virgil Abloh's Off-White.

Diana used the media's and the public's perception of her as a quiet and subservient clotheshorse to her advantage. The woman who graduated school without any formal qualifications, and who was disturbingly underestimated, used her most formidable skill to deliver her own narrative from the moment she stepped into the public eye: her power to connect with everyday folk without saying a thing.

Although privately gagged, Diana was no yes-woman. Through wry facial expressions caught in photographers' lenses, strategic changes in direction of both her style and haircuts, and her dedication to humanitarian work, Diana used her superior emotional intelligence to successfully penetrate the line between the untouchable "firm" and the people. She appealed to and communicated with the masses in a way no other royal has ever been able to. She outplayed the press, the media, and the public's ever-changing perception of her (the Princess was not always the beloved woman that she is today). Twenty-five years after her death, Diana is still the most personable and relatable royal in modern history—a fact, it seems, the Royal Family were able to appreciate only much too late after her tragic early death.

The Lady Di Look Book is the culmination of my research on the Princess's best outfits. It's my interpretation of Diana's sartorial choices and the subliminal, often tongue-in-cheek, messages I believe she wanted to convey.

From the pink gingham pants and pastel-yellow overalls of a sacrificial lamb to the sexy Versace minidresses, power suits, and leg-baring cycling shorts of a free woman, this is my selection of Diana's most showstopping eighties and nineties outfits. Whether it's eighties polo-field Diana, androgynous bow-tie Diana, little black dress Diana, or athleisure Diana, there's a look for all of us. There's a bit of Diana in all of us.

#FyouCC

(For those who don't know, it means "Fuck you, Charles and Camilla.")

PART I

Diana's Eighties Looks

THE BACHELORETTE LOOK

"It was nice being in a flat with the girls. I loved that—it was great. I laughed my head off there."[4]

This might be a controversial view, but kindergarten teaching assistant Diana, aka "Shy Di," knew how to pull a look together. The year was 1980, and a nineteen-year-old Lady Diana Spencer, fondly known as "Duch" by her friends and family (short for "Duchess," sweetie darling, a nickname playfully bestowed on her because she acted like a duchess long before she actually was one), had settled into her new three-bedroom apartment, bought for her by her parents in a fancy Kensington mansion block named Coleherne Court, with three of her closest friends. Mondays, Wednesdays, and Fridays she worked at the Young England Kindergarten in Pimlico. She worked as a nanny the other two weekdays, initially for friends of her sisters—a group of high-society toffs Diana called the "Velvet Hairbands"—and later for an American oil executive's young son.

Intermingling with the Velvet Hairbands came with the territory of living in the elite London neighbourhood of Kensington. This group of well-connected, upper-class women spent their time mostly taking Cordon Bleu cooking classes, giving birth to heirs of the British aristocracy, and sauntering around the luxurious shops along the King's Road, just off Sloane Square.

According to Diana's biographer Andrew Morton, these upper-class women "fitted a loose template of values, fashions, breeding and attitudes and were commonly known as 'Sloane Rangers.'"[5] Diana, although considered by many to be one of the original Sloanes and born into one of Britain's oldest aristocratic families, felt different. They were the polished "velvet hairband" brigade, and she was unsophisticated, insecure, and quite happy to clean her sister's friends' apartments for the humble fee of £1 an hour. At this point in time, she had never had a boyfriend, once recalling, "I'd always kept them away, thought they were all trouble—and I couldn't handle it emotionally, I was very screwed up."[6] She still referred to herself as a schoolgirl—perhaps in reference to her immaturity—but most young women of Diana's age and background, of course, didn't go on to higher education; they were expected to list themselves on the marriage market instead.

She was unbothered, unfussed, and quite happy to be living with her unpretentious roommates Carolyn Bartholomew, Anne Bolton, and Virginia Pitman: who, according to the latter mentioned, were a group of "giggling lavatorial girls" who spent their free time together plotting pranks on their

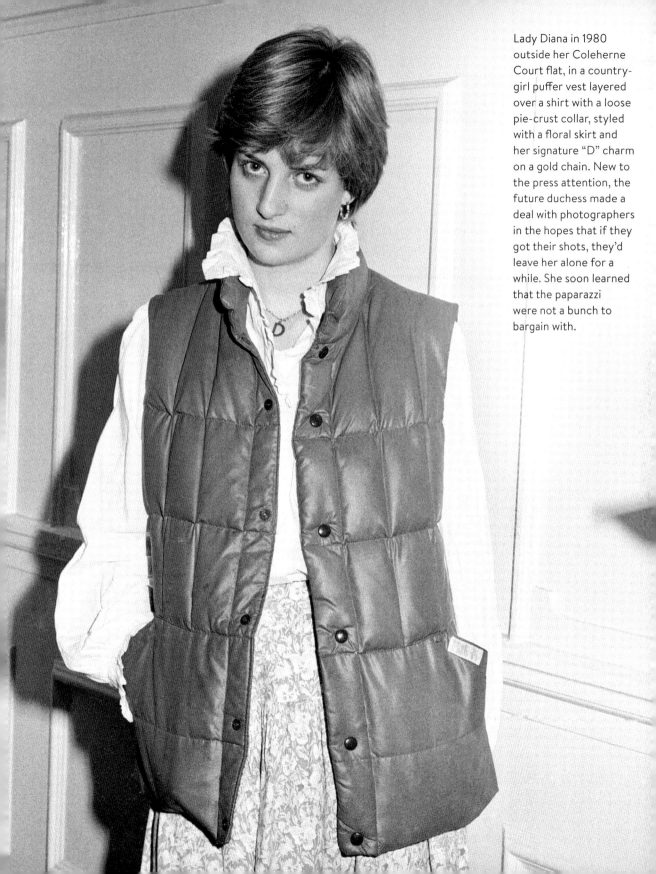

Lady Diana in 1980 outside her Coleherne Court flat, in a country-girl puffer vest layered over a shirt with a loose pie-crust collar, styled with a floral skirt and her signature "D" charm on a gold chain. New to the press attention, the future duchess made a deal with photographers in the hopes that if they got their shots, they'd leave her alone for a while. She soon learned that the paparazzi were not a bunch to bargain with.

unsuspecting male friends. Diana had a revenge streak in her then. Morton wrote that on one occasion, a friend, James Gilbey, "woke to find his prize Alfa Romeo car covered in eggs and flour that had set like concrete. For some reason he had let down Diana on a date so she and Carolyn had taken their revenge."[7]

The girls borrowed each other's clothes and feasted on "Harvest Crunch cereal and chocolate." Diana, being the landlady, had "Chief Chick" emblazoned across the door to her bedroom. It might sound like any other regular nineteen-year-old's experience (admittedly a tad posher, and a little more sugary than my own), except that Princess Diana knew she had to keep herself "tidy" for what lay ahead. Always a little clairvoyant—she was known to enlist the mystical talents of psychics throughout her life—she mused later on that from a young age, she had a hunch that a life of duty was what was in store for her but had imagined being married to an ambassador of some kind. She had never imagined her duty would be to marry "the top one,"[8] Prince Charles, the Queen's son and the future king of England.

Diana first met Charles in 1977, when he was dating her older sister Sarah Spencer. Diana was sixteen and remembered being "a fat, podgy, non-make-up, unsmart lady,"[9] but a twenty-nine-year-old Charles still showed interest. He danced with her after dinner and invited her to show him her family's gallery, a tour which was promptly interrupted by Sarah, who said to Diana, in true older sister fashion, "Now you can go,"[10] irked by the attention her little sister was receiving from the Prince. Diana recalled, "I was just sort of amazed, 'why would anyone like him be interested in me?'"[11] It's a thought that anyone who's ever suffered from low self-esteem has pondered, and in another series of tapes with her voice coach Peter Settelen, Diana further explained, "It was the fact that an older man—um, who was in a prominent position, liked me and wanted to have me around."[12] She idealized the Prince and suffered from what I like to call "chosen syndrome"—the belief that you've been plucked from the crowd by somebody superior, and you don't deserve it.

In 1980, Diana was reacquainted with the Prince at his thirtieth birthday party. She'd received an unexpected invite, much to the unamusement of her sister Sarah, Charles's on-again, off-again girlfriend. The courting began with a series of meetings, followed by a visit to Balmoral, a stay that Diana admitted in her secret tapes with Colthurst, had her "shitting bricks." In total, Diana Spencer and Prince Charles met thirteen times before they were married. "We fell in love gradually. It wasn't really dramatic. One blink and it would have

gone,"[13] Diana recalled. She later criticized his courting abilities, saying, "He'd ring me every day for a week, then wouldn't speak to me for three weeks." She continued, "The thrill when he used to ring up was so immense and intense. It would drive the other three girls in my flat crazy"[14]—a hot-and-cold love cycle all too relatable to many of us. "She was a willing puppy who came to heel when he whistled,"[15] said Andrew Morton.

Once the press cottoned on to the royal romance, Diana effectively said goodbye to her innocent, undisturbed life, and the hunting began. From the start, the paparazzi were unapologetically intrusive. They followed her everywhere, even renting a flat on Old Brompton Road across from hers, so they could see in through her windows. Photographers, usually around thirty of them, tailed her red Austin Mini wherever she went. On occasion, she rushed traffic lights just as they were changing, so the paps would get stuck at the red light. It was mayhem; she was their bounty. But Diana was able to "recognize an inner determination to survive,"[16] with no help or support at all from Charles or the Palace.

"I'd describe Diana's preengagement style as 'vicar's daughter meets Prada' (old Prada, obviously)."

With the eyes of the world watching, Diana realized she had to pay closer attention to her appearance since her every waking move was being tracked and reported by the press. I'd describe Diana's preengagement style as "vicar's daughter meets Prada" (old Prada, obviously). It's conservative, refreshing, and minimalistic, while at the same time, experimental in that I'm *nineteen years old and the eyes of the world are on me, who the hell do I want to be?* kind of way. At times, we see her dressing her age in whimsical sweaters and a charming gold necklace with a "D" charm, which was gifted to her on her sixteenth birthday by her school friends. At other times, she dressed far too maturely for her age, in matronly maroon suits and frumpy ensembles featuring midlength

pleated skirts, typically plaid, with tights that matched her sweaters. (Green or peach-tinted tights, for the record, never were, and never will be, OK.)

I love the naiveté of her preengagement outfits. There's a sense of serious commitment to her future duty in the formality of her clothing, contrasted against typically youthful, interesting details and the occasional sartorial mishap. Even the looks that are, ahem, dodgy, to say the least, have a sense of charm and profound innocence to them. Supposedly, at the time, Diana "regularly raided her friends' wardrobes so that she would have a presentable outfit to go out in."[17] We can see a nineteen-year-old experimenting with her style, balancing her personal identity while attempting to fulfill the ideal of what a potential future princess should look like. By her modest hemlines, high necklines, and buttoned-up collars, it's evident that she took her association to

"... behind all the clothes and the press attention, there was a nineteen-year-old girl in love."

the monarchy, and her future duty, very seriously.

Diana's staple accessories included a black-and-tan basket bag, which she carried with her everywhere; cashmere knits in jewel tones (always layered neatly over a pie-crust shirt collar or a turtleneck); and a light dusting of blue eyeshadow. Her eyes stayed mostly to the ground, with a coy smirk that became her trademark expression through the eighties. This might be our most authentic view of Diana until later in the mid-nineties, when she becomes empowered enough to start expressing her personal style away from the influences and rigidities of royal life.

Anna Harvey, acclaimed British *Vogue* deputy editor and friend of Diana's sisters, was introduced to the Princess when it became evident she needed a little extra help. Diana's first and longtime stylist recalled that when she met Diana, "She really had nothing in her own wardrobe—a few Laura Ashley blouses and skirts, and some bobby jumpers. That was it."[18] In a piece Harvey

wrote for British *Vogue* in October 1997, one month after the Princess's death, she explained that at the time Diana first came to public attention as Charles's love interest, she was "incredibly unsophisticated."[19] She continued, "Her taste was typical of her background; upper-class English girls weren't as knowing about clothes as they are now—there were no It-girls then." Diana, of course, changed all that. At first, according to Harvey, there was no strategy to Diana's wardrobe. "There was no grand plan, it was simply a case of choosing who was around or who had been recommended by her new friends from *Vogue*." Jacques Azagury, Diana's long-time couturier, told me, "I think she met Anna Harvey just in time."

Yet behind all the clothes and the press attention, there was a nineteen-year-old girl in love, her first love. When Charles proposed, she laughed. She recalled, "I remember thinking 'this is a joke,'" before he reminded her of the enormity of her decision, that by accepting his proposal she would one day become Queen. A foreboding voice inside her head told her, "'You won't be Queen but you'll have a tough role.'"[20] Diana said, "In my immaturity, which was enormous, I thought that he was very much in love with me, which he was, but he always had a sort of besotted look about him, looking back at it, but it wasn't the genuine sort. 'Who was this girl who was so different?'"[21]

The night of the proposal, Diana went back to her flat and broke the news to her three flatmates. They "screamed and howled" and celebrated by going on a drive around London with their secret. Soon after, the engagement was announced. Diana wore an unflattering blue skirt suit, one of the matronly outfits I mentioned earlier, picked out for her at Harrods with the help of her mother, Frances Shand Kydd. The press attention after the announcement became unbearable.

She spent her final evening with her girls before leaving Coleherne Court for the last time. She was driven to Clarence House, the home of the Queen Mother, and, as her brother Charles Spencer once said, "Suddenly the insignificant ugly duckling was obviously going to be a swan."[22]

Diana at the Young England Kindergarten in 1980, shortly after her relationship with Charles was revealed. Her skirt, bought from Laura Ashley, became backlit when photographers cunningly maneuvered her into direct sunlight, knowing they'd get a bombshell shot that would show a full silhouette of her legs through the diaphanous fabric. I'm sure that later on, her army of royal style councilors would not allow such a mishap. Once these pictures appeared in the press, Charles was said to have commented, "I knew your legs were good but I didn't realize they were that spectacular."

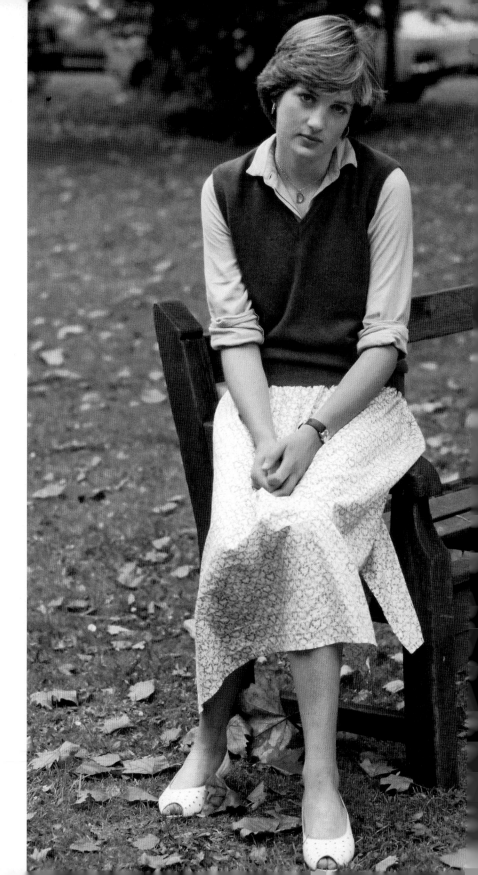

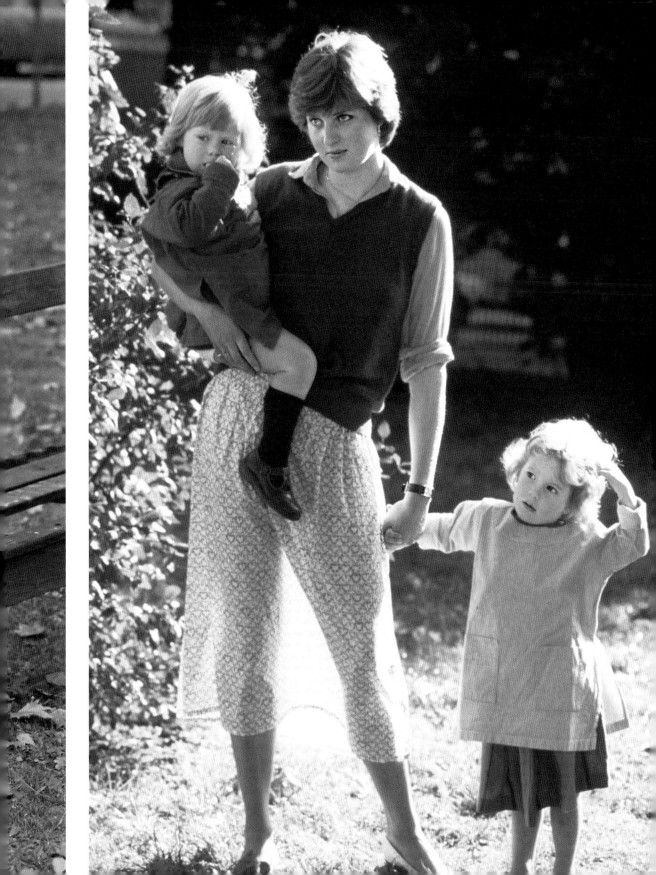

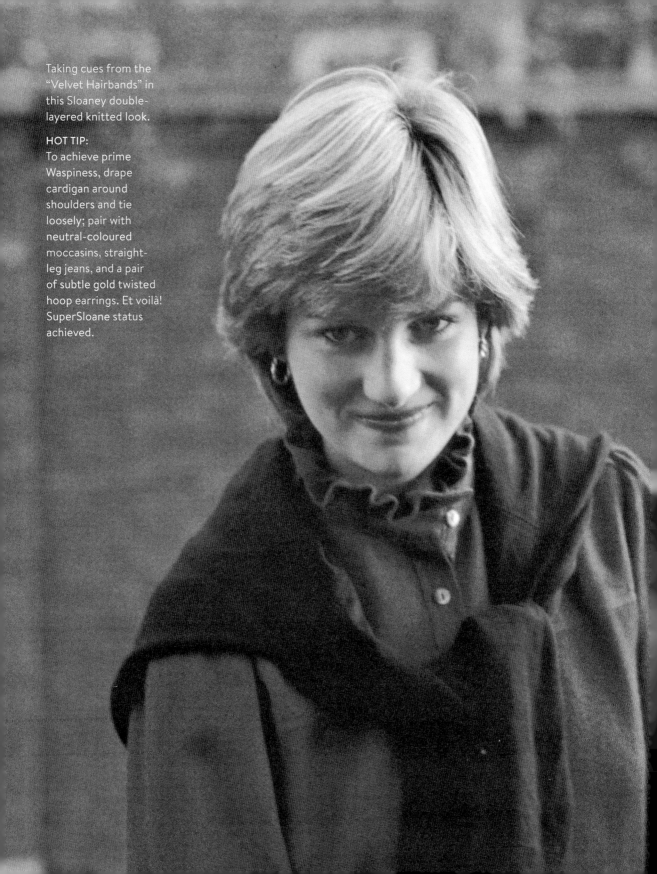

Taking cues from the "Velvet Hairbands" in this Sloaney double-layered knitted look.

HOT TIP:
To achieve prime Waspiness, drape cardigan around shoulders and tie loosely; pair with neutral-coloured moccasins, straight-leg jeans, and a pair of subtle gold twisted hoop earrings. Et voilà! SuperSloane status achieved.

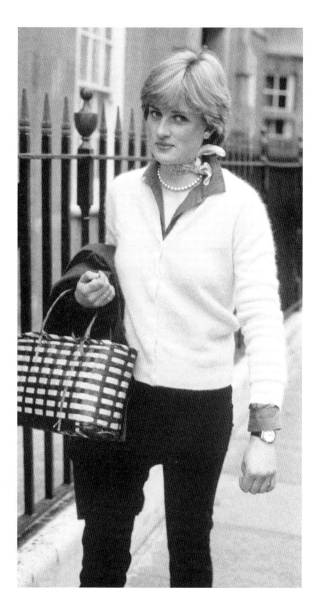

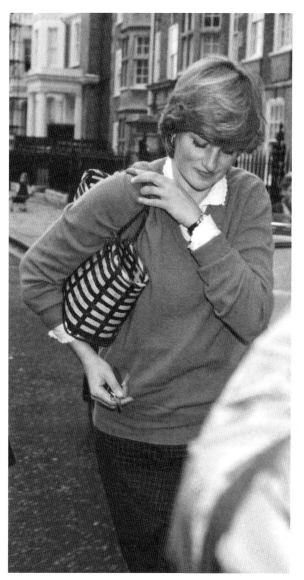

Lady Di showing up to her nannying job for a little boy named Patrick Robinson, the son of an American oil executive. The cashmere cardigan, single string of pearls, and neckerchief could easily have felt a little stuffy, but she saved it by accessorizing with a quaint woven basket bag—a touch of Jane Birkin.

Wearing a green V-neck styled over her favorite pie-crust collared shirt. Not visible (for a good reason) is a pair of matching green tights.

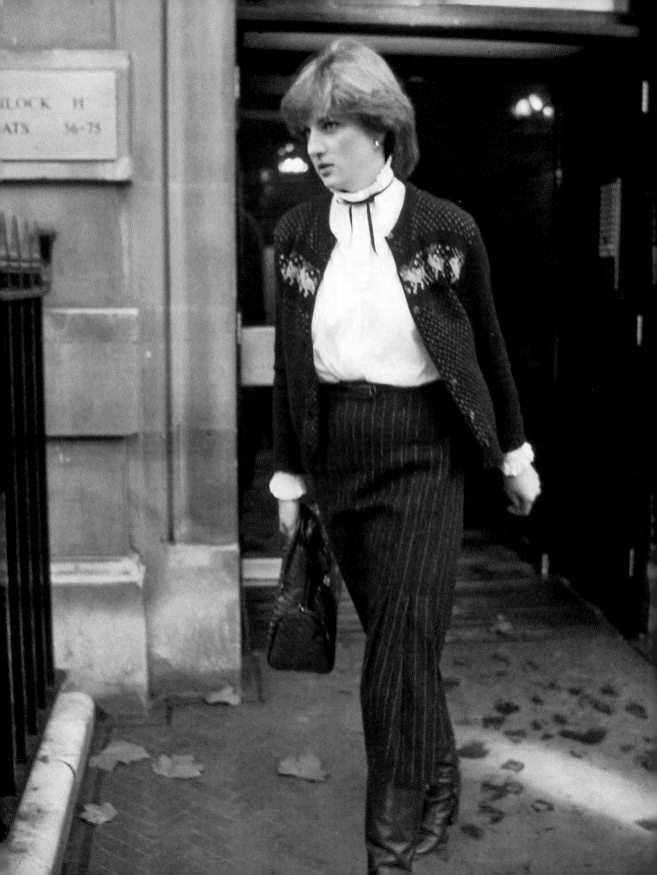

Pinstripes, plaid, and bows for a future princess! There's a stroke of real genius to each of these outfits—she's got her plaid, colors, and accessories just right. Her favorite pie-crust collar is styled with a little more sophistication this time: buttoned up and finished off with a single black ribbon tied into a bow. Sloanedom to princessdom.

Diana bought this joyful Peruvian Fair Isle sweater (complete with llamas!) for the modest sum of £11.50 at a shop called Inca in London's Belgravia—my sources told me they made the softest knitwear around!

It's a little loud and somewhat childish, not what you'd have in mind when you imagine the clothing of a future princess. But I like that she paired it with bootcut jeans and exposed lace cuffs and collar—a serious nod to her eventual role as wife to the future king.

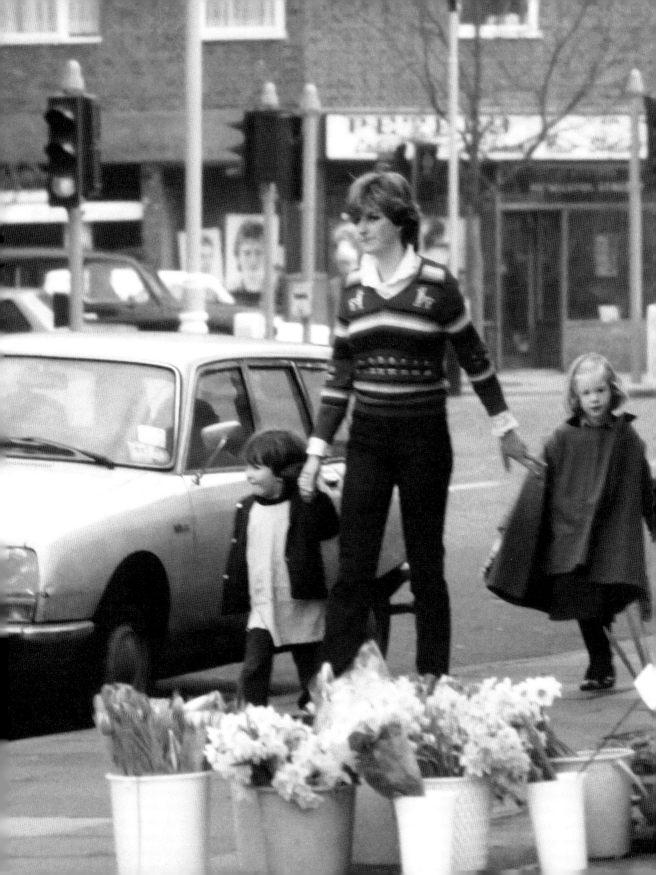

"I left my flat for the last time and suddenly I had a policeman. And my policeman the night before the engagement had said to me "I just want you to know this is the last night of freedom ever in the rest of your life. So make the most of it." And it was like a sword went in my heart. I thought 'God,' then I sort of giggled like an immature schoolgirl."[23]

2

THE POLO LOOK

"One minute I was nobody, the next minute I was Princess of Wales, mother, media toy, member of this family, you name it, and it was too much for one person at that time."[24]

Diana was the original queen of cottagecore. For those of you who aren't familiar with the term, it's an aesthetic inspired by a romanticized interpretation of a domesticated, countryside life. A return to the earth, if you will. Think gingham pants, embroidered bumble bee sweatshirts, patchwork Provençal bags, and pastel-yellow overalls—aka, everything Lady Di wore during the early half of the eighties, appearing all the way through to 1990. It's the "good wife, good life" style.

A country girl at heart—the Princess spent her childhood years in the quaint setting of Norfolk and her teen years at her father's estate at Althorp in rural Northamptonshire—even with the initial styling assistance from *Vogue*'s Anna Harvey, Princess Diana had some sartorial tactics up her sleeve when it came to bucolic dressing. She grew up wearing overalls and wellies, after all.

Although the jet-setting royal diva Princess Margaret preceded Diana in the celebrity stakes, the young duchess was arguably the royal family's first modern-day celebrity. She had "tremendous hope" for her marriage and that, eventually, the press attention would calm down once she formally entered into royal life. In fact, it got a lot worse. The public thirst for everything and anything Diana fanned the media's flame. People all over the UK, and the world, looked to her as their fairy-tale princess, who'd bagged the eligible prince. (It's hard to believe, but there was a time when people fawned over Prince Charles. The cover of *Tatler*'s February 1992 issue read, "Is Prince Charles Too Sexy for His Own Good?" Princess Diana supposedly found it "hilarious because of its unintentional irony."[25])

Everything from the duchess's clothes to her hairstyles were copied. Her unique haircut, described by *Time* magazine in 1981 as "a soft wedge graduated to the nape of the neck,"[26] was requested by young women all over Britain, who demanded a replica "Di job" from their local hairdressers. *Time* journalist Michael Demarest whimsically wrote that it was the "coiffure that launched a thousand snips."

Long before the world was keeping up with the Kardashians, they were desperately seeking Diana Spencer. As soon as the young duchess stepped into the royal spotlight, she caused manic frenzies as women rushed to emulate her unique brand of princess. Much like the celebrity royals in the spotlight today, if Diana wore something affordable—for example, that Fair Isle Inca sweater

she wore on multiple occasions throughout the eighties—brands were inundated with requests and would quickly sell out of their stock. On a trip to the States in 1985, Diana visited a J.C. Penney inside a Virginia mall and picked up an $8 red polka-dot scarf. Minutes after the royal visit, the department store's stock of seventy-five scarves sold out—decades before fast fashion and heavy inventory flow became a standard business model.

In many ways, Diana was one of the original influencers. (Harry Styles, who recently wore a sleeveless version of Diana's infamous black sheep sweater, has nothing on Diana when it comes to sartorial influence!) Just as women tried to outdo each other with gargantuan puritan collars in the early eighties, people today sign up for waiting lists to be the first to get their hands on revived versions of some of Diana's most iconic off-duty pieces, which have been brought to life again by brands who recognize the late Princess's everlasting, cultish appeal.

Joanna Osborne, the co-designer behind the Warm & Wonderful sheep sweater, most recently revived by preppy brand Rowing Blazers, described to me the Diana effect on their own business: "The postman would arrive with a great sack over his shoulder and empty out all these requests for catalogues and orders, and empty it into our shop window. Then the next day, he'd bring another big sack and do the same thing again." Joanna reminded me that, at the time, the sweaters were hand-knit in people's homes and not made in factories—"so we were pretty swamped," she said.

It's important to remember that during this time, as much as Diana intrigued the public with her vibrant and very copyable wardrobe, the press treated her as a toy. They realized they had created an astronomically profitable engine. Everything, from her shy facial expressions to her rapidly decreasing waistline, was written about and dissected at humiliating length. They knew that gossip (true or false, it didn't matter) was a winning formula. All sources were welcome—especially friends of Mrs. Camilla Parker Bowles.

The beast had to be fed.

Diana's bowed head and coy facial expressions were completely misinterpreted by the media. They framed her as spoiled and immature. "Diana Throws a Wobbly" was one among many headlines that appeared soon after her 1981 marriage to the Prince of Wales. In 1982, the *Daily Express* commented, "The indirect head, the hands on the hips . . . the look that says 'I am not amused,'"[27] captioning one photograph at a polo match, the "wish-we-weren't-here look." Although the caption was spot on, her apparent disinterest was

misjudged. Diana recounted, "When I first arrived on the scene, I'd always put my head down. Now that I interpret it, that did look sulky,"[28] she explained. "I was just so frightened of the press attention I was getting."

On Diana's honeymoon, various articles appeared saying that she wandered through the Scottish countryside and the great halls of Balmoral, the royal family's Scottish home, with headphones in her ears, listening to music on her Sony Walkman. The Queen was said to have remarked, "She can't hear anyone coming with that contraption, you know. She just walks straight past me,"[29] while the Queen Mother reportedly told her inner circle that Diana was a "silly little girl." Diana was just twenty years old when she walked down the aisle, and her interests—romantic novels, ballet, candy, and pop music—would have been perfectly fine for any other young woman her age. But she was no longer "Duch," she was "ma'am"—and just like her clothing, her behavior was expected to reflect her superior position.

Her old flatmate from Coleherne Court, Carolyn, said that when Diana moved to Buckingham Palace, that's when "the tears started." She was weighed down, not simply by the weights placed in the hemlines of her skirts (to stop rogue gusts of wind from sabotaging propriety before the press), but by the expectations placed on her from the Prince, the Palace bureaucracy, and the British public, who were facing the most severe recession since the 1920s and who so badly needed their real-life fairy-tale princess. With the bar for perfectionism set unattainably high by outside forces, it's impossible to imagine the pressure she faced to be the "perfect" princess bride.

"I missed my girls so much I wanted to go back there and sit and giggle like we used to and borrow clothes and chat about silly things, just being in my safe shell again,"[30] Diana later said in her secret tapes.

Then, her weight began as a topic of discussion within the press—more infuriating and heartbreaking, since we now know she was facing a vicious and silent battle with bulimia around this time. Between the announcement of her engagement and her wedding day, six months later, Diana had lost a dramatic five and a half inches from her waist. Not surprisingly, women's magazines lauded her weight loss and started to publish articles encouraging the Di Diet. Diana said that the bulimia began the week after she and Charles got engaged and continued through her pregnancy with William and most of the 1980s. "My husband put his hand on my waistline and said, 'Oh, a bit chubby here, aren't we?' and that triggered off something in me,"[31] she said, recalling the moment her bulimia started.

Then, of course, there was the issue of Camilla—aka "Gladys," Charles's forbidden love. When Charles went to Australia shortly after the announcement of his engagement to Diana, Camilla wrote to Diana inviting her to lunch to celebrate. "I'd love to see the ring," she wrote. (I bet she did!) The lunch was later recounted by Diana as "very tricky indeed." Two weeks before Diana was to be married, she intercepted a parcel at the palace, which contained a gold chain bracelet with a *G* and *F* intertwined on a blue enamel disk. The initials stood for *Gladys* and *Fred*, the secret nicknames the two had for each other.

Diana came from a broken family herself. Her mother, Frances Kydd, had left the duchess's father for a wallpaper heir she had fallen madly in love with, and, subsequently, she lost custody of Diana and her siblings. At thirteen, Diana was sent to live with her father at Althorp and was soon introduced to Raine McCorquodale, her father's second wife-to-be and the future stepmother of the Spencer children, who dubbed her "Acid Raine."

"She was no longer 'Duch,' she was 'ma'am'—and just like her clothing, her behavior was expected to reflect her superior position."

"Diana had every reason to hope that she could create with Charles the happy family life she herself had been denied—the happy family life that he told her he too wanted," wrote Anthony Holden for *Vanity Fair*. In many regards, Diana was searching for someone to heal the wounds of her childhood trauma and love her unconditionally. "The denial of that hope, at the very outset of her marriage, was to Diana the ultimate betrayal."[32]

The newspapers profited from her silence; they had free rein to spin their own narrative. Unable to speak directly to the press, but soon understanding

how they dissected her outfits to interpret what they thought she was saying, Diana realized her clothes had the power to communicate what she didn't dare say. Each outfit became somewhat autobiographical.

Between the campy sweaters and patchwork bags, little pops of Diana's personality shone through, as well as more than a few cries for help. We can see a young woman facing a deep internal crisis, desperately clinging to her innocence *and* her husband, all the while getting to know her own personal style and what she liked to wear away from the pomp and ceremony.

By 1984, thanks to Anna Harvey and Diana's direct communication with some of Britain's top designers, the Princess had become well versed in the ropes of royal dressing. As a result, her style began to evolve with a higher level of sophistication. Diana's affinity to countryside chic blended with her waspier, London-esque Sloane Ranger style. She became a fan of a white shirt and pencil skirt on the polo field, with a preppy red sweater draped around her neck. Her outfits signified a growing sense of confidence, a signal that she was "fighting back," not just against Charles and "his lady," but against all the individuals and entities that sought to define the Princess's life and narrative for her.

Although some people are fans of the giant puritan collars the Princess wore over tunics, I've purposefully omitted them from my selection—they were often styled over dowdy dresses and haven't stood the test of time the way some of these other outfits have. I prefer the looks that would evoke an envious side-eye from Diana's rivals and make the stiff upper lips of the "men in grey" tremble.

It's 1981 and the Fair Isle llama sweater by Inca makes a comeback! This time, it's styled over an ivory-coloured turtleneck, paired with Margaret Howell corduroy pants and traditional Wellington boots. It's not hard to imagine her in the woodlands of Balmoral, foraging for mushrooms. After Diana appeared in this engagement photo, the shop who made them sold over 400 of the llama sweaters within just three days.

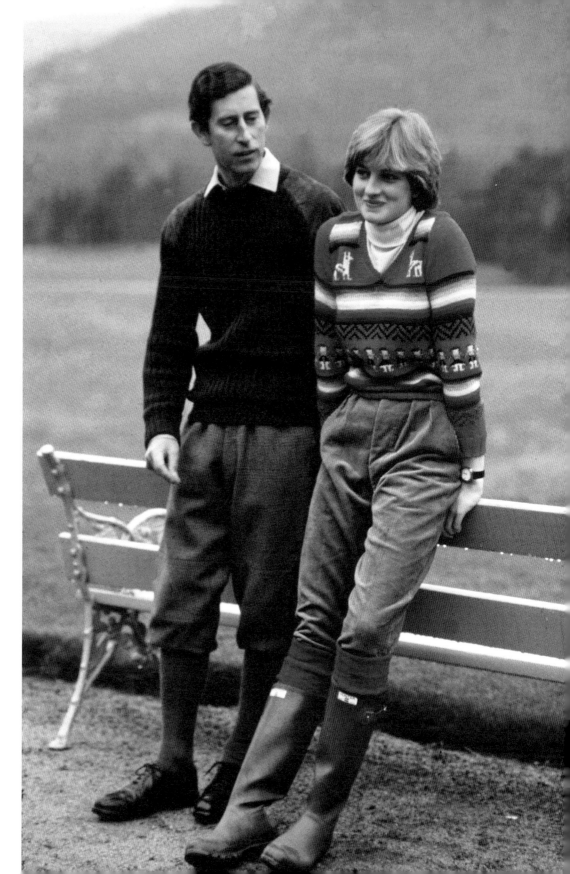

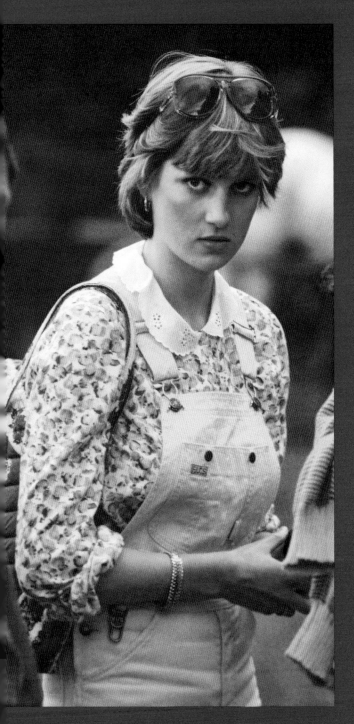

"I learned to be royal in one week."[33]

The wish-we-weren't-here look, in all its moody, angsty glory. These photos were taken one month before the royal wedding—it's impossible to imagine how tough it was at such a young age to suddenly be shoved under the microscope of the entire British public. Diana is seen wearing a floral blouse with a scalloped-edge Peter Pan collar, red espadrilles, and a pair of pastel lemon overalls, known as "FU's" by eighties denim brand "FU" denim. An early "eff you" to Camilla, perhaps?

She's sporting her favorite Souleiado tote bag, which she bought for £25 at the brand's West London shop. She had about five styles from the Provençal brand (and they're still making some of the same ones today!).

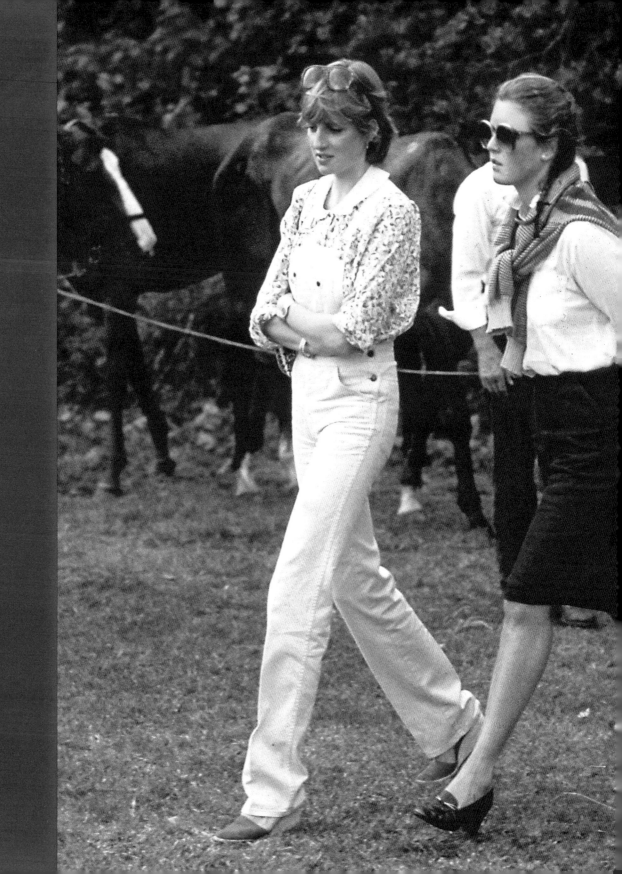

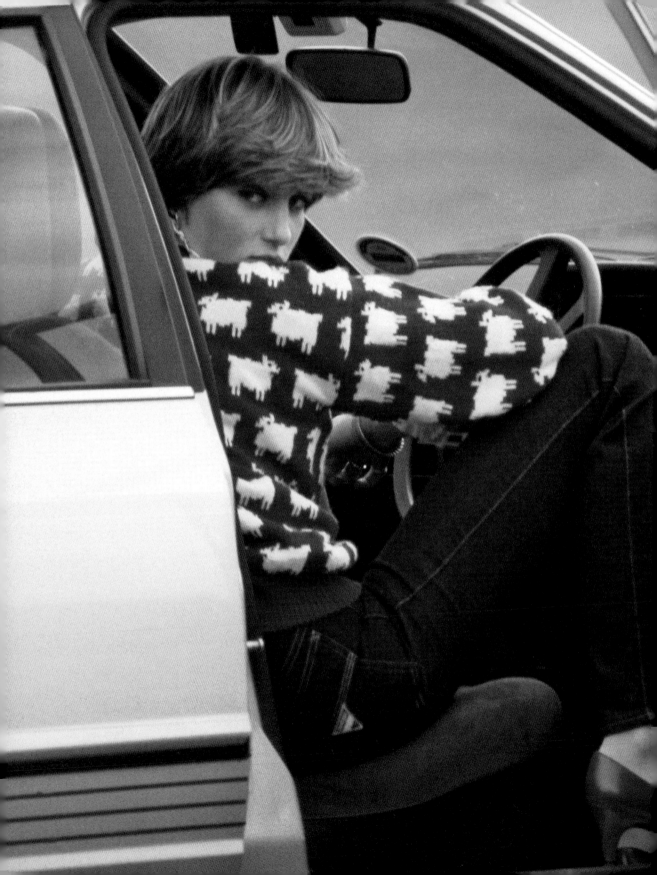

"I felt I was a lamb to the slaughter."[34]

Speaking in her tapes about her early relationship with Charles, Diana said, "He'd found the virgin, the sacrificial lamb,"[35] and on her wedding day, she described herself as a "lamb to the slaughter." In the life of Princess Diana, sheep crop up as a recurring theme. She first wore the infamous black sheep sweater, by kitsch brand Warm & Wonderful, in June 1981 for the sidelines of a polo match. Not visible in this image is a single black sheep among a white herd—comical in its design and subliminal in its message. The knit, however, goes beyond its obvious proverbial takeaway.

This is the original catalogue Sally Muir and Joanna Osborne put together shortly after Diana appeared in one of their sheep knits.

Warm and Wonderful

1 Sheep jumper. Sizes small, medium, large, available in red with white sheep, grey with white sheep, blue with white sheep, green with white sheep.
£38.00+£1.50 p&p.

4 Brickwall jumper. Sizes small, medium, large. Round or V-neck. Available in rust bricks with fawn cement, sage green bricks with fawn cement.
£32.00+£1.00 p&p.
Optional graffiti of your choice 50p a word.

2 Ruffle cardigan. Sizes 34", 36", 38" available in white and pale pink, pale blue and yellow ridges, red with green, yellow and mid blue ridges, black with gold ridges.
£34.00+£1.00 p&p.

5 Hand knitted Kite jumper. Sizes small, medium, large. Available in royal blue and petrol blue.
£45.00+£1.50 p&p.

3 Meadow jumper. Sizes 34", 36", 38" available in pale blue and green, fawn and mushroom, pale blue and pale pink.
£34.00+£1.00 p&p.

6 Car Jumper. Sizes small, medium, large. Available in navy blue with red and yellow cars, grey with red and navy blue cars, pink with fuschia and purple cars.
£29.00+£1.00 p&p.

All these jumpers are knitted in pure wool and must be handwashed with care.
Small size measures 36", length 23," medium size measures 38," length 24," large size measures 40," length 25."
Other sizes and colour combinations are available, please state with your order. We can also make up jumpers to your design – these are more expensive but do phone us for a quote. As these jumpers are individually made, please allow 3 to 6 weeks for delivery.

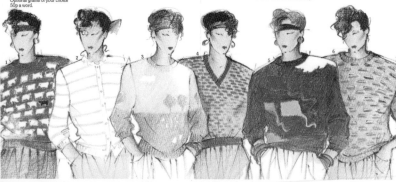

We'll knit your favourite sweater

Ironically, the Spencers were the oldest sheep-farming family in the UK, who made their vast fortune beginning in the fifteenth century. From an early age, Diana said, "I always felt very different from everyone else, very detached. I knew I was going somewhere different but had no idea where."[36] Certainly the sheep reflects not just her inward thoughts about her new family and foray into public life, but memories of rejection from her childhood and teenage years.

The designers behind the sheep sweater were Sally Muir and Joanna Osborne, who co-knitted for their small, independent label Warm & Wonderful. Joanna described to me the moment she discovered Diana had worn their hand-knitted design to a polo match: "I went to buy the Sunday papers one morning [in June 1981], and there was our jumper all over the front pages worn by Diana." The design duo hadn't a clue that the Princess was the owner of one of their very first designs. "We were staggered," she added. The pair had only recently before that, through Sally's brother, met and inspired by their mutual love for knitting, decided to start a business. "It was very impulsive," said Sally, "I gave in my notice the next day."

Soon after the Princess wore the sweater, the press tracked them down. Eager to respond to the influx of inquiries and orders, Sally and Joanna rushed out a catalogue, and in quite the opposite of a royal shopping experience, Di-hard customers would have to visit the duo's market stall if they wanted to buy their own sheep sweater. Their business was very bare bones at this point—before the time when David Bowie, Shelley Duvall, and Tippi Hedren became impressive names on their client list. I asked the designers if they had ever encountered Diana in the flesh, to which Sally responded just once, but at a distance, while Diana was presumably driving home to Kensington Palace. She did however encounter a Mrs. Camilla Parker Bowles in her local "Waitrose" supermarket, recalling "she was shoveling chicken Kievs into her trolley."

It's not just the message-laden sweater that strikes me here. Diana's two-inch Dorothy-esque heels, I imagine rather unsuitable for the grassy, damp terrain of an English polo field, also hint at a subtle rebellion.

In the *Wizard of Oz* movie, "the slippers represent the little guy's ability to triumph over powerful forces,"[37] wrote Rachelle Bergstein for *Forbes*. "As the item that she—a simple teenage farm girl from Kansas—steals from the dictatorial Wicked Witch and ultimately uses to liberate the oppressed people of Oz, they're nothing less than a symbol of revolution."

Just as the Emerald City was far away from Kansas, Buckingham Palace was a million miles away from Diana's old Kensington flat, figuratively speaking, and Diana certainly wasn't in Sloane Square anymore.

At the end of the movie, Dorothy leaves the royal palace of Oz and wakes up to find herself home in Kansas with her loving aunt sitting at the side of her bed. "There's no place like home, there's no place like home," chanted Dorothy. One can't help but wonder if Diana tapped her ruby slippers together three times, hoping to go back to her old ordinary life as just any other Sloane Ranger.

By 1983, Diana's style had gone through its first royal metamorphosis. Two years after its first appearance, the sheep sweater made a comeback, this time styled over a pussy-bow blouse with a pointed flat collar. She paired the knit with cool white carpenter pants and a white folded floral clutch by Souleiado. The full look, complete with a copious amount of hairspray, looks dramatically more refined and confident than her 1981 ensemble. Joanna Osborne told me "she's wearing it much more stylishly, she looks much more confident, she looks like she's in control of her situation—which, I don't think she was at the time, but she had that aura."

Elizabeth Holmes was first to point out in her book, *HRH: So Many Thoughts on Royal Style*, that the second time around, the black sheep was facing a different way. According to Warm & Wonderful's designers, Sally Muir and Joanna Osborne, this was because she'd torn a hole in her first one, which Sally suspects was probably due to her "enormous engagement ring" (and since, in all likelihood, the meaning behind it was still relevant).

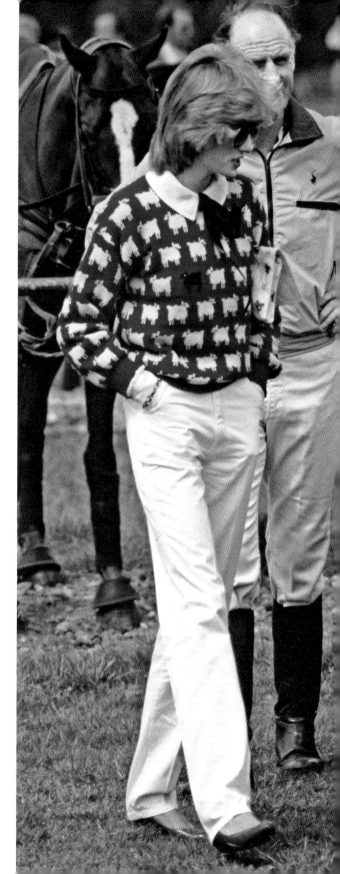

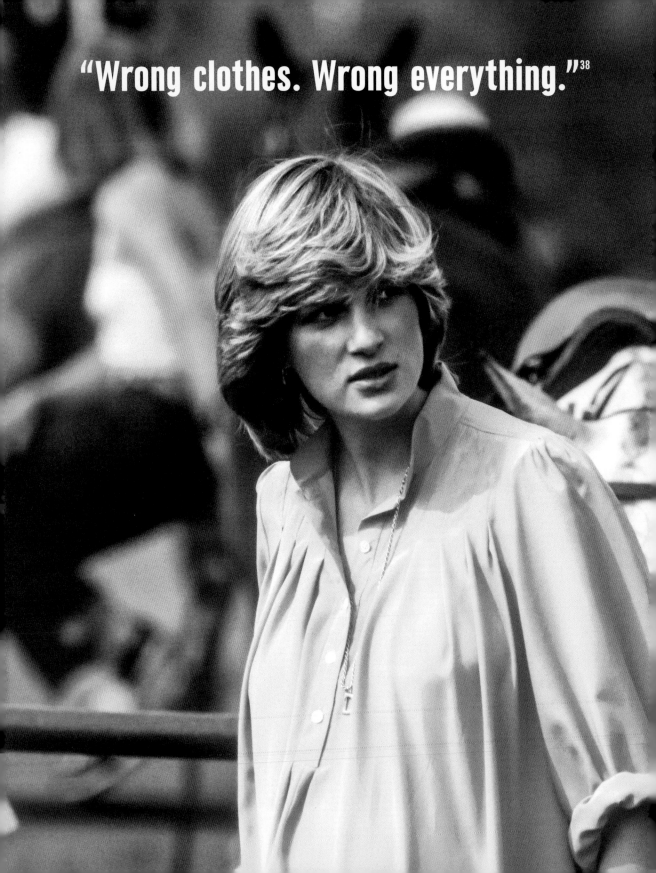

"Wrong clothes. Wrong everything."[38]

THE MATERNITY LOOK:
Heavily pregnant with Prince William, Diana wore a simple bubblegum-pink tunic dress to a polo match with her favorite Souleiado tote in 1982. Her signature *D* necklace, a nod to her past life, still hangs by its delicate gold chain. There aren't too many photos of Princess Diana during her pregnancy—did she know her bump provided even more fodder for an overbearing press? Just like her Victorian predecessors, the Queen was never pictured in public when she was visibly pregnant (perhaps to avoid anyone fantasizing about the methods of how she got there in the first place), so these appearances were somewhat rebellious against the status quo. Diana's also seen here wearing white, open-toe sandals—another big royal no-no. Royalty didn't show their toes in public back then (no cleavage on display, ever—and that includes toes) and still rarely do to this day!

This is as much of Diana's bump as the public got to see as she mainly wore loose-fitting tent-style tunic dresses. She was, sadly, still sick with bulimia *and* morning sickness, describing it as a "very difficult pregnancy indeed."

When Diana's labor was induced, she had to schedule a time in the calendar to do it so "Charles could get off his polo pony." The Queen took a first look at baby William lying in the incubator and said, "Thank goodness he hasn't got ears like his father."[39] Ouch.

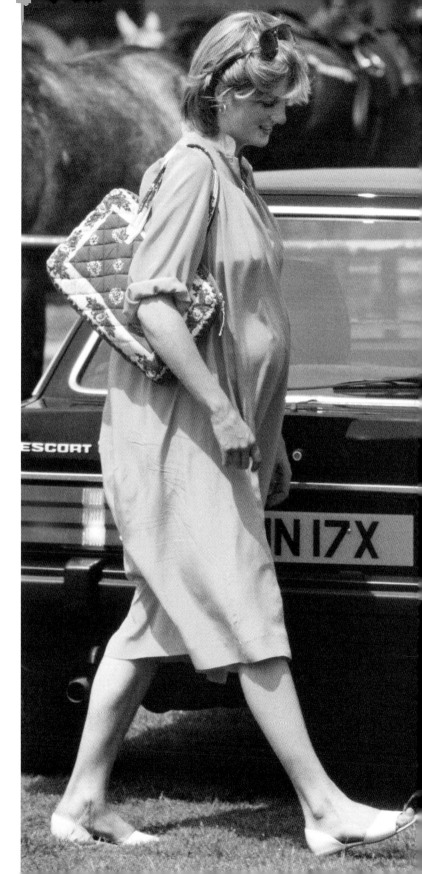

THE POLKA DOTS

"She's different, she's doing everything we never did."[40]

(Opposite, Top to Bottom)

Shy Di looked sugar, spice, and all things nice for keeping company at the polo match with Her Majesty the Queen in 1983.

Later the same day, sans Her Majesty, Diana sported a more sinister expression. She wore a polka-dot tea dress, which she accessorized with a nameplate necklace engraved with her beloved "William." You may notice she's wearing two watches: the gold was her own, made by Genevan timepiece designer Patek Philippe, and the other watch belonged to Charles, which she wore as a good luck token for his game—although her expression indicates she had other sentiments in mind. Was Diana lost in the drama of the polo game? Or was she already plotting vengeance?

(Far Right)

In June 1986, the year that Charles officially reignited his affair with Camilla Parker Bowles, Diana took to the polo field stage wearing this pleated skirt with coordinating sweatshirt by affordable German clothing brand Mondi, a Munich-based clothing line helmed in the 1970s by Escada's Margaretha Ley. The *Daily Mail* said that Diana was "missing the right spot"[41] with her bobby socks, but I think they've become fresher with age—they have a Kawaii-like, youthful charm to them.

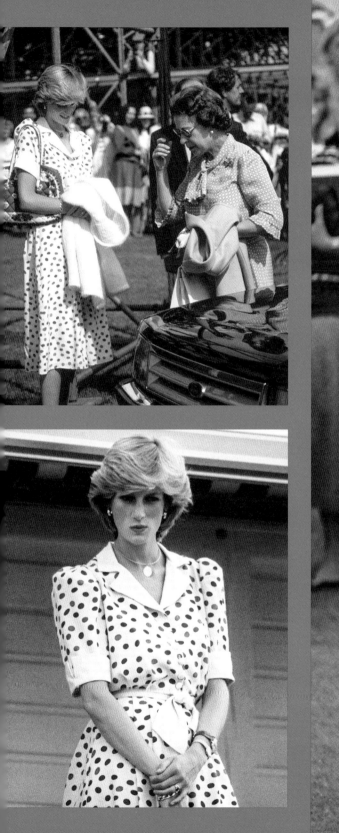
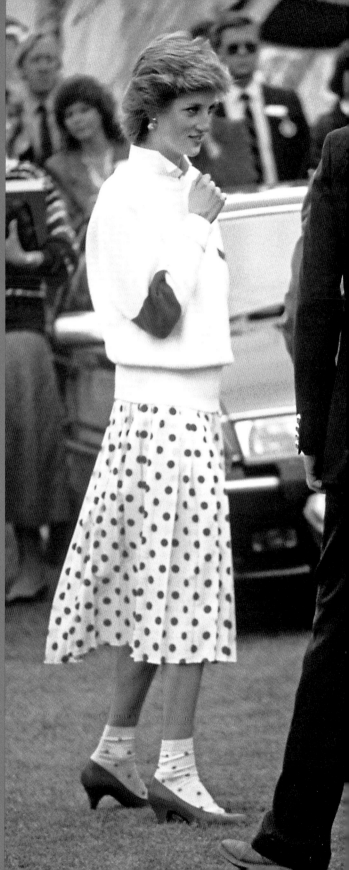

(Left)

Where to begin with this super-chic 1985 look? First, there's the pencil skirt, originally belonging to a two-piece Laura Ashley set, worn by Diana at Wimbledon in 1981. She ditched the frumpy tie-waist jacket and paired the floral skirt with a crisp white bishop-style blouse, a preppy red cardigan draped around her neck, and elegant gold jewelry—with not a pearl in sight. Her trusty Souleiado tote bag was folded underneath her arm. It's a flawless blending of the frills of her past with the puff sleeves and shoulder pads of her mideighties present.

(Opposite)

With the help of Anna Harvey, Diana began to develop her oeuvre for polo "WAG"* fashion. *For those who don't know, the acronym WAG means "wives and girlfriends," particularly of high-profile soccer players, and was made popular by the Victoria Beckham cohort in the early noughties.

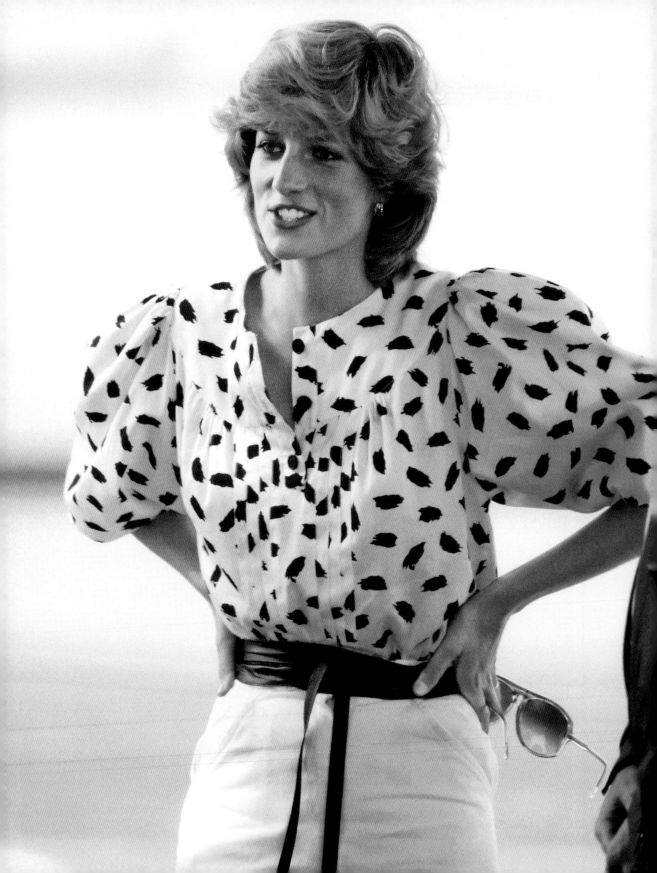

AUGUST 1983: This wasn't the first time Diana wore this black-and-white printed blouse by Dutch designer Jan van Velden. She was first seen wearing it on her 1983 tour of Australia and New Zealand. The press reported that the shirt, worn loosely over a black pleated skirt, looked "decidedly dumpy." Always one to get the final word, and perhaps with a little help from Anna Harvey, she gave it another go, this time tucking it into a white pencil skirt, belted with a chic black leather tie. She also happened to be having a great hair day. The result: *chef's kiss* superb and a big middle finger to all of her sartorial critics. Virgil Abloh revived this print by replicating it for Off-White's Diana-inspired cycling-shorts-and-blazer—infused Spring 2018 collection.

Circa 1986, around the time that we now know there was trouble brewing behind the Kensington Palace gates, Diana wore a sweater by the small "witty knit" label Gyles & George for a personal family photograph with her young boys. On the front, the sweater read "I'm a Luxury . . ." and on the back, "Few Can Afford." The slogan was thought up by British actor, broadcaster, and former member of Parliament, Gyles Brandreth—who became known for his lively hand-knits which he wore on television in the 1970s—and the ideas were brought to life by his co-founder and knitwear extraordinaire, the designer George Hostler.

Diana happened to stumble upon this sweater in a small shop in her local neighbourhood of Kensington. As she was leafing through the knitwear, George told me that she eyed the "I'm a Luxury" jumper and declared "this is for me, this is hilarious, I love this." According to Gyles, this wasn't the only piece she was interested in, "we had another one that she did not buy, which basically says 'what the **** is going on'" but ultimately, Diana opted for the more tongue-in-cheek choice. "She thought I'd better not dare with this one" said Gyles, "but what caught her with the 'I'm a Luxury' [sweater] was the back—that really got her."

While this look, to many, is one of the more recognizable of Diana's eighties "revenge looks"—Gyles Brandreth believed her wearing it was more a signal of her "larky, great sense of humor and fun." Perhaps, he admitted, "it fed into the exact message she wanted to send out," something that signified moving forward, rather looking back. "She's more carefree, doesn't really mind so much what she says or what the world thinks. And I think, that rather, the sweater actually exemplifies that," he said.

What's striking in this photograph is how little this clothing item has dated, and in 2020, it was revived by Rowing Blazers, the same clothing label who brought back the Warm & Wonderful sheep sweaters I mentioned earlier. "She has joined the ranks of people like Marilyn Monroe," said Gyles, "she is now one of the 'immortals' and what I love about this look of hers is it just makes her seem totally real, modern, alive, young, vibrant, witty and now."

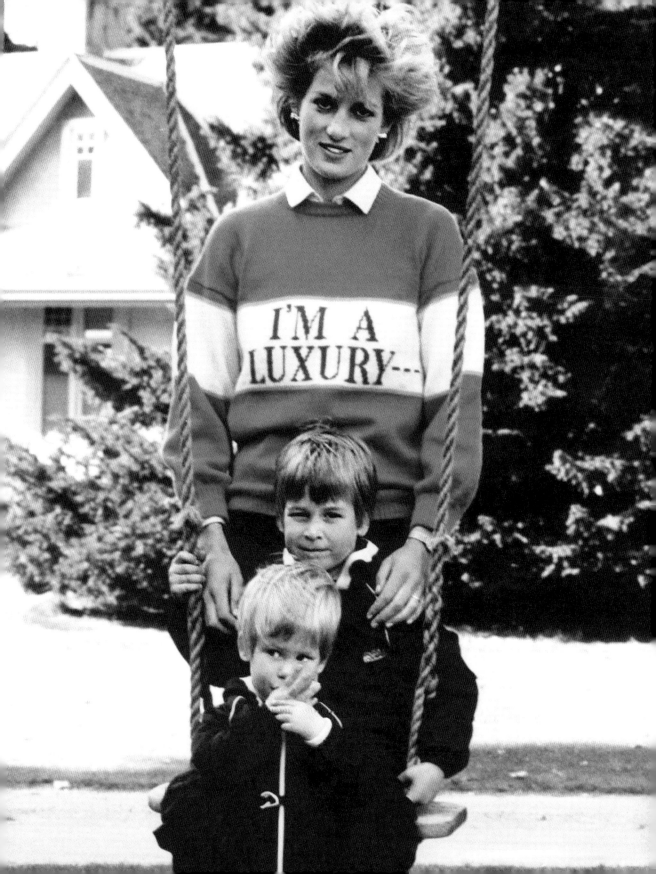

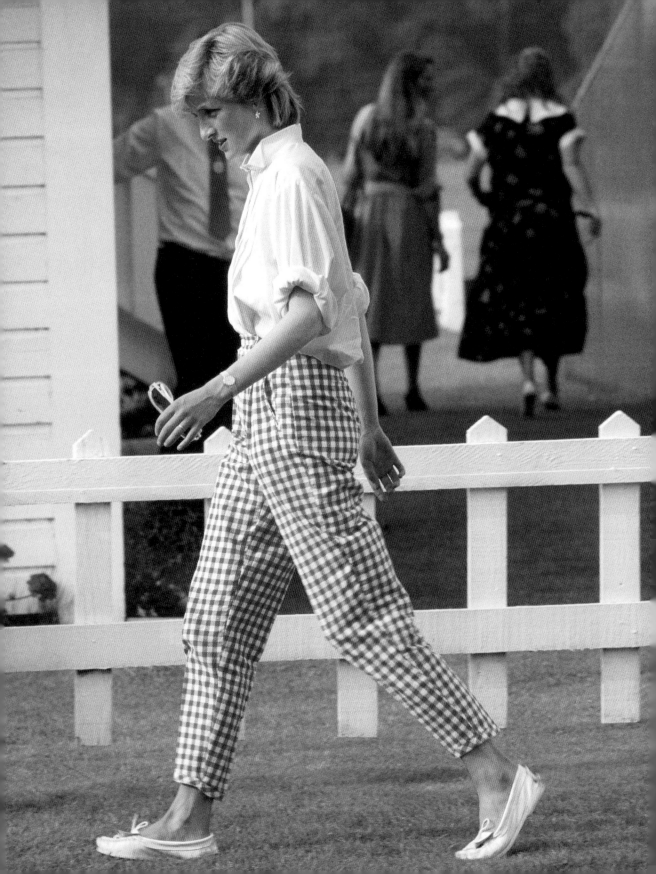

JUNE 1986: Five years into royal life and a mother to two small children, Diana had learned some key rules of survival when it came to life inside the royal family. Here she is, taking confident strides across the polo field in gingham pants and white moccasins. Gone are the puff sleeves; it was time to roll up her sleeves and get her hands dirty and her clothes grubby—at the hands of her energetic toddlers.

JULY 1986: The Princess and baby Prince wear pink at Highgrove. Prince Harry wears OshKosh B'Gosh overalls, and Diana, a pair of romantic Laura Ashley–esque floral pants styled with a pink pie-crust-collared blouse. Tied around her waist is an ivory-coloured cashmere sweater— the Princess had a penchant for wrapping her knitwear around her like protective armor.

JULY 1990: Sometimes appearances can be deceiving, but in this scenario, everything adds up. Before Diana collected her husband from hospital after he broke his arm in a polo accident, Camilla had been in to see him. "His staff was responsible for listening to police radios to track Diana's journey to the hospital, so they could get Camilla out of Charles's room before the Princess arrived,"[42] wrote Andrew Morton.

Diana styled an unbuttoned chambray shirt over a casual white T-shirt and wore it with a floral knee-length skirt and coordinating, but not quite matching, flat shoes. For Sloanes, florals were worn as neutrals, and they had an affinity toward wearing the same romantic designs they'd wallpaper their houses with—Laura Ashley made a thriving clothing and homeware business off this particularly posh aesthetic. For years, Diana wore shoes no higher than two inches—out of respect to her husband's ego, since he was the same height as she was.

This outfit is what I like to call a predivorce revenge look. Of course, Diana's best accessory here is her wicked grin, showing that there was no love lost. She looks as though she's finding the whole thing hysterical, while a delicate Charles looks less than impressed, sporting a pitiful expression similar to the kind my exes have made when they've had a terrible case of the man-flu. One simply can't help but wonder if she wishes she'd put him in that cast herself!

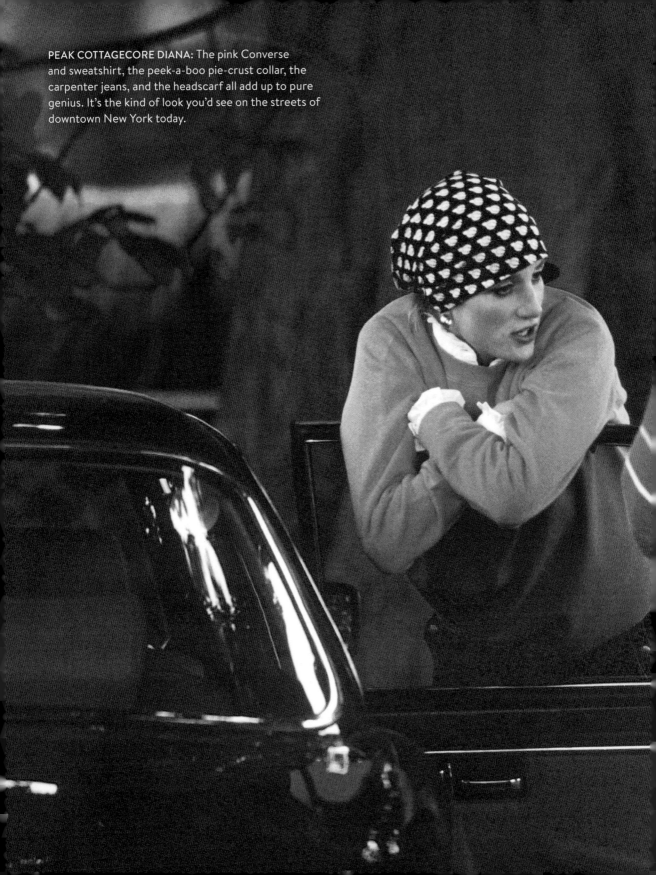

PEAK COTTAGECORE DIANA: The pink Converse
and sweatshirt, the peek-a-boo pie-crust collar, the
carpenter jeans, and the headscarf all add up to pure
genius. It's the kind of look you'd see on the streets of
downtown New York today.

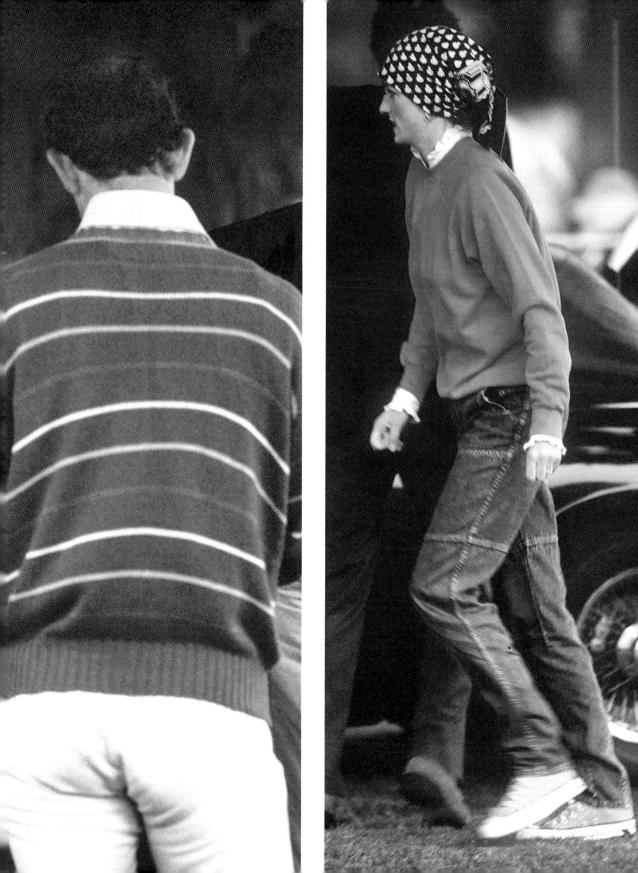

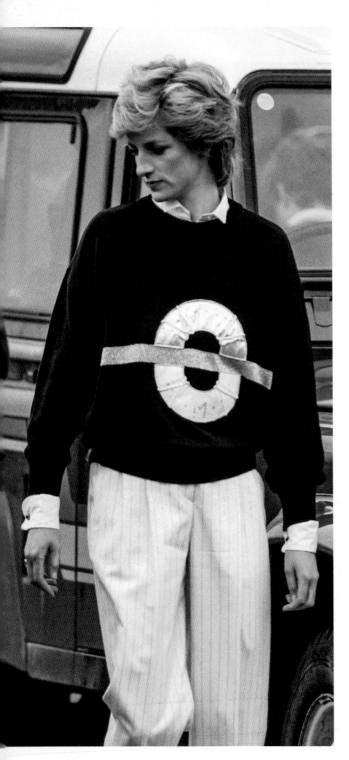

(Left)

Diana sported ivory pinstripe trousers with a wing-tip tuxedo collar and a sweatshirt bearing the metallic London Underground roundel to a polo match in 1987.

According to Diana's longtime bodyguard, Ken Wharfe, the People's Princess was fond of using the tube, and from time to time she traveled across London with her boys and rejoiced when they went undiscovered. Wharfe said she often wore a headscarf as a disguise, and "loved the anonymity London gave her,"[43] although he always had to remain by her side. She couldn't use the tube all the time due to the security risks involved, but when she could, Wharfe recalled that, "She always saw these moments as major victories."

(Opposite)

Disney Princess, but make it sporty. Diana and Prince Harry brought athleisure to the polo field in 1987 with coordinating Mickey Mouse sweaters.

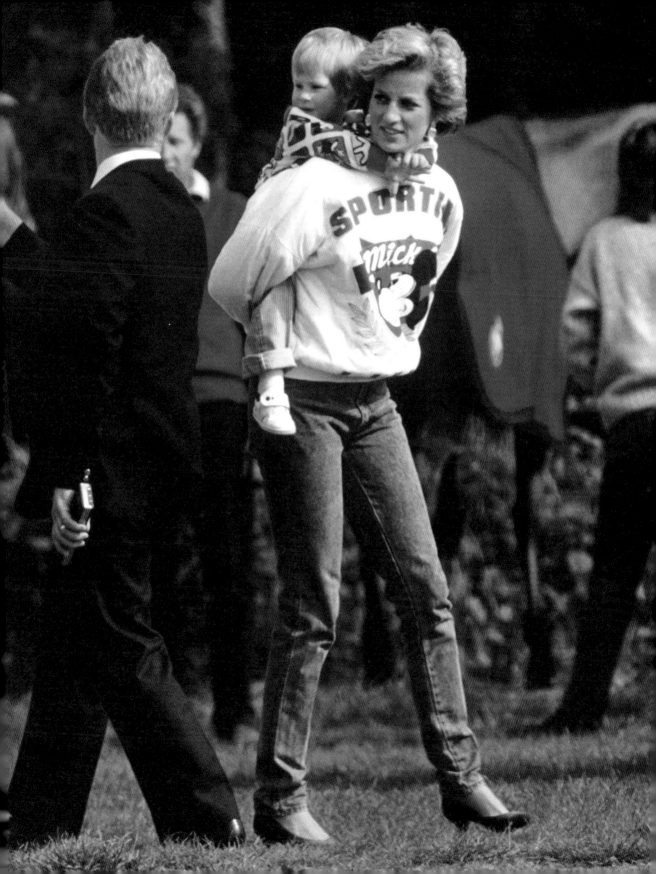

This was another recycled outfit for the Princess. In June 1984, while pregnant with Harry, she wore the same cerise-coloured sweatshirt with bauble-esque blue and pink glass earrings, complementing her signature electric blue kohl.

On vacation in the Isles of Scilly in 1989, wearing a whimsical bumblebee-embroidered sweatshirt. Charles is buttoned up in a suit and tie, while Princess Diana looks like one of the kids. She wasn't a regular mom. She was a cool mom.

"She knew in her heart that in order to survive she had to rediscover the real Diana Spencer."

—ANDREW MORTON

3

THE SLOANE AND THE CITY LOOK

When I was a teenager in London during the early aughts, the "Sloane," neé Sloane Ranger, was certainly still a thing, although it looked a little different than it did in the days when Diana roamed around Chelsea and Knightsbridge with the Velvet Hairbands.

Kate Middleton was queen of the Sloanes during this era; it was all skinny jeans, cropped tweed blazers, and "ok yah's." The look included floral dresses for lunch dates on the King's Road and sparkling sequined minidresses with suede knee-high boots for nights out at Mahiki—a Polynesian-themed nightclub that serves alcohol out of treasure chests. (Once upon a time it was frequented by Princes William and Harry.)

If there was one thing Y2K Sloanes had in common with their eighties predecessors, it was that their look wasn't considered fashionable by anyone who was on the outside of their class, or geographical parameters—in fact, if someone said I looked Sloaney back then (I was from an area of London "over the river," practically the Atlantic Ocean as far as the toffs of the noughties were concerned), I would have taken it as a bit of an insult. They didn't want to dress like me, and I didn't want to dress like them. I was more interested in Kate Moss than Kate Middleton, digging through ratty old vintage clothes on London's Brick Lane at the weekend and purposefully poking holes in my tights (to this day, I don't know what trend I was going for there), so it's safe to say I was headed in a different sartorial direction than the typical clientele of Brora knitwear and Joseph.

For those of you who aren't familiar with the origins of the Sloane Ranger, it was invented in 1975 when Ann Barr and Peter York wrote an article for the now-defunct British magazine *Harpers & Queen* about a posh new demographic who were becoming more prominent around an area named Sloane Square, in London's affluent Chelsea neighbourhood. "They congregate there because they feel safest among their own kind,"[44] wrote *The New York Times* in 1984.

The term, invented by York and his colleague, Tina Margetts, was a pun on the "lone ranger," which was then immortalized in Barr and York's satirical book *The Sloane Ranger Handbook: The First Guide to What Really Matters in Life*. They dubbed Princess Diana the *Supersloane*, queen of all toffs.

When Diana first moved into her shared flat in 1980, her style wasn't anything groundbreaking. She wore a uniform, exactly the kind her circle of

female friends also sported. Sloanes weren't meant to stand out from the crowd; they were meant to blend in with their own, opting for high-quality clothing in conservative, classic silhouettes—any high-end or flashy clothes were for nouvs (short for *nouveau riche*, dahling).

Vanity Fair editor and Diana biographer Tina Brown once described Diana as "one of the new school of born-again old-fashioned girls who play it safe and breed early. Post-feminist, post-verbal, her femininity is modeled on a fifties concept of passive power."[45] Given that most women of Diana's background followed a similar path (described by York and Barr as "Hatched, matched, dispatched"), you can see why their dress code was so buttoned-up and matronly—it was as much a reflection of the conservatism of their backgrounds as it was a reassurance to any future husbands that they were the kind of even-minded women who'd behave. The dimmer they were considered to be, the better.

Fashion designer Jacques Azagury described the notorious eighties style as a "particularly English look," which you didn't see anywhere else in the world, made up of ruffled collars, long skirts, little cardigans, and puff sleeves. "It was fashionable but particularly to those women, the Knightsbridge ladies," Jacques told me, "don't get me wrong, it was a look, not an international look, it didn't go anywhere else . . . let's put it that way."

Although the Sloane uniform never made it past the English Channel (the Americans had their own thing going on with preppies, so they weren't too interested), the style did go through a number of rebirths, thanks to Diana. "The old Ranger brigade (Knightsbridge knotted era) looked like an endangered species at the end of the Seventies," wrote Barr and York, "but when Diana Spencer hit the lenses she pepped up the Ranger wardrobe and boosted morale, reaffirming the Sloanes' looks and qualities but reinterpreting them for the eighties, encouraging Sloanes everywhere to be a touch dressier, a little more dashing."[46]

When the duchess's marriage reached its breaking point in the latter half of the eighties, she became emboldened to take the Sloane look to the next level. At that point a mother to two small children, she ditched the frilly blouses, ribbon ties, and court shoes in exchange for sophisticated brightly coloured skirts, cowboy boots, and . . . wait for it . . . sweatpants. She redefined a look that for so long had been regarded in fashion circles as bland. Thanks to Diana, the late eighties brand of Sloane had a bit more edge with power-player shoulder pads and modern leather pants. "She created a fashion style in England by heightening and glamorizing the basic wardrobe requirements of the Sloane Ranger,"[47] wrote Tina Brown.

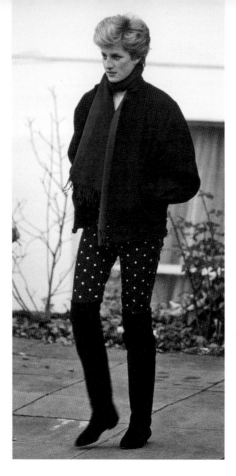

DECEMBER 1986: Doing the school run in some star-print leggings, over-the-knee suede boots, and a black bomber jacket—accessorized with a cobalt scarf. I'd describe this as King's Road meets a bit of eighties New Romantics. (I can't tell if the hairstyle is more Sloane or Duran Duran.) Either way, I'm into it. 100% would wear.

For Prince Harry's first day of school in 1989, his mum wore classic Escada by Margaretha Ley. In the early half of the eighties, Diana opted for muted colors and conservative plaids, but here, she's not interested in subtlety. She's kept the choice of pleated skirt from her Young Sloane days but traded in subservient navy for guns-a-blazing red.

While Diana's marriage left her in a state of deep discontent, she found purpose in her role as a mother and started to pave the way for a more independent future in her charitable work and in her private life. "She is much more self-conscious about her image, much more professional,"[48] said Brown. While her look had undoubtedly evolved, in my view, there was more to it than just a desire to appear professional: behind every outfit simmered a spirit of defiance. The royal Sloane had gone a bit punk.

ALL THE ESSENTIALS NEEDED TO GET THE EIGHTIES SLOANE LOOK

(Take this list when you go thrifting or search on eBay.)

- A string of pearls, or multistrand if you're feeling a little wild

- A bag made from some kind of patchwork quilt or tapestry

- Shirt with pie-crust collar

- A sweatshirt or cashmere sweater for layering over frilly shirt

- Long pleated skirt

- Classic Gucci loafers

- Mummy's acrostic ring that's been in the family since the Georgian era. The first letter of every stone should make it spell out a mushy word like *adore* or *regard*.

- Hermès scarf

- A Land Rover

- Plenty of "ra-ra" attitude*

*You can't find this on eBay. You must look deep inside yourself and maybe take a few elocution lessons to check this one off the list.

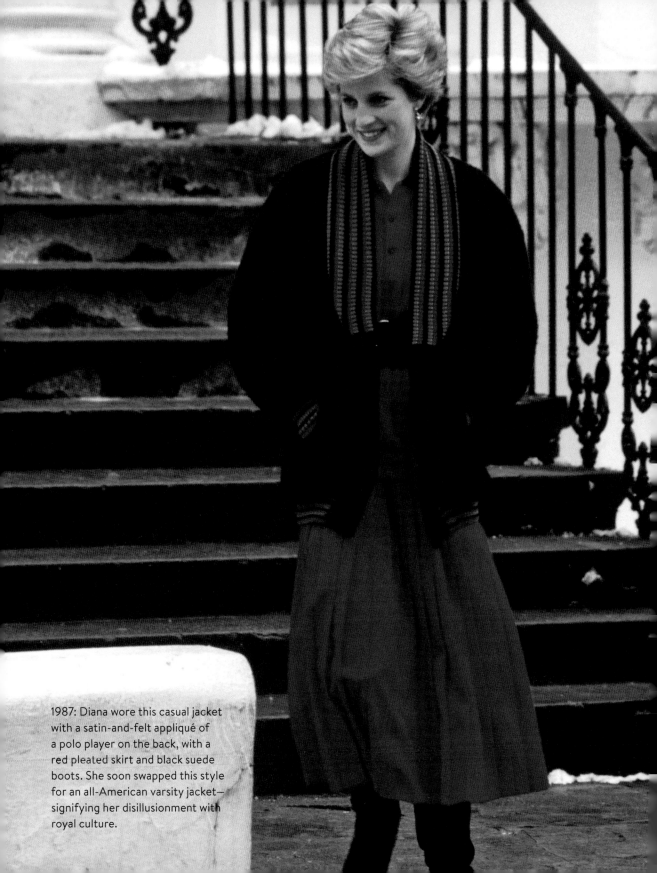

1987: Diana wore this casual jacket with a satin-and-felt appliqué of a polo player on the back, with a red pleated skirt and black suede boots. She soon swapped this style for an all-American varsity jacket—signifying her disillusionment with royal culture.

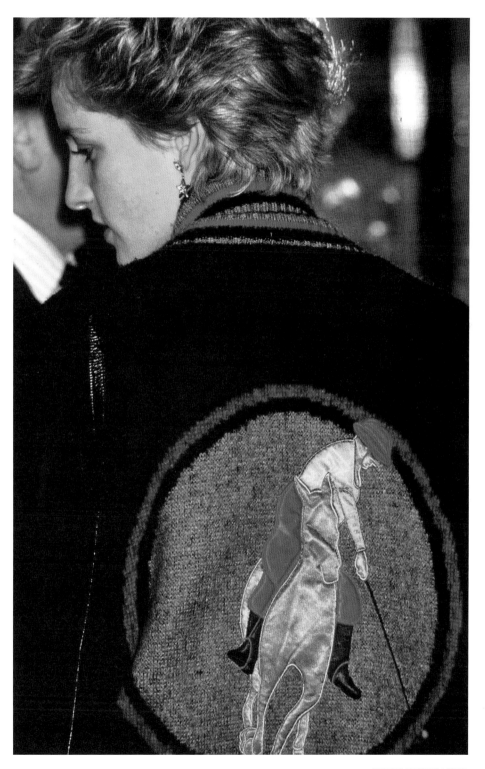

"It's not so much that you are stuck with the royal family, rather they are stuck with you."[49]

—STEPHEN TWIGG, Diana's therapist

1987: Wearing a chic ivory-coloured turtleneck with an ankle-length suede skirt and waisted belt. Walking two steps ahead of Prince Charles, just in the way the Queen always walked two steps ahead of Prince Philip. (I'm going to make this a mandatory rule for any of my future relationships.)

(Below)

In April 1987, Diana threw in a bit of Max Mara–esque leather to her off-duty princess wardrobe. Two months later, she got a royal bollocking by the Palace for wearing black leather pants to a David Bowie concert: "I went in leather trousers, which I thought was the right thing to do, completely putting out of my mind that I was the future Queen, and future queens don't wear leather like that in public. So I thought that was frightfully 'with it,' frightfully pleased to act my own age. Slapped hands."[50]

 In my view, all queens should wear leather.

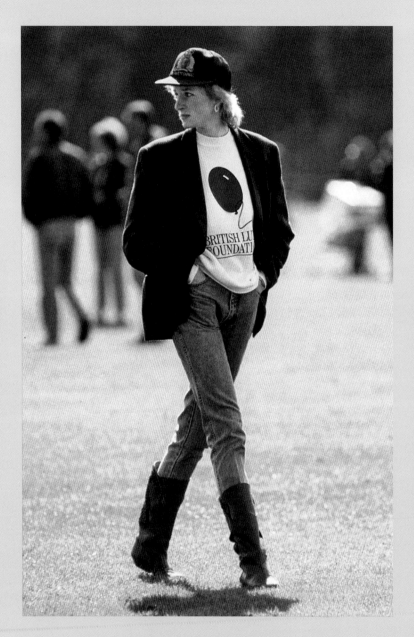

WINDSOR 1987: No frills, no florals, no court shoes—instead, a men's tweed blazer, cowboy-style boots, jeans, and a sweatshirt worn in support of the British Lung Foundation charity. Diana's baseball cap (worn dozens of times throughout her life) is the official Royal Canadian Mounted Police snapback, possibly picked up on her royal visit to Vancouver in 1986.

In Lee Hazlewood's unforgettable words, made famous by Nancy Sinatra, "These boots are made for walkin' and that's just what they'll do. One of these days these boots are gonna walk all over you."

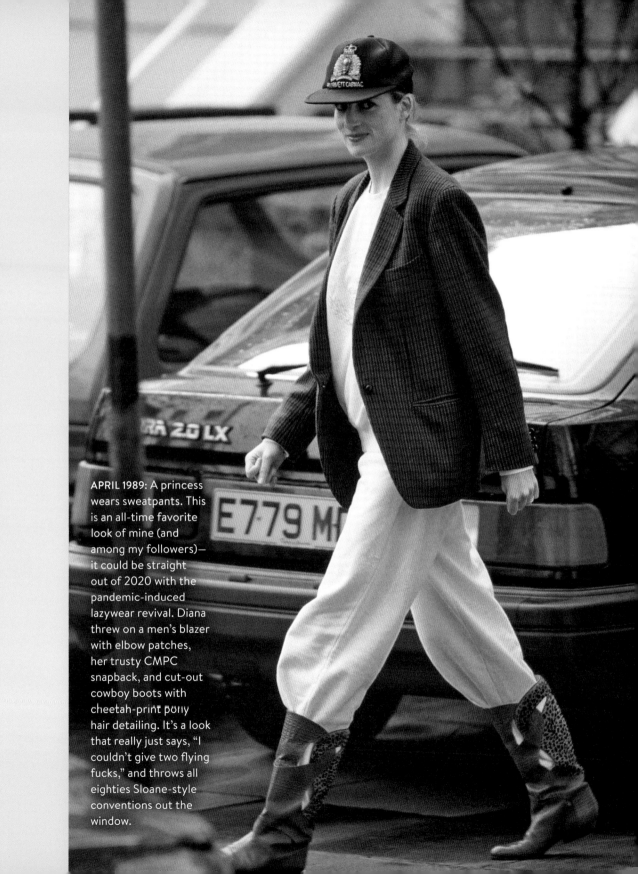

APRIL 1989: A princess wears sweatpants. This is an all-time favorite look of mine (and among my followers)— it could be straight out of 2020 with the pandemic-induced lazywear revival. Diana threw on a men's blazer with elbow patches, her trusty CMPC snapback, and cut-out cowboy boots with cheetah-print pony hair detailing. It's a look that really just says, "I couldn't give two flying fucks," and throws all eighties Sloane-style conventions out the window.

A
TRIBUTE
TO
FERGIE'S
WILDEST
HEAD
ADORNMENTS

Just as Diana became known for her pearl-laden chokers and quirky sweaters, Prince Andrew's wife Sarah Ferguson, the Duchess of York, had her own thing going on with some rather outrageous headpieces.

The other "black sheep" of the royal family, Fergie was the subject of many the royal blowout over the years, including a certain toe-sucking scandal with Texan millionaire, John Bryan. A photographer took the salacious photos with a telephoto lens while the duchess was vacationing with her new lover and children in the South of France in August 1992, not long after her separation from Prince Andrew. She was caught topless on a sun lounger, in a series of compromising photos in which it appeared she was having her toes tenderly sucked by Bryan (whatever floats your boat, eh?). The night before the photos were published in the *Daily Mirror*, Diana was reported to have paged *Daily Mail* reporter and friend Richard Kay, saying, "The redhead's in trouble," and the next day, after the toe-job bomb went off, the Queen personally banished Fergie from Balmoral. For a royal who wasn't even allowed to show cleavage in open-toed shoes, having them sucked by a strange, rich American man was decidedly beyond the pale, and she was slut-shamed to kingdom come by the disapproving public.

Diana and Fergie were friends from the start of the early eighties, but their relationship was often fraught with sisterly ups and downs—intensified by their individual insecurities and their shaky standing within the royal family. Sarah was once loved by the royals; she was jovial, funny, and a keen player of all the royal sports. "Why can't you be more like Fergie?" Charles once asked Diana. On the flip side, although Diana was misunderstood by the royal family, she was accepted by the people. Anything she stepped out in was copied. Women everywhere took shears to their hair in their quest to achieve the Diana look. The duchesses were jealous of one another because each had affirmation in an area where the other enjoyed only opprobrium. They were royal frenemies. Between the bitchy back-and-forths, though, Diana and Sarah had a close bond; they were often seen having a grand old time stirring up trouble, poking a royal courtier in the bottom with an umbrella on one occasion at

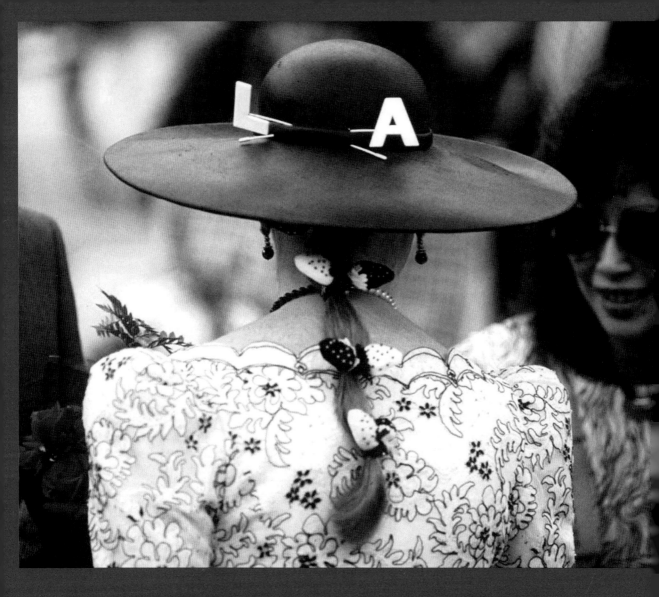

Royal Ascot in 1987 and the same year, mock play-fighting in the snow on a ski trip to Klosters, while Charles looked on scoldingly (fun police, *nee-naw, nee-naw*). *The Sun* called them "silly, simpering girls."

They were separated from their husbands within months of each other and divorced in 1996 just three months apart. They understood each other like no one else, not only because Fergie and Diana were married to two flawed princes and trapped inside a compressive system, but because both were subject to intense media scrutiny and the most horrifically hurtful headlines (Sarah Ferguson was once cruelly nicknamed the "Duchess of Pork" by the press).

Although Fergie wasn't the style queen Diana proved herself to be, she did have a knack for pulling off some exuberant headgear. From Hollywood sign–esque letters spelling out "L.A." atop a wide-brimmed hat for her trip to California to crystal-embellished Union Jack and star-spangled hair clips, it's safe to say the scarlet haired extrovert, and the first royal pot-stirrer to ever sit down with Oprah, has never been interested in subtlety. These head ornaments were Fergie's alternative versions of tiaras—they crowned her as the ultimate royal rebel.

4

THE REBEL REBEL LOOK

"I was the girl who
was supposed to be a boy."[51]

hen Diana became engaged to Prince Charles, she was required to address him as "Sir," while he called her Diana. This wasn't anything unusual; she was used to these types of gender formalities from her own aristocratic background. In her tapes, she stated bluntly, "I was meant to be a boy." She was the third child, the younger sibling to two older sisters, and described feeling like a "nuisance" throughout her childhood because her parents had been desperately seeking a male heir. She described what she believed was her parents' reaction when she was born: "What a bore, we're going to have to try again."[52]

From the start, Diana lived in a man's world. The Palace, though ruled by a woman, Queen Elizabeth II, was operated by the "men in grey," a group of faceless courtiers and public relations experts who ran the institution behind the family, known unofficially, and rather ominously, as *The Firm*, who sought to censor and define everything from the Princess's role to her appearance. Of course, the role they had in mind for her was as a loyal and obedient wife to Prince Charles. Shopping, smiling, and making appearances as and when she was meant to were all a part of the bargain; anything off course from that was considered a problem.

At nineteen, Diana was a suitable wife for Prince Charles because she wasn't yet old enough to come with any baggage (or so he and The Firm thought). In a 1985 *Vanity Fair* article, Tina Brown concluded that the reason the Prince was eager to put a ring on Diana's finger was because "the chances of another eligible virgin coming his way were slim."[53] Charles's friends, including a married Camilla Parker Bowles, supported the union because "they had met the blushing little Spencer girl and deduced she was not going to give them any trouble." Little did they know, "Diana's famed shyness was one of her most misleading character traits," wrote Brown.

Throughout the eighties, Diana appeared in a series of androgynous outfits, blurring the lines of traditional gender norms while also crossing the boundaries of royal dress codes. She appeared in a series of tuxedos and traditional men's suits, usually accessorized with a bowtie or a pair of low heels. While each of the looks had a touch of Charlie Chaplin (Diana was a performer at heart), there were hints that she was leveling up with the men in her life by rejecting the label of a shopaholic bimbo. For one night, she could be "one of the boys," and even if to pretend, she could absorb that power.

Just in the way the Princess's friend David Bowie presented his gender-ambiguous persona, Ziggy Stardust, it seemed that Diana had an androgynous alter ego of her own. She knew, ultimately, that she didn't have to explain the choices behind her outfits to anyone, and the press would spin into a tizzy trying to decode each of them. It was an act of autonomy, plus, Prince Charles hated it when she'd steal the spotlight, which undoubtedly ran through her mind every time she slipped into a tuxedo and straightened her tie.

In 1984, while pregnant with Prince Harry, Diana wore a white Margaret Howell tuxedo with Alexander Gabbay low heels to a Genesis rock concert, knowing that the press were waiting to capture a photo of her pregnancy bump.

With its straight lines, the look concealed any hint of curves. The Princess had a beaming smile on her face—she would not be giving permission for anyone to use her body as a bounty that night. Her clothes provided self-protection, similar to the protections men duly inherit at birth, and she could finally get her own back at the press who had traveled to Birmingham's National Exhibition Center that night, looking to get the ultimate money shot at her expense.

"I felt I was an oddball, and so I thought I wasn't good enough. But now I think it's good to be the oddball, thank God, thank God, thank God!"[54]

Just like the women in the eighties professional workplace, Diana asserted her power through clothes. Although she had no formal educational credentials, in her own way, she had the most high-flying job of all, and over time she excelled at it—she became an authoritative, unpredictable PR machine: the People's Princess. With shoulder-padded tuxedos and power suits, Diana fiercely guarded her femininity and role-played the powerful man, hitting back against archaic and sexist stereotypes. Diana was playing politics with the opposition, and just as women throughout history have experienced, suit wearing has always been a deeply political act.

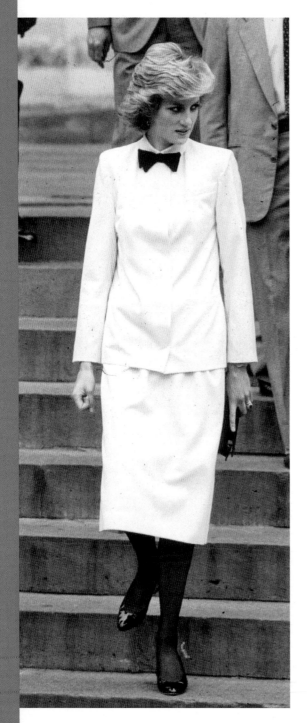

When Diana first wore this ensemble in 1985, in Florence, many thought she looked as though she were about to read off the daily house specials. Looking back, though, this suffragette-white skirt set by Jasper Conran and black bow tie strikes a more symbolic meaning—she's the outcast, claustrophobically sandwiched between the Prince and the "men in grey."

(Opposite)

MAY 1986: Diana is pictured meeting the singer Bryan Adams. She's ready to rock in a black evening suit with jodhpurs by Jasper Conran, accessorized with a snake brooch by costume jewelers Butler & Wilson. She loved costume jewelry and got a kick out of tricking people into believing they were fine jewels.

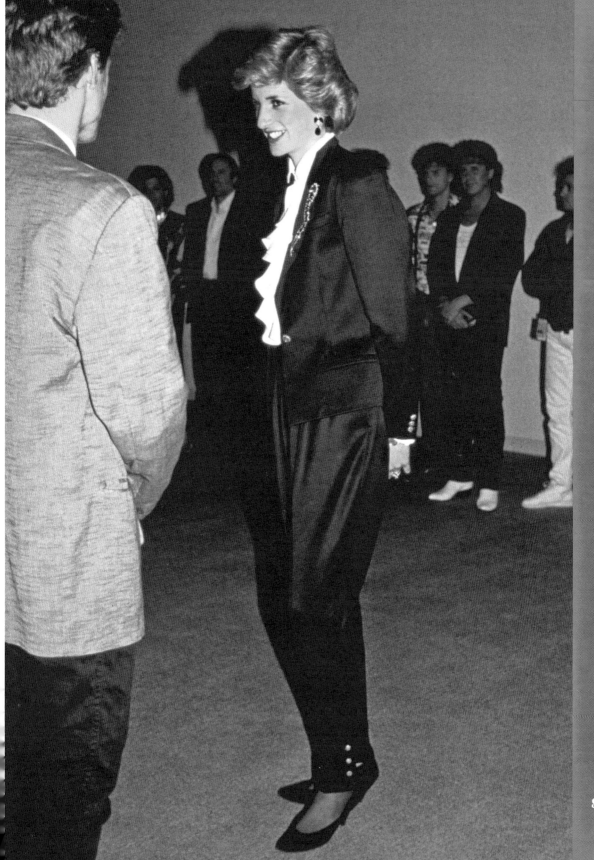

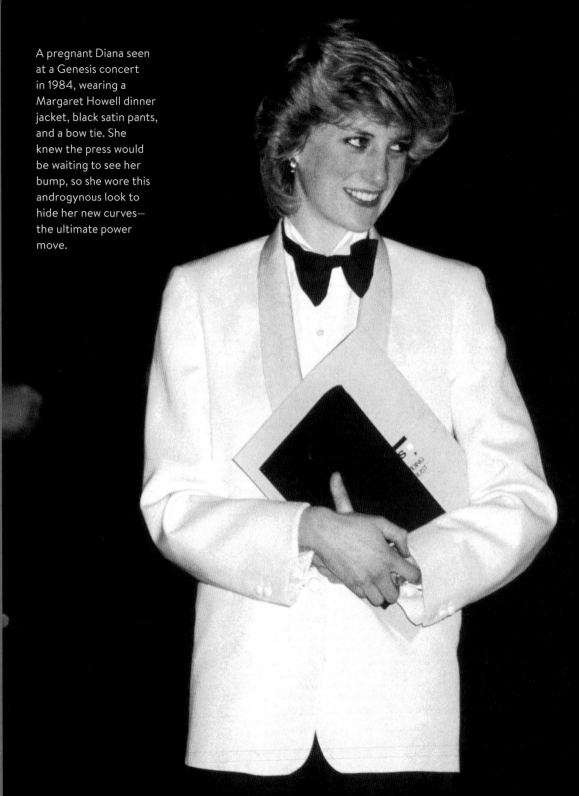

A pregnant Diana seen at a Genesis concert in 1984, wearing a Margaret Howell dinner jacket, black satin pants, and a bow tie. She knew the press would be waiting to see her bump, so she wore this androgynous look to hide her new curves—the ultimate power move.

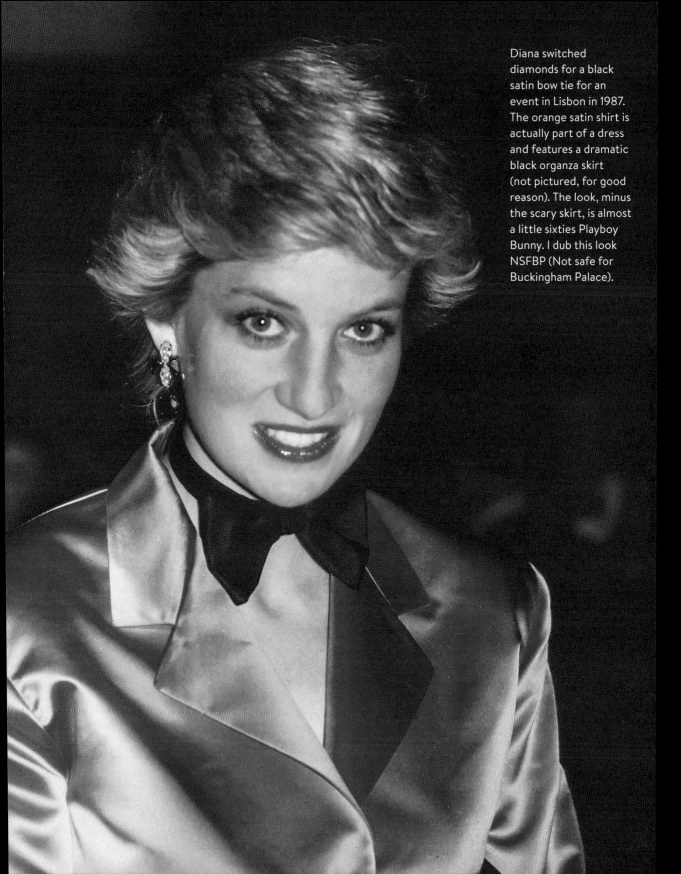

Diana switched diamonds for a black satin bow tie for an event in Lisbon in 1987. The orange satin shirt is actually part of a dress and features a dramatic black organza skirt (not pictured, for good reason). The look, minus the scary skirt, is almost a little sixties Playboy Bunny. I dub this look NSFBP (Not safe for Buckingham Palace).

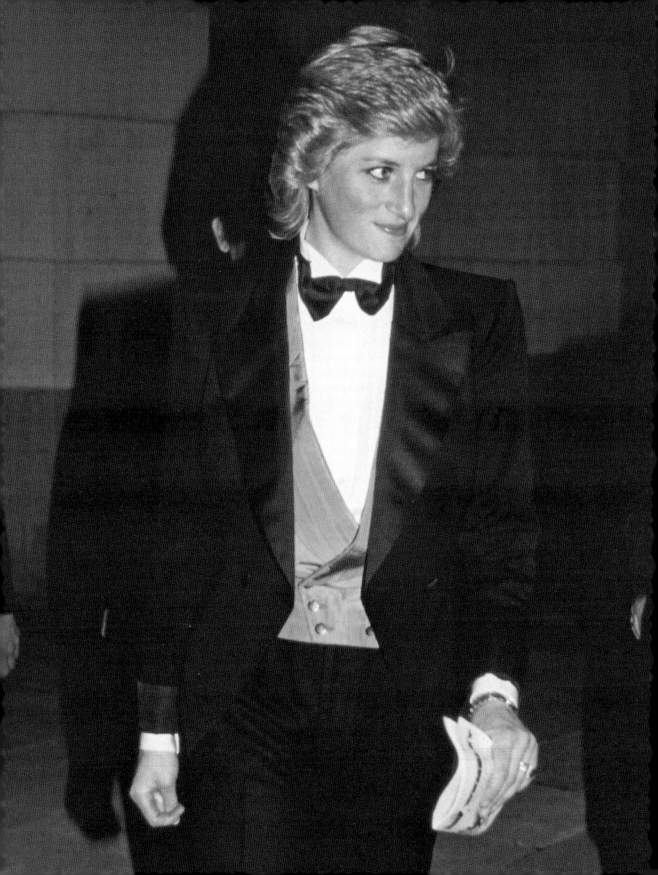

Diana wore this Catherine Walker suit with a green Hackett waistcoat in 1988 to a charity greyhound racing event at Wembley Stadium, which she asked to attend in support of the London City Ballet. Harold King, the founder of the dance organization, described her outfit as purely tactical: "It was a clever move. She knew we needed the publicity and, sure enough, she got her picture and a mention of the ballet on the front pages the next morning." She was a little miffed that she had to ask for an invite, and apparently told King after the event, "You know I'm a good fundraising tool, so make sure you invite me to these things."[55]

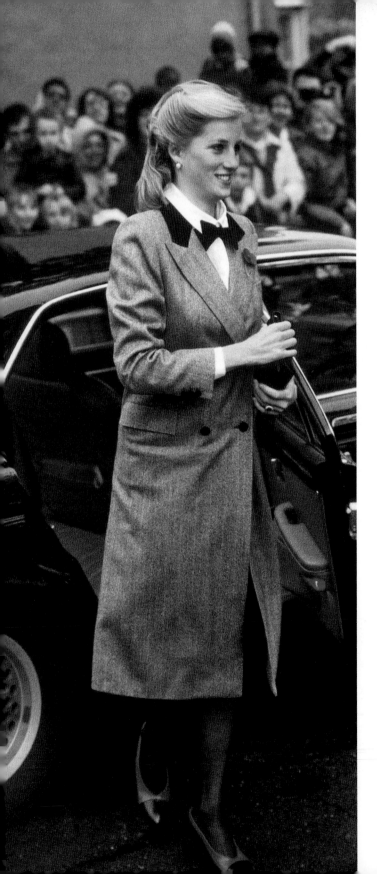

For a Barnardo's event in 1984 (a British children's charity supporting vulnerable young people in the care system), Diana paired this Piero de Monzi tailored coat with a pair of two-tone spectator shoes. The hunter-style velvet-collared coat, although uber-Sloaney, is styled with a bow tie and a sleek forties hair-do—a sexy, androgynous twist on her conventional, posh aesthetic. "She did enjoy the feeling of being a forties movie star," said designer Jasper Conran.[56]

Even with the experimental accessories, Diana stayed loyal to her regulatory Sloane style, in her determination to fit into the royal mould for her husband and family. Royal Goody Two-shoes Kate Middleton, for example, has never given up her Sloane-ifides for one single outfit since she got engaged to Prince William. (Bring back Kate's seductive, sheer bandeau dress from her college fashion show days, I say!)

Diana even experimented with a longer, forties-style hairdo.

5

THE ROYAL DUTY LOOK

"At night I dreamt of Camilla the whole time."[57]

"S hit-scared" was how Diana described feeling during one of her first official events at London's Regent Street, where she had to turn on the annual Christmas lights and make a speech. She wore a pale pink shirt with velvet culottes, a matching blazer in midnight blue, and a subtle monogrammed Louis Féraud clutch tucked beneath her arm.

This event, not more than six months after the royal wedding, was just the beginning of Diana's being catapulted into a full royal diary. Drowned by press attention and her new role as the Princess of Wales, she hoped that she could ease into her royal duties with time and a little patience from those surrounding her. Instead, she "had to become royal in one week."[58] She followed Charles's lead, too unsure of herself to brave any of the crowds alone.

In the early days, Diana went through an experimental whirlwind with her style. As she tried to find an aesthetic that stuck, and conform to the royal dress code, she was also learning on the job what was required in terms of her duties. "I couldn't have fashionable clothes because it wouldn't have been practical for the job,"[59] she said.

There's no way to describe some of Diana's early "on-duty" looks as anything except utterly heinous—think royal-themed cosplay, but from the Crusades era. Robin Hood–esque, feather-adorned hats and terrifying tartans would have you thinking Camilla paid off Diana's stylist for some serious sartorial sabotage.

Between the experimental disasters, there were, however, some true diamonds in the rough. On returning from her Mediterranean honeymoon, Diana exited a private plane in Scotland wearing a peach silk dress with a white double-breasted tailored coat layered on top. Around her neck, she wore a simple knotted string of coral beads, and she carried her favorite Souleiado patchwork tote bag—a security blanket, of sorts. She looked fresh, age-appropriate, and positively ecstatic to be back on British soil.

Diana's honeymoon cruise wasn't exactly the starry-eyed sojourn it would be for most newlyweds. She was amazed to learn once they set sail, that Charles had brought seven (yes, seven) Laurens van der Post novels along with him. If Diana thought she'd be getting some quality time with her new husband, then that hope was squashed, dead, and buried when, on top of the stiff philosophical novels she had to hear about at lunch, at night she was expected to entertain an

entourage of "men in grey." Diana realized as early as her honeymoon that her duties had begun the moment she signed the royal contract—by saying *I do.*

To make matters even worse, as the newlyweds were having a conversation about their upcoming plans, out popped two photos of Camilla from Charles's diary. Then, during a white-tie dinner, the Prince sported a new pair of cufflinks featuring two entwined *C*s, "like the Chanel *C*s," Diana recalled. Bitter arguments ensued, with Charles—in true deceptive husband fashion—insisting that they were "just friends." A tale as old as time.

By then, Diana's bulimia was full-blown, and it only got worse after the honeymoon. "(I was) obsessed by Camilla totally,"[60] she said, "didn't trust him, thought every five minutes he was ringing her up asking how to handle his marriage." By October 1981, in the early stages of pregnancy, Diana began to self-harm by cutting herself with razor blades. It was a cry for help: "When no one listens to you, all sorts of things start to happen."[61] The Palace didn't see it that way, and believed the answer was to put her on medication. "They could go to bed at night and sleep knowing the Princess of Wales wasn't going to stab anyone,"[62] she said sardonically.

Diana's first overseas tour to Australia and New Zealand was a turning point. The Australian people took to her as one of their own, and thousands showed up in crowds to get a view of the young, dazzling Princess. "I've got to go home, I can't cope with this,"[63] she told one of her ladies-in-waiting, having multiple panic attacks.

Neither Charles nor Diana had ever seen crowds like these. As they were driven in an open-top car past the Opera House in Sydney, photographer Ken Lennox captured a photo of the Princess in a pink floral dress, clasping her hat and weeping. As Charles looked in the other direction, the exhausted Princess, suffering from jet lag, morning sickness, and episodes of bulimia, cried publicly for a couple of minutes. Lennox said, "It was the first sign something was wrong."[64] There were many more signs to follow.

Then the cries came: "We're on the wrong side, we want to see her, we don't want to see him." While this caught the Princess by surprise, Charles was even more shocked. Before her husband's very eyes, Diana enchanted a nation. She walked up to the crowd, looked them in the eyes, and shook their hands. Her star allure instantly dwarfed Charles's—"He was jealous; I understood the jealousy but I couldn't explain that I didn't ask for it,"[65] she said.

Later, in a speech at a banquet in New Zealand, Charles said, "I've come to the conclusion that really it would have been far easier to have two wives, to

have covered both sides of the street, and I could have walked down the middle directing the operation." He appeared to be making light of the situation, and his bruised ego, but behind Palace doors, bitter jealousy ensued—neither he, nor the Palace, had anticipated that Diana, the girl with the floppy haircut, who looked to the floor and had zero school qualifications, would win the royal popularity contest by a landslide. It was a direct echo of John F. Kennedy's 1961 Paris speech, where he opened proudly, saying, "I do not think it altogether inappropriate to introduce myself to this audience. I am the man who accompanied Jacqueline Kennedy to Paris, and I have enjoyed it." Unlike the awfully sour prince, the thirty-fifth president was abundantly aware of what an asset, in both the personal and the diplomatic sense, his glamorous wife was to him.

Diana returned from the tour with a renewed sense of purpose: "By the end, when we flew back from New Zealand, I was a different person. I realized the sense of duty, the level of intensity of interest, and the demanding role I now found myself in."[66] As Diana's confidence grew, her outfits became chicer than ever as she developed her own hands-on, not-before-seen brand of "princessing." She declined to wear formal kid gloves because she wanted to appear relatable and real to the people she encountered, with actual skin-to-skin contact when she shook their hands. "I ordered a dozen of suede gloves in every shade for her because the royal family always wore gloves,"[67] said Diana's style advisor, Anna Harvey. "Heaven knows where they all went because she never wore any of them." Diana even considered the textures of her clothing in her quest to relate and communicate with the people she encountered in her charity work. Caroline Charles, esteemed British designer to the royals, remembered Diana's thoughtful approach to her clothing when she first met her in 1981. "I remember her choosing a velvet suit for a visit to the blind because they would enjoy touching it,"[68] she said. Similarly, when Diana visited children's hospitals in the 1990s, she wore bright colors and large beads so the very young children would be able to play with them.

Such was Diana's emotional intelligence that she began to immerse herself in television programs, from evening soap operas like *Coronation Street* to popular music shows like *Top of the Pops,* so she'd always have something to talk about with regular people: "You are not the princess and they the general public—it's the same level."[69] When describing Diana's unique appeal, designer Jacques Azagury told me, "Princesses weren't supposed to be human, they weren't supposed to show feelings. She changed all of that." As Diana threw herself into charity work and more public appearances, French-born designer Catherine

Walker was key in helping to shape Diana's serious "workwear" wardrobe with sophisticated suits made for a thoroughly modern princess.

Diana's blossoming within her work and public life translated to her becoming more empowered in private. By 1986, she knew that Charles had long been back with the uber-toff Camilla Parker Bowles, and she began a (well-deserved) love affair of her own with a cavalry officer named James Hewitt, who offered to give her horse-riding lessons. The affair lasted for roughly five years, before Hewitt went away for his military duties. Later on, he betrayed her by publishing a tell-all book about their affair. "It was very distressing for me that a friend of mine, who I had trusted, made money out of me. I really minded about that."[70]

I'd like to pause here to say AMAB (All Men Are Bastards).

In 1987, Diana finally confronted her husband's mistress at the fortieth birthday party of Camilla Parker Bowles's sister. Usually, when greeting her husband's friends, she would kiss them on both cheeks, but she had an icy handshake planned out for Camilla that evening—a small, subtle power move that would prove she was not the shy, scared little girl she once was. Later that night, she confronted her: "Camilla, I would just like you to know that I know exactly what is going on."[71]

It was these small acts of bravery that helped Diana transform her self-esteem, and by simply embracing more of herself, she unwittingly burst a carefully guarded and unrealistic public perception of what life behind the palace gates was actually like. By the mideighties, the Princess was finally ready to stand up for herself in chic ensembles with dignified clean lines, blazers that meant business, and khaki military-style jumpsuits that signaled a war was brewing. Diana had no intention of standing down.

As her popularity soared, Charles, tired of being outshone by his wife, decided it would be best if they did separate engagements. "A future Queen more popular and respected than the future King—the status quo for the foreseeable future poses an open-ended nightmare for the British monarchy,"[72] wrote *Vanity Fair*. It seemed that the Princess was aware of this fact too: "I can do this job so much better on my own,"[73] she said.

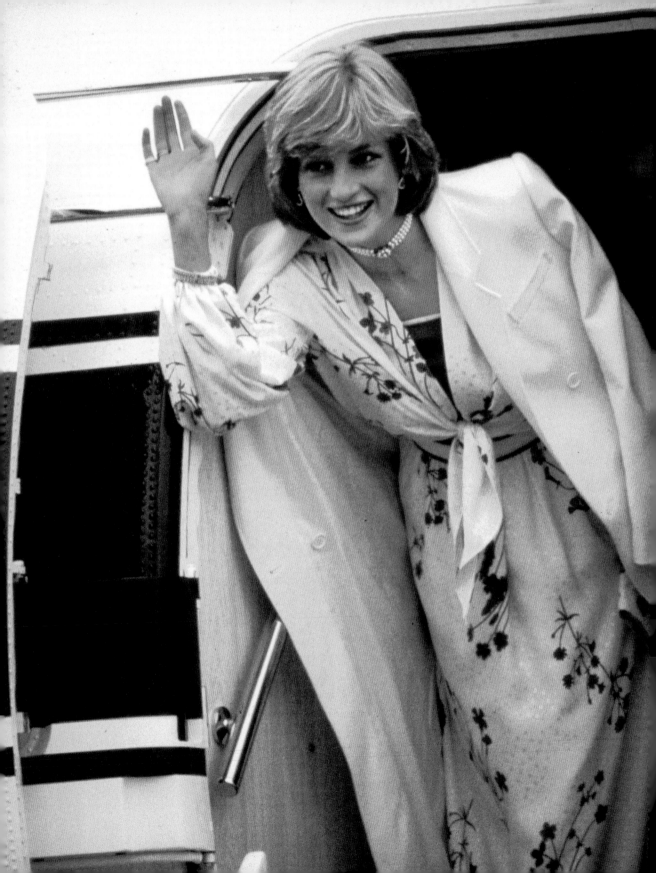

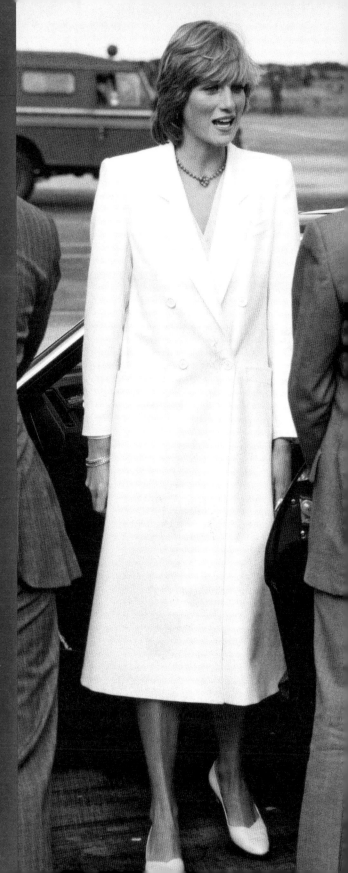

"With the media attention came a lot of jealousy."[74]

(Opposite)

So much hope in her heart—the Princess waved goodbye to adoring crowds and set off on her honeymoon around the Mediterranean, wearing a bridal-white, floral silk dress by designer Donald Campbell.

(Right)

Returning from her honeymoon cruise in one of my favorite early looks: a white three-quarter-length coat with coral knotted beads. She was surrounded and surveilled by the "men in grey" from the start.

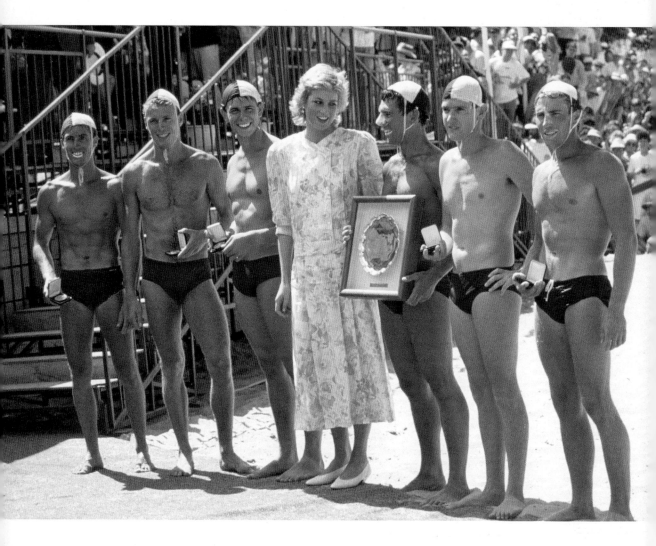

The Princess in 1988, happily sandwiched between lifeguards in Sydney—she looked terribly delighted (and even a little flushed) to be with the group of budgie-smuggling men her own age—Prince Charles, who?

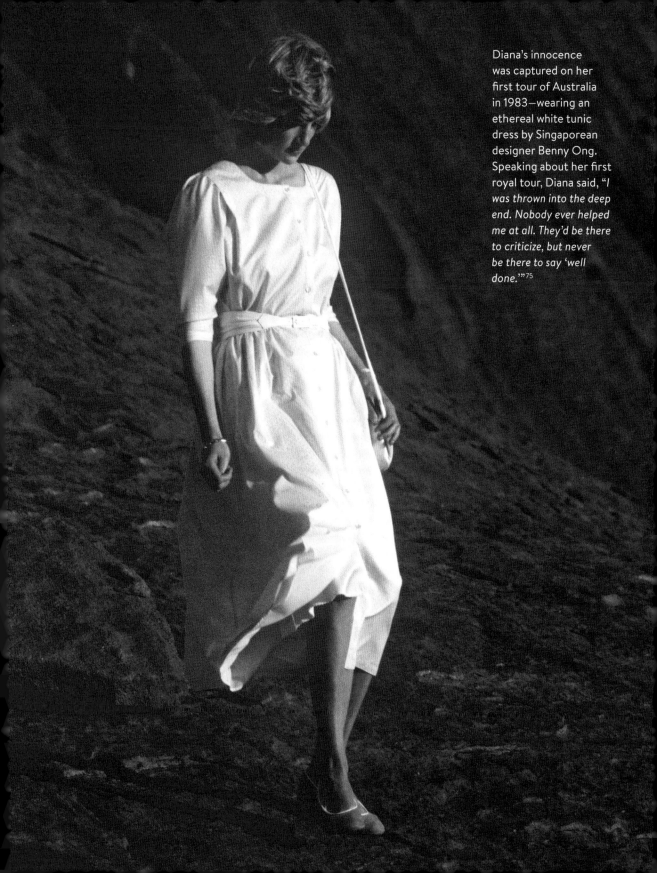

Diana's innocence was captured on her first tour of Australia in 1983—wearing an ethereal white tunic dress by Singaporean designer Benny Ong. Speaking about her first royal tour, Diana said, "*I was thrown into the deep end. Nobody ever helped me at all. They'd be there to criticize, but never be there to say 'well done.'*"[75]

(Far Left)

1986: Wearing a Jasper Conran pleated skirt with black boots, a Fair Isle sweater, and a varsity jacket, with a baby Prince Harry.

(Left)

At Aberdeen Airport in 1986, Diana wore a polo-inspired sweater by German label Mondi, with a white pleated skirt by Jasper Conran.

99

"Because I had a smile on my face everybody thought I was having a wonderful time. That's what they chose to think— it made them happier thinking that."[76]

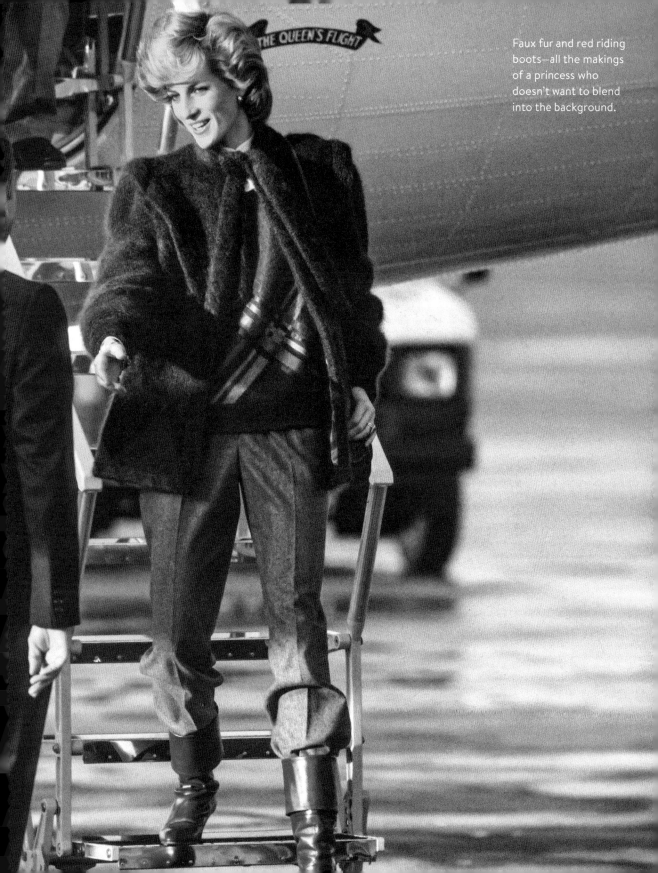

Faux fur and red riding boots—all the makings of a princess who doesn't want to blend into the background.

THE PLAIDS

With the help of the royal family's most favored designers, Diana learned how to make the best out of the sometimes tricky Scottish fabric. Thankfully, she had retired the coordinating colorful tights from her nannying days.

(Opposite)

At the annual Scottish Braemar Gathering in 1981, Diana wore a black tam-o'-shanter–style hat by milliner Stephen Jones and a pair of classic twisted hoop earrings. She styled the accessories with a plaid skirt-set featuring velvet-covered buttons, created by esteemed British designer Caroline Charles, who began her eponymous brand in 1963 and became known for her mod, swinging-sixties designs. Her oeuvre captured a very London look at the time, which brought her exposure in the States, where buyers were eager to get her pieces in their department stores.

Diana wasn't the first royal Caroline had dressed—she had made dresses for the Queen and Princess Anne, and she also outfitted rock royalty Mick Jagger and Ringo Starr.

"Diana was a joy to dress because she was tall and everything sat well on her,"[77] remembered the OBE-awarded designer. In the early days, synthesizing Diana's fashions to the royal dress code was top priority: "We would experiment with necklines so that modesty would be maintained when she leaned forward," said Caroline. Later, in 1985, Diana repurposed the set and had the neckline reconstructed to sit openly—in an effort to prove she could recycle even her on-duty outfits.

It was the second time she had worn this suit, wearing it previously in 1983 with some outlandish pink tights, but in April 1985, she came under fire when it was reported that she had spent a grand total of £100,000 on clothes for a single tour to Italy.

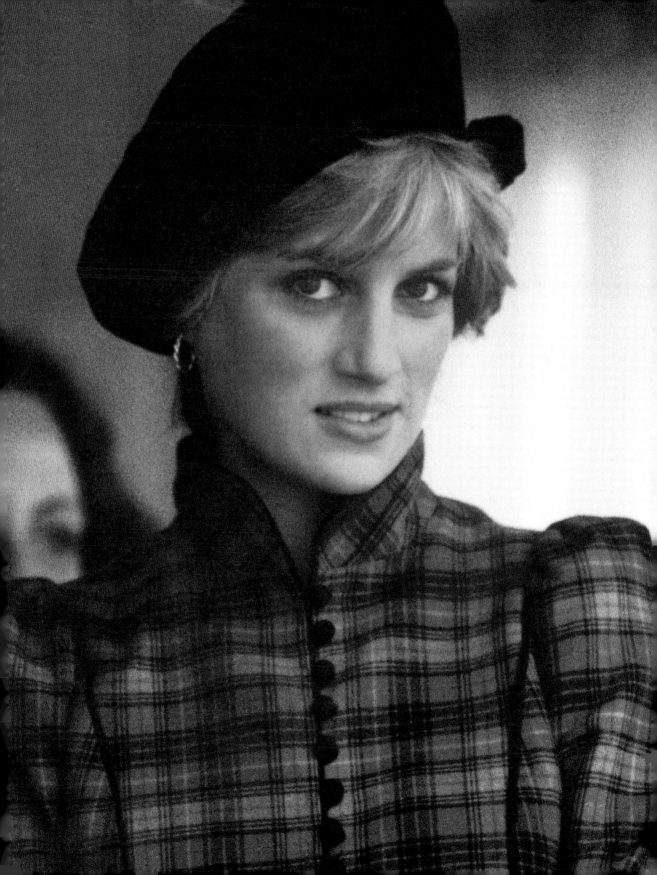

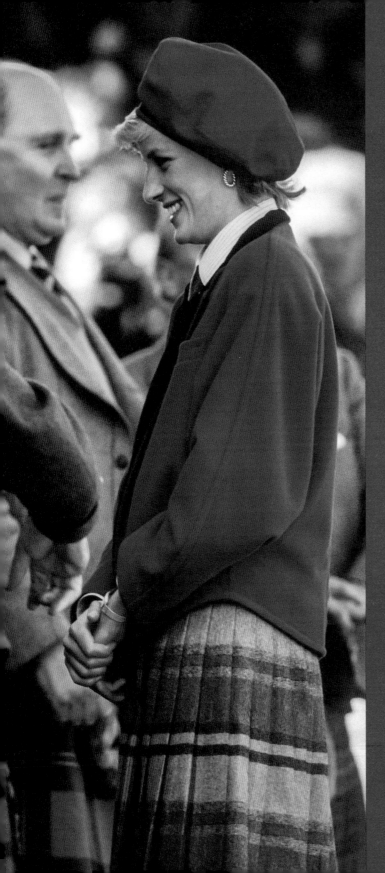

"Like Jackie O before her, she shops compulsively to relieve the tension and is probably unaware, in the rush it gives her, of what it all costs," wrote Tina Brown in her 1985 *Vanity Fair* article "*The Mouse That Roared.*" Diana was shocked to learn that she had been feeding into the clotheshorse image she resented, so she started to recycle her outfits as a way of pushing back against the unflattering headlines that insinuated she was a bored shopaholic housewife who ruled her marriage with an iron fist and frittered away Charles's money on clothes.

"*She* throws slippers at him when she can't get his attention. *She* spends all his money on clothes. *She* forces him to live on poached eggs and spinach. *She* keeps sacking his staff,"[78] wrote Brown about the newspaper coverage of Diana at the time. If reading this feels like déjà vu, that's because there are almost identical reports from 2019 about Meghan Markle, who was similarly accused in pot-stirring media stories of spending over half a million pounds on her maternity wardrobe, with questions about who was footing the bill, since royals aren't permitted to accept any clothes as gifts. Prince Charles, historically, has provided an allowance (we're not talking pocket money, here) for each member of his family from his private estate, the Duchy of Cornwall, including the spouses of his children. Between Diana, Camilla, Kate, and Meghan, the Prince has certainly bought a lot of women's clothes in his time.

In an exact echo of Diana's coverage from 1985, Markle also was blamed for the resignations and

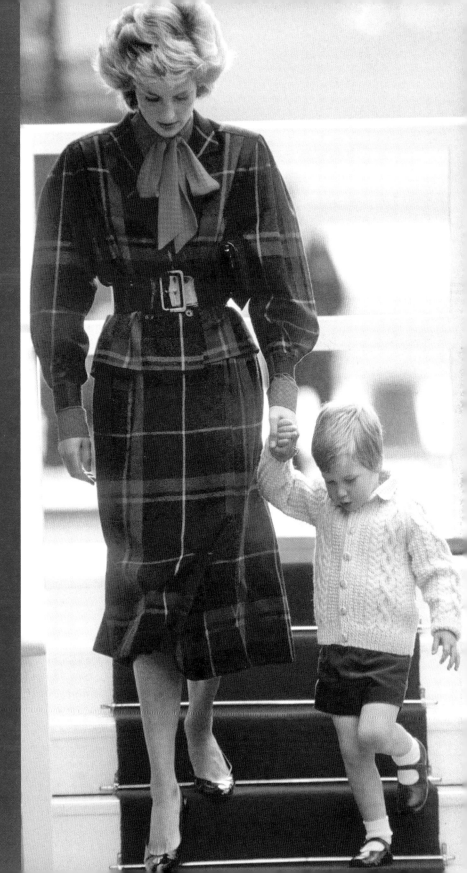

(Opposite)

Five years later, Diana was back at the Braemar Gathering and once again sporting the traditional Scottish headwear—this time in hot pink, a color she had become accustomed to for her royal appearances.

(Right)

1985, ABERDEEN: The shoulder pads on this ultra-eighties plaid suit are even more exaggerated by Diana's patent leather belt, which cinched her tiny waist—she was still, sadly, very ill with bulimia. Love the look or loathe it (I can't be sure which one it is for mo), this skirt set and pink pussy-bow blouse made quite the royal statement.

firings of many royal staff members. It seems the story of the attention-seeking, controlling outsider and royal shopaholic (she's *always* a woman) seems to sell newspapers. Of course the media's intent (an industry mostly headed up by men, by the way) is to initiate a collective, tomato-throwing, "boo, shame" reaction. I don't want to know the dollars that are made from perpetuating these narratives that ultimately end up harming *all of us*.

What disturbs me most is that many seem to enjoy these public takedowns, even though we know better by now. We've seen it before . . . remember?

"I was so fed up with being seen as someone who was a basket case, because I am a very strong person and I know that causes complications in the system that I live in."[79]

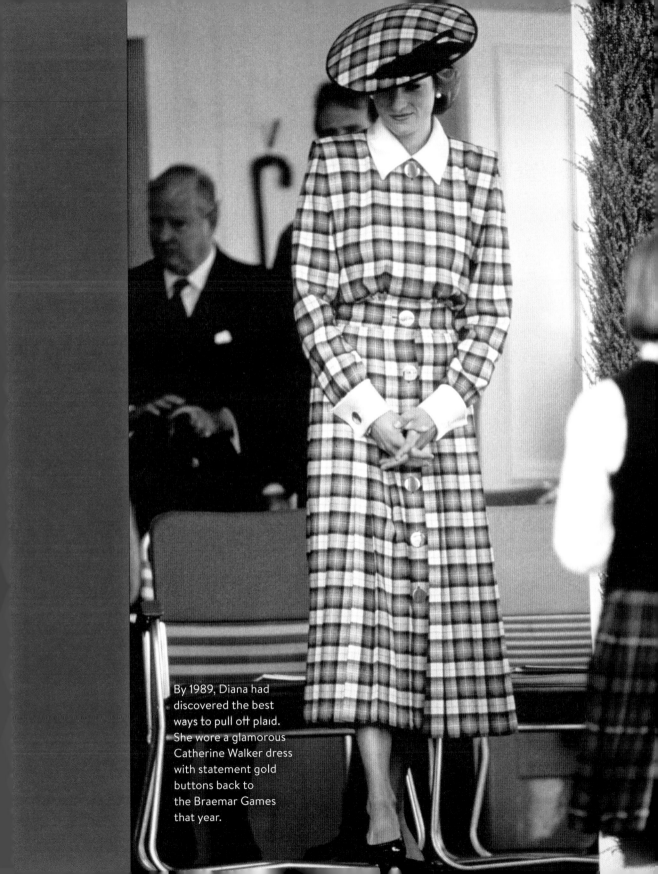

By 1989, Diana had discovered the best ways to pull off plaid. She wore a glamorous Catherine Walker dress with statement gold buttons back to the Braemar Games that year.

DIANA'S APPROACH TO SUSTAINABILITY

1980: The young Sloane was new on the Kensington scene and had only a few practical items in her wardrobe—regularly borrowing from her flatmates' closets. She wore a conservative gray coat over a pink silk gown to Princess Margaret's fiftieth birthday party, concealing any real view of her dress, and again, on nanny duty, pushing the young boy she cared for in his stroller. Always one to embrace a signature accessory, Diana regularly carried the same woven basket-style bag everywhere she went.

1981: Diana's "something borrowed" on her wedding day was a pair of pear-shaped diamond earrings from her mother, Frances Shand Kydd.

1984: Diana recycled many of her polo-field looks, with firm favorites including the black sheep sweater by Warm & Wonderful, a skirt suit by Laura Ashley, a pair of pink Converse, and a cerise-coloured sweatshirt that she always layered over a shirt with one of her trademark collars.

1985: Diana came under fire for spending £100,000 (of Charles's money) on new clothes for a single trip to Italy.

1986: Diana had many of her early eighties gowns retailored to tone down the shopaholic narrative many magazines and newspapers had spun. Many of her evening dresses were reconstructed—long-sleeve styles were often edited into asymmetrical or halter-neck designs, while other dresses were simply repeated with fresh accessories. Diana further experimented with her evening aesthetic by recycling a diamond-and-sapphire-embellished velvet choker and styling it as a headband.

1987: The Princess swapped out the elaborate hats and started to appear in the official snapback cap of the Royal Canadian Mounted Police. It became a regular feature in her off-duty outfits, and she was seen wearing it in more than a dozen photographs: on the polo sidelines, for school runs, and even for outings on ski trips to Lech.

1992: Diana had many of her and Charles's possessions burned at Highgrove once the Queen agreed to their separation, although some items were donated to charity or put into storage.

1994: As part of her famous "revenge dress" look at the Serpentine, Diana wore the pearl and sapphire choker she'd worn throughout her tenure as Princess of Wales, gifted to her by the Queen Mother. The choker was one of the only pieces from her "past life" that made a recurring appearance at official events in the nineties.

1995: Diana tactically recycled her gym outfits. She believed the paparazzi would leave her alone if they were capturing the same material over and over. The same year, Diana was gifted a Dior "Chouchou" bag by Madame Bernadette Chirac, the wife of French president Jacques Chirac. The Princess adopted the handbag as one of her staple accessories, and the brand renamed it the "Lady Dior" in tribute to her.

1996: Some of Diana's clothes were acquired by family and friends in what Diana's mother described as "upmarket car-boot sales" at Kensington Palace. The Princess gave a vast sweatshirt collection to her personal trainer Jenni Rivett, and many of her clothing items were bundled up in suitcases, ending up in consignment shops—she reportedly used the earnings from the secondhand store sales as pocket money to pay for trips to the cinema with her boys.

1997: In Diana's final year, she took a "less is more" stance regarding her clothing. Her new working wardrobe featured mostly a few smart suits, some crisp shirts, jeans, and loafers. She donated and auctioned seventy-nine dresses to Christie's, with the $3.25 million in proceeds going to charities benefitting cancer and AIDS causes.

The original hipster of the royal family.

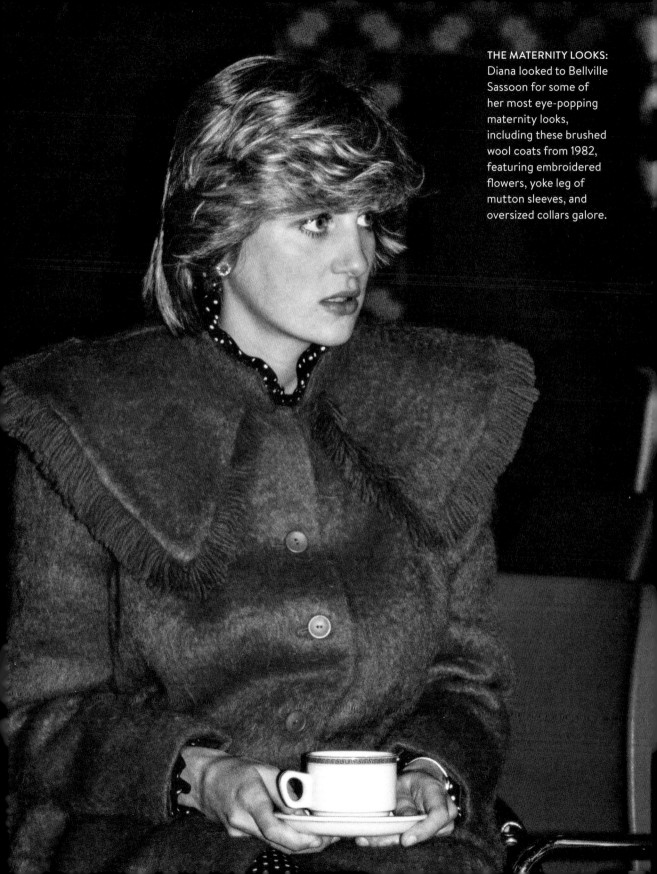

THE MATERNITY LOOKS: Diana looked to Bellville Sassoon for some of her most eye-popping maternity looks, including these brushed wool coats from 1982, featuring embroidered flowers, yoke leg of mutton sleeves, and oversized collars galore.

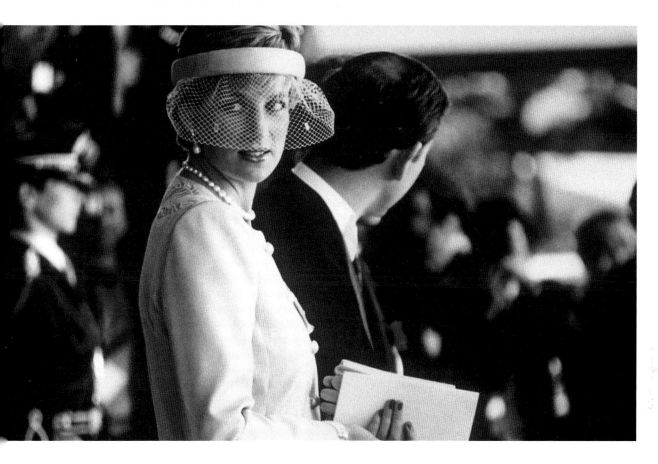

(Opposite)

A little older, a little wiser and the clothes a little bitchier for a trip to the races in Melbourne, 1985. She wore a fierce-looking black-and-white skirt suit, designed by Bruce Oldfield; a hat by Christopher Morgan; and uncharacteristic black gloves—an indication that she was feeling a little frosty and not seeking any hand-to-hand touch (at this point, Diana was convinced that Charles had gone back to Camilla). Notably missing is Diana's signature oversized collar, which she wore almost without fail to her royal appearances. It was almost as though Diana was playing up to the royal diva media reports. "His Royal Highness . . . is, it seems, pussy-whipped from here to eternity,"[80] wrote Tina Brown in *Vanity Fair*'s (suitably titled for this photograph) "The Mouse That Roared." Black and white reveals her mindset: wearing black was rebellious, as it was deemed strictly for mourning, while white, historically, symbolizes women's liberation. The blending of the two implied that she was stuck somewhere in between.

(Above)

In 1990, Diana wore a veiled headband to attend the enthronement ceremony of the Japanese Emperor Akihito in Tokyo. She and Charles were forced to continue to engage in their joint royal duties while they were otherwise living practically separate lives. The veiled headband acts as a protective shield. Just one year before, she had told her bodyguard Ken Wharfe, "I can't help thinking of them [Charles and his staff] as the enemy. I know that's how they think of me— they call me 'that mad woman who just keeps causing trouble.'"[81]

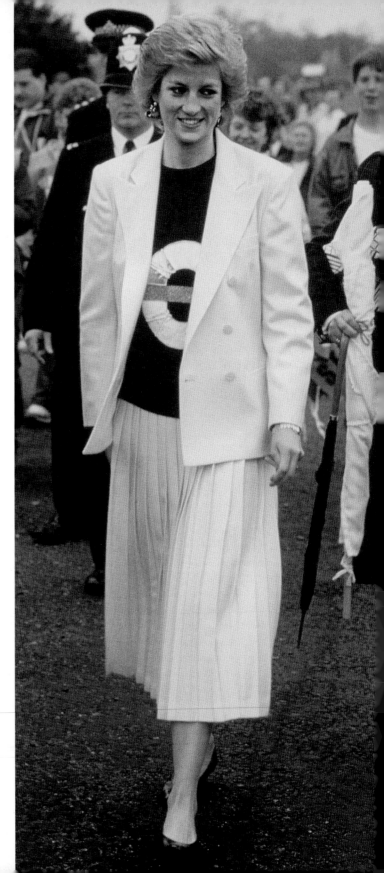

(Right)

A cool lemon-coloured pleated skirt suit worn with a navy sweatshirt featuring a metallic London Underground emblem was a winning look for Diana at the London Marathon in 1988. Diana liked to take her off-duty clothing and repurpose it for her on-duty wardrobe—she was seen wearing both the skirt set and sweatshirt on the sidelines at polo matches.

(Far Right)

The Faux Fur Beret Look: In my opinion, Diana's most iconic on-duty look, featuring a cream cashmere-and-wool coat trimmed with faux beaver (*très chic*) by Arabella Pollen and a faux fur beret by Gilly Forge.

THE PRIMARY COLOURS

"I realized the sense of duty, the . . . intensity of interest, and the demanding role I now found myself in."[82]

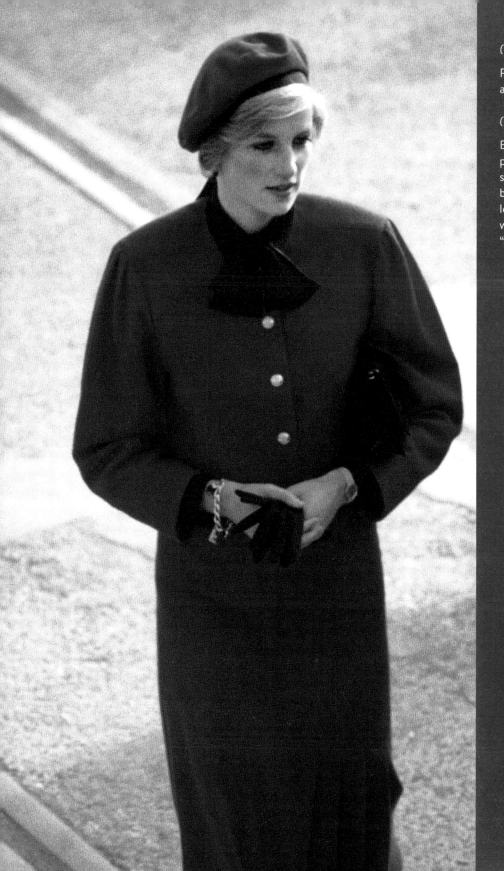

(Far Left)
Royal duty meets cobalt androgyny.

(Left)
Every inch the perfect princess in an all-red suit with matching beret. She wore this look to a ceremony where she named a ship "The Royal Princess."

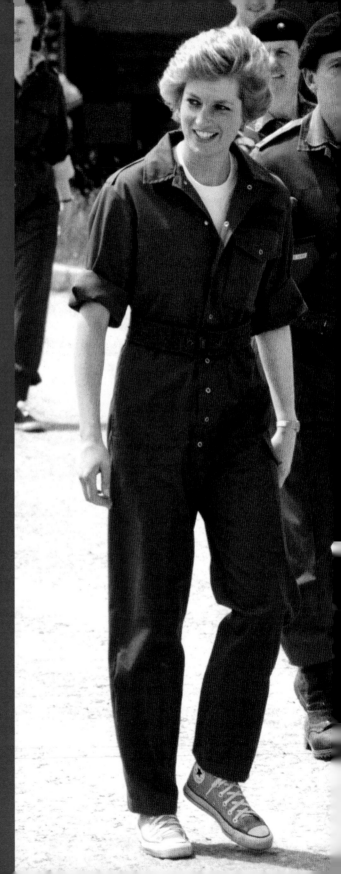

(Right)

Preparing for the war of the Waleses: From the khaki military jumpsuit to the pink Converse sneakers, and with the blue kohl penciled inside her lower lids, Diana brought a touch of her own off-duty charm to the British battlefields.

(Far Right)

OCTOBER 1985: Princess Diana visited British troops in Germany, wearing a yellow-and-black nylon tracksuit. She was given the opportunity to take the controls of a military tank, and, intending to reverse, she "accidentally" lunged the vehicle toward the press stand. "The princess clearly loved it," one reporter said.

"If you give Di a hand-grenade she'll throw it like a pro and if you hand her a rifle she'll handle it as if it's second nature."[83]

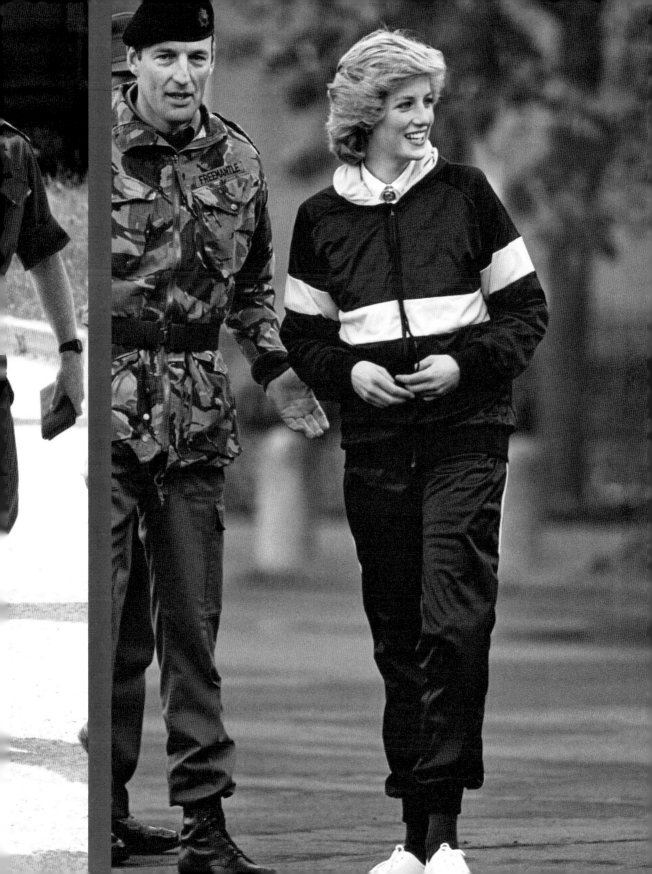

Fired up and ready for war!
A deadly focused Princess Di
took the controls of the *Scorpion*,
an armored tank. One can't
help but wonder what—or who—
her imaginary target was . . .
Fiiiiiiirrrrrreeeeeeee!

THE FAIRY PRINCESS LOOK

"They wanted a fairy princess
to come and touch them
and turn everything into gold.
All their worries would be
forgotten. Little did they realize
that the individual was
crucifying herself inside."[84]

Speaking to Spanish *Esquire* in 2021, John Travolta recalled the moment after Nancy Reagan tapped him on the shoulder and told him Diana wished to dance with him. "Think about the moment," he said. "We are in the White House. It's midnight. It's like a dream, the whole scenario. I approach her, touch her on the shoulder, invite her to dance. She turns around and when she sees me she displays that captivating, somewhat sad smile, and accepts my invitation. And there we were, dancing together like in a fairy tale."[85]

Wearing a midnight-blue velvet dress with an off-the-shoulder neckline by British couturier Victor Edelstein, the Princess glided seamlessly around the dance floor in what Nancy Reagan's press secretary described as "more energetic than a fox trot. I don't know what you'd call it—rock or whatever."[86] Reportedly, they danced to a medley of *Saturday Night Fever* songs and the *Grease* hit "*You're the One That I Want*," before Tom Selleck interrupted to catch his turn to dance with the Princess, followed by Clint Eastwood, who was said to have been an awkward dancer. In a press conference a few days later, a reporter asked Charles if Diana enjoyed her whirl around the dance floor with Travolta. He replied, "I think you enjoyed it, didn't you, darling? Be an idiot if she didn't enjoy dancing with John Travolta, wouldn't she." Jeez, bitter much?

In the years before 1985, Diana's formal-occasion outfits weren't as figure-hugging but rather featured poufy, full-skirted silhouettes in sugary hues of fuchsia, lilac, and lemon. Her ball gowns were based on the romantic fairy tale, reflecting her desire to fit into the mould, to give her new family, and the people, what they wanted to see.

Diana's foray into royalty was set against a backdrop of a divided Britain, where national anxiety was at an all-time high thanks to Maggie Thatcher's tearing apart of the unions and separate IRA attacks. Diana came along at just the right time, when people were looking for a vicarious escape. She sold a fairy-tale dream that was genuinely soothing to some, so how could she let them down?

When creating some of her very first gowns, designers got terribly excited about the opportunity to dress a real-life princess, and they took to the task quite literally. Some gowns looked as though they took direct references from Barbie's closet. Elizabeth Emanuel, a co-designer of the Princess's wedding dress, recalled, "It was like doing our own catwalk show with the most famous woman on the planet. We wanted Diana to love it, but for everyone else we

wanted them to see a fairy-tale dress, like a Disney movie."[87] I don't necessarily dislike Diana's early black-tie looks (although some were real shockers); I just think they portray the perception rather than any real personality.

Diana loved young designers. David and Elizabeth Emanuel, a husband-and-wife team, were four years out of school at the Royal College of Art when they designed the black strapless gown Diana wore to her first official event, where Grace Kelly was in attendance. Jacques Azagury met Diana in 1987 at just twenty-two years old, two seasons after he graduated from St. Martins. He described to me the moment he met her: "I was on the stand at the Hyde Park Hotel showing my collection and Anna Harvey, who'd already given me a couple of pages in *Vogue* editorials, came over and said: 'Jacques, there's somebody I'd like you to meet.' And then, of course I turned around and there was the princess standing right in front of me." It's unimaginable to think what that moment must have felt like, and although Jacques said the introduction momentarily threw him, "She had this amazing ability to make you feel immediately comfortable within seconds."

Three weeks after this unexpected meeting, the Palace phoned Jacques's atelier and said that Diana wanted to visit, and that's when she bought her first dress from him. Made from black velvet, it featured a dropped waist with blue sparkles, shoulder pads, and an indigo taffeta skirt—her trademark frills were notably missing. Although the dress could have been straight out of a John Hughes prom scene with its ultra-eighties silhouette, it was in fact part of a spectacular new sartorial strategy.

"A curious role reversal has taken place in the marriage,"[88] wrote Tina Brown in 1985. The fairy-tale princess had indeed transitioned into a glam princess, swapping the ribbons and bows for sequins and lamé, earning her the nickname "Dynasty Di," after the wildly successful eighties soap opera. It wasn't just the glitzy dresses that got Diana the nickname—reports of trouble in paradise were brewing at this point, though at the time people didn't know that Diana was fully aware that Charles had "gone back to his lady." Diana was living in her own soap opera, and perhaps she was inspired by Joan Collins's *Dynasty* character, Alexis Carrington, the fabulously vengeful multi-divorcée with one prime *raison d'être*: to seek revenge on her ex-husband.

"I'm going to see to it that you get down on your knees and beg for mercy and when you do I'm going to be there, watching and cheering, and waiting to see you rot," was one of Joan Collins's impeccably bitchy lines. Indeed, the Dynasty Di transformation would have you wondering if the Princess shared more in common with Alexis Carrington than just the sensational, sparkling dresses.

While the Palace got an all-American taste of *Saturday Night Fever* at the White House in 1985, the Prince came down with a rather dire case of jealousy. Not because his wife was gliding around a ballroom with any of the usual crowd of foreign dignitaries, but because this night made history as the iconic time that Princess Diana stole the dance floor with John Travolta.

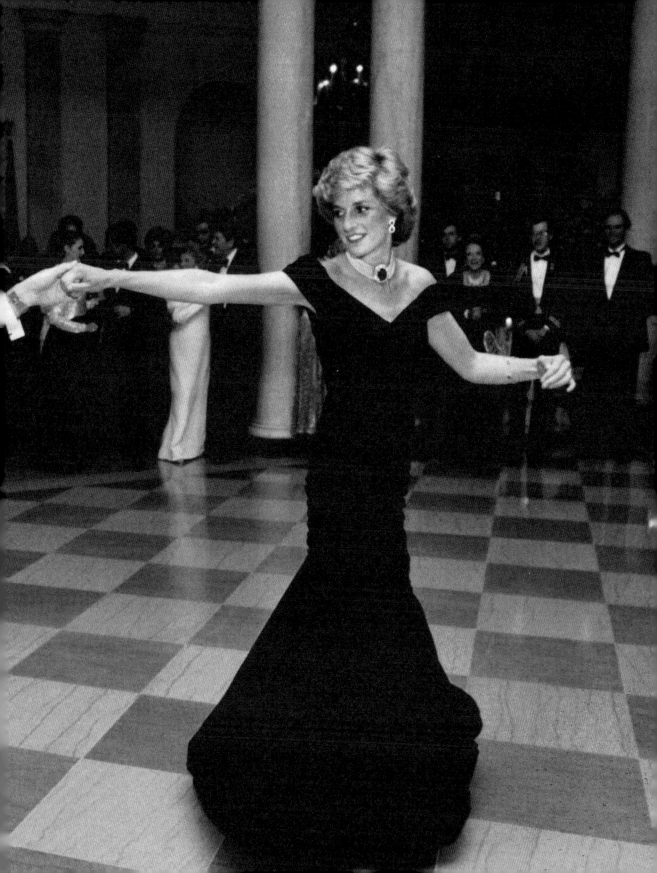

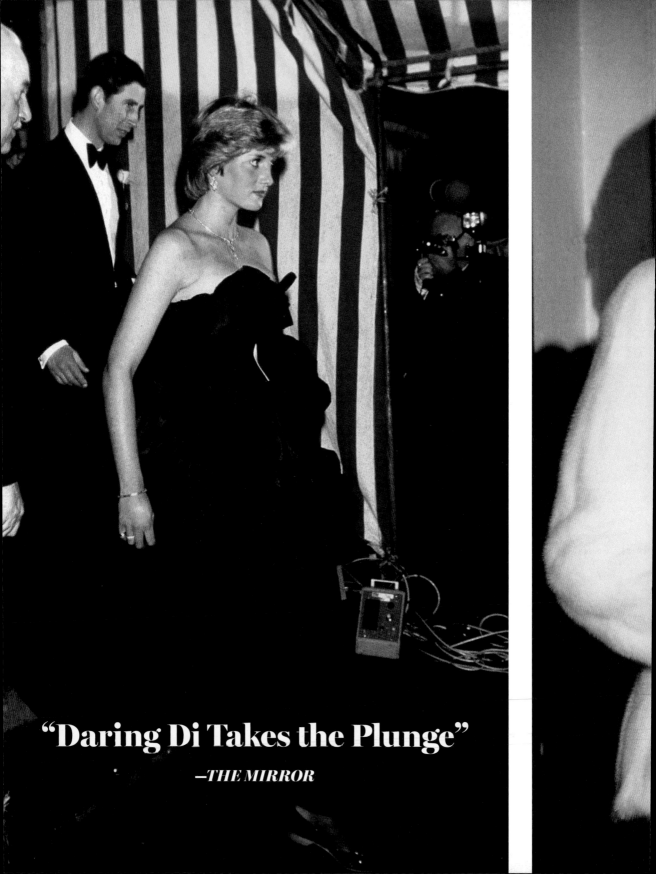

"Daring Di Takes the Plunge"

—THE MIRROR

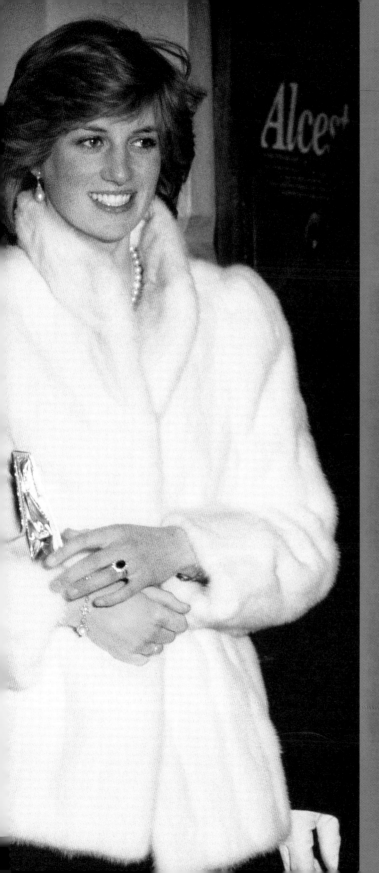

(Far Left)

1981: "You're not going in that dress, are you?"[89] was the reaction of Prince Charles when he first saw Diana all dressed up for her first royal engagement. The strapless ballgown, designed by the Emanuels, was made from black taffeta, considered to be a color of mourning by the royal family and off limits for any other occasion. The newly engaged duchess insisted on wearing it, since she thought black was the "smartest color you could possibly have at that age."

The gown hadn't been made to measure, and when she stepped out of the car, "a crowd of 200 gasped,"[90] with bemused guests commenting on its revealing neckline. *Time* magazine said the gown "radiated a wolf-whistle glamour not associated with Britain's ruling ladies for generations,"[91] while British newspaper *The Times* commented that "the royal couple will be known as the King and Di"—I bet that wound ol' Charles up.

(Left)

FAUX FUR TO THE ROYAL OPERA HOUSE IN 1981: When Diana recycled this coat and wore it for a second time, she recalled, "I turned up in a fake white fur coat and all the antis [antifur activists] came out against me for evermore. So that went back into the cupboard, never to be seen again."[92] Big props to Diana for wearing *faux* before everyone else.

AN ODE TO TAFFETA!

While I'm aware that billowing taffeta is not to everyone's taste, the lustrous fabric can do no wrong in my eyes, especially if it's in a delicious color.

(Clockwise, from Top Right)

Diana was an early advocate for repurposing her clothes. Anna Harvey explained, "Her turnover of clothes was phenomenal and she was criticised for being extravagant, so she recycled."[93] She had worn this lilac gown by Donald Campbell before, but conscious of criticism, she had it altered with an updated halter neck to prove that princesses too can be thrifty. They're just like us, really!

Wearing a sweet lemon meringue delight by Murray Arbeid with gold court shoes in 1985. Arbeid once joked, in an interview with the *Chicago Tribune*, that if there existed a Nobel Peace Prize for taffeta, he would have won it.

MAY 1983: Opening a renaissance exhibition wearing an extravagant fuchsia number by Bellville Sassoon with a velvet, crystal-embellished choker. She picked out the color herself, writing, "Bright pink one please" on the sketches given to her by Belinda and David Sassoon. I ADORE this look, but I also have a sick, sick (probably diagnosable) obsession with taffeta. Cut this into a mini dress and it could look like it was made today. Three years later, Diana reworked her crystal-embellished choker and wore it as a headband—not so chic, but she wins thrifty points from me for repurposing her pieces.

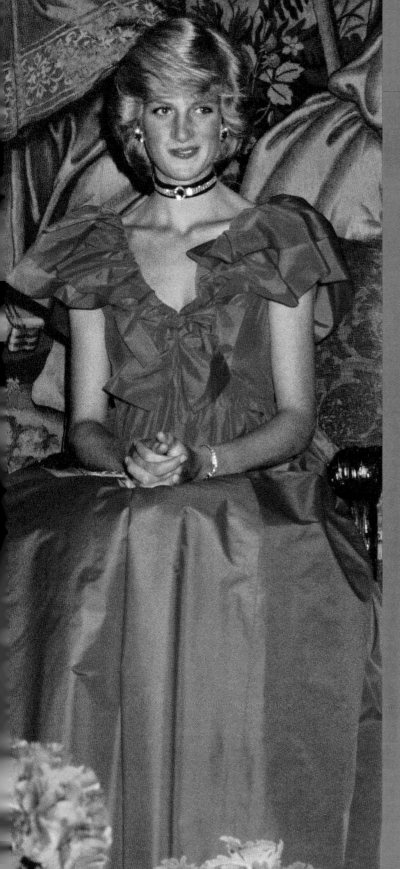

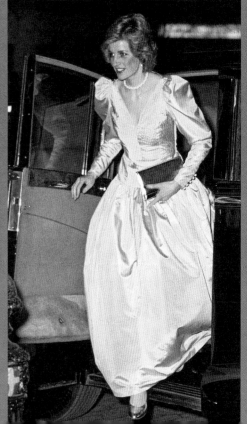

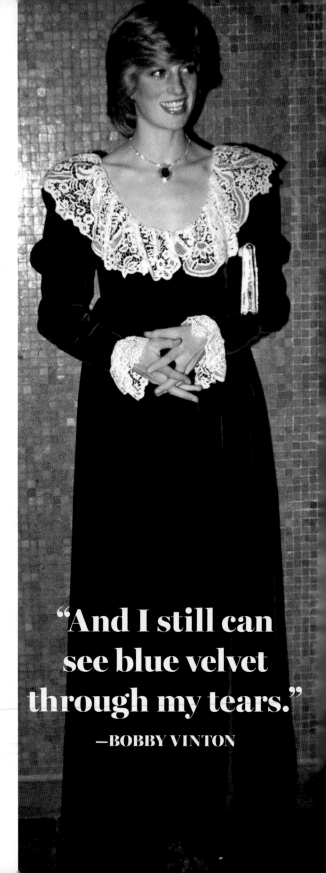

(Right)

Diana wore blue velvet to a dinner for the British Film Institute in 1981, a few months pregnant with Prince William. Designed by Bellville Sassoon, a label worn by Diana since her royal engagement announcement—this heavenly Victorian-inspired design is one of my favorites due to its romantic simplicity and beautiful lace trims.

Diana loved to be a part of the design process and would often give her feedback on sketches submitted to her: "This in dark blue, please," she wrote. Although she dazzles in midnight blue, her smile masks something a little more sinister going on. It is impossible not to notice her dramatic weight loss. "Sick the whole time, bulimia and morning sickness," she recalled from this period. "The whole world was collapsing around me."[94]

(Center and Far Right)

Ethereal spangled dresses with lurex details stand out as some of the looks that have actually aged well, including this red Bellville Sassoon dress worn to the premiere of the James Bond film *For Your Eyes Only*—youthful and glamorous.

"And I still can see blue velvet through my tears."
—BOBBY VINTON

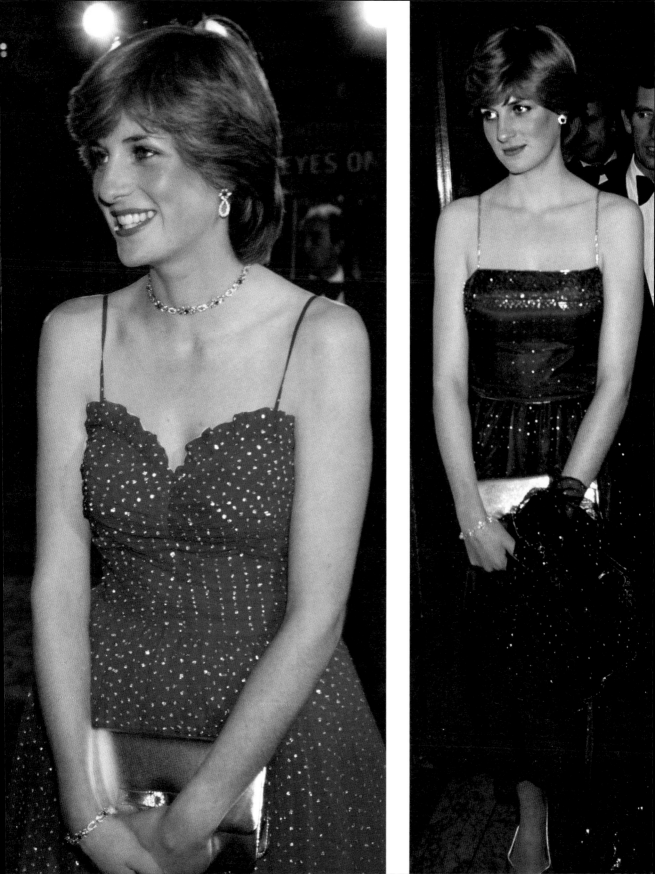

PRETTY IN PINK

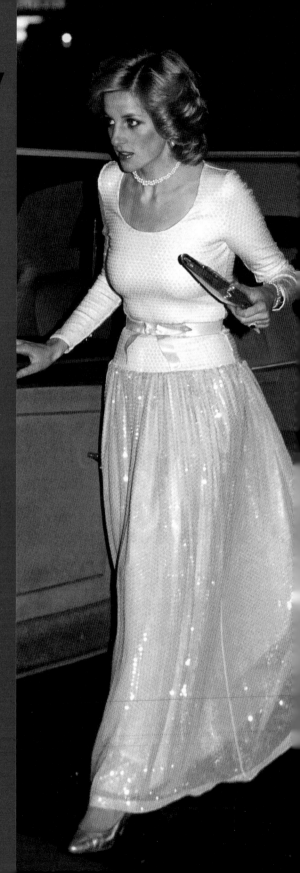

(Clockwise, from Right)

DECEMBER 1984: Diana role-played the fairy-tale princess with glitz and sequins by Catherine Walker in practically edible pink hues.

OCTOBER 1986: In an upcycled puff-sleeve dress from Catherine Walker's atelier, the Chelsea Design Company.

NOVEMBER 1987: Diana wore this Catherine Walker gown to the Royal Ballet in Berlin. It brings to mind Gwyneth Paltrow's 1999 bubblegum-pink Oscars dress by Ralph Lauren. Who wore it better?

NOVEMBER 1985: In Palm Beach, Florida, the Princess wears a ruched pink velvet Catherine Walker dress with a classic double strand of pearls. When she turned around, guests got a glimpse of her back with a sexy, plunging cowl-back—Diana loved the element of surprise.

APRIL 1983: Diana wore this pink Victor Edelstein gown with diamond and sapphire jewelry to a banquet in Brisbane. Poignantly, she opted to wear the Spencer family tiara, rather than the Windsor's, created in the 1930s by Crown Jeweller Garrard.

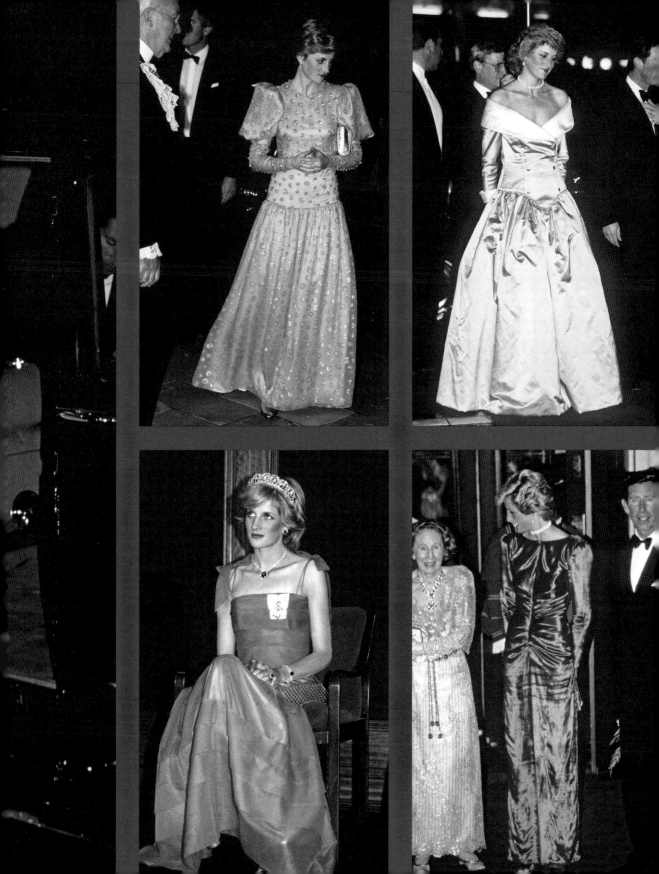

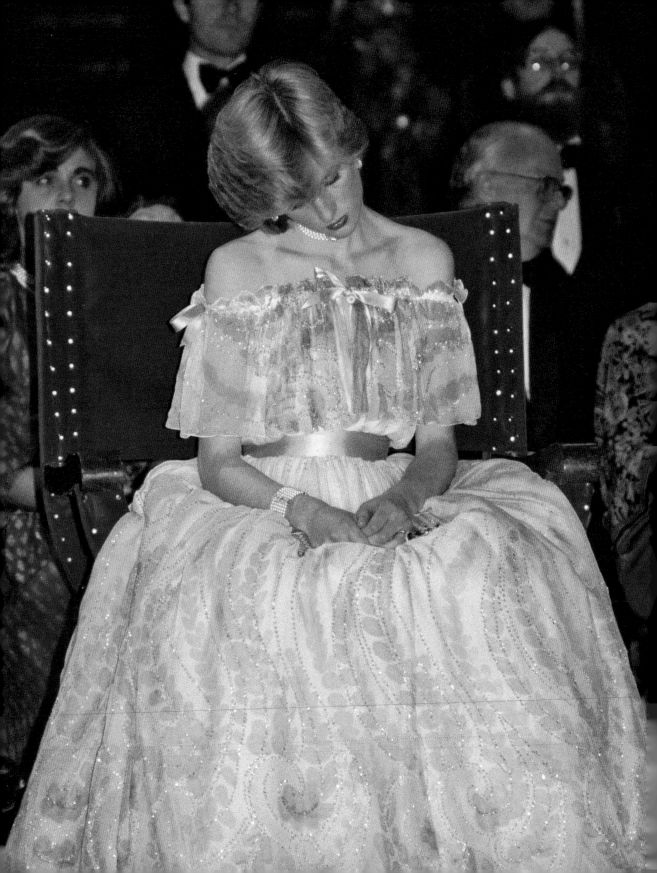

"I didn't like myself. I was ashamed because I couldn't cope with the pressures." [95]

Sleeping Beauty asleep on her throne, wearing a frock with silver speckles by Bellville Sassoon. Was Charles making a speech or telling a joke perhaps? I'd be having a snooze too! In all seriousness, Diana was pregnant and very weak from bulimia and morning sickness. After this photo was printed, the Palace finally announced the Princess's pregnancy to denounce rumors that she was simply bored to sleep at the exhibition gala at London's Victoria and Albert Museum.

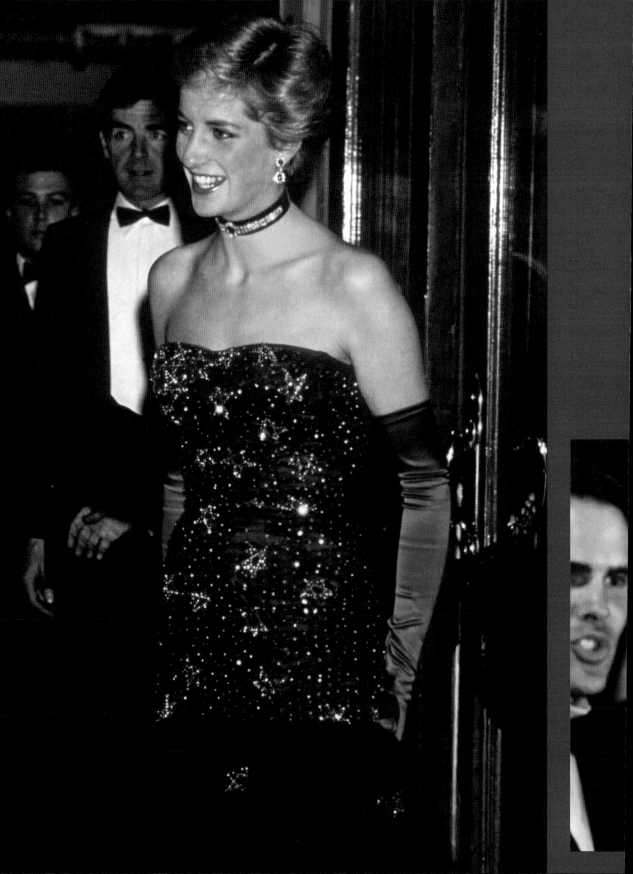

BABY, I'M A STAR

(Opposite)

In February 1987, Diana opted for a glitzy look—indicative of the world-famous superstar she had become. Her gown was designed by Murray Arbeid, and she paired it with contrasting pink satin opera gloves and a crystal-embellished velvet choker. It's Hollywood, baby.

(Below)

1988: Diana wore a hair clip by Butler & Wilson to a fashion show at the Sydney Opera House. The Princess *loved* to wear pieces by the British brand known for their costume jewelry (as did Alexis Carrington, Joan Collins's character, in *Dynasty*).

"Princess Diana, the shy introvert unable to cope with public life, has emerged as the star of the world's stage."

—TINA BROWN

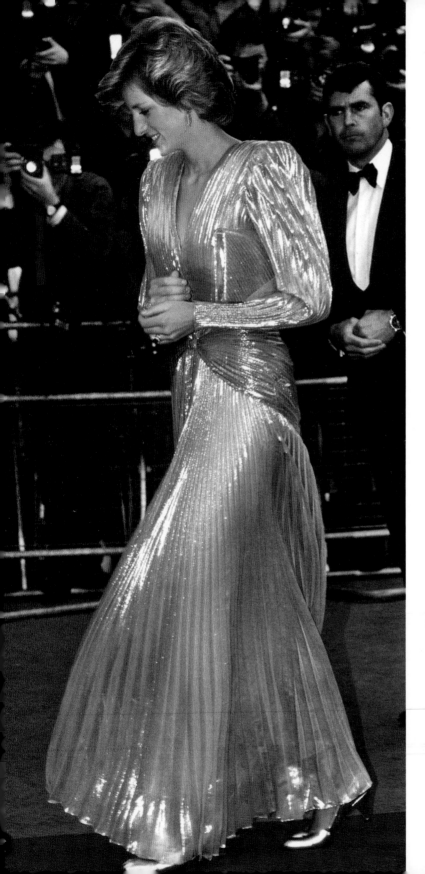

Fittingly, Diana wore this sweeping, pleated lamé gown to the 1985 premiere of the James Bond film *A View to a Kill*. It was a dress that defined an era, catapulting her from royalty to international super-starlet. Diana's appeal was magnetic, and she proved, in a single look, that she wasn't about to dim her flame for anyone any longer.

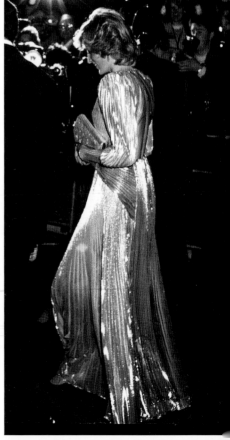

"Sex for breakfast, sex for dinner, sex for tea, and sex for supper."

—SHIRLEY VALENTINE

Dynasty Di goes to the movies!
Arriving for the 1989 premiere
of *Shirley Valentine* (a revenge
classic) in a mermaid-green
gown by Bruce Oldfield, which
she recycled on more than
two occasions. Oldfield can be
credited with helping Diana
to break free from the sugary
Sleeping Beauty pastel tones of
the early 1980s, replacing them
with lustrous jewel tones—colors
that were only appropriate for
her stratospheric stardom.

Diana wore this one-shoulder beaded dress by Japanese designer Hachi to the premiere of the James Bond film *Octopussy*. Anna Harvey explained that this figure-hugging gown came at a turning point in her marriage: "She began playing with glamour and becoming much more daring. The establishment hated it," Harvey said. "It was too revealing; they didn't think it was royal. After that she was dubbed 'Dynasty Di' and rarely wore full skirts. She was proud of her figure and of how feminine it was— and she wasn't going to be pushed around. Years later when everyone complained about an outfit, she said to me, 'I'm certainly going to wear it again,' and I said, 'I think you should . . . If you really have faith in it.' I don't think she did wear it, but she'd made her point."[96]

THE TINSELTOWN LOOK

"Now, with her shoulder pads and frosted bearskin hairdo, it's all gone Hollywood."

—TINA BROWN

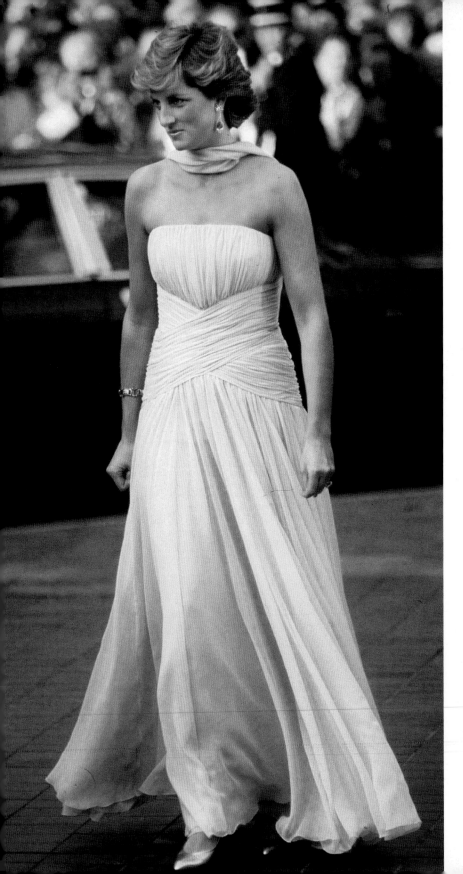

(Left)

Looking every inch the stuff of Greek mythology at the Cannes Film Festival in 1987, wearing an ice-blue chiffon dress by Catherine Walker. If Prince Charles was jealous about his wife stealing the limelight in the early days, one can only imagine how he felt about this particular look.

(Opposite)

The Marilyn Monroe effect in a 1950s-style silk cocktail dress with a portrait collar, worn to the ballet in 1988.

HOT TIP: Match your eyeliner to your sapphire jewels for that extra *je ne sais quoi.*

"**Amazonian supermodels like Christie Brinkley, Naomi Campbell, and Cindy Crawford ruled. And Diana—tall and athletic like a supermodel herself— outshone them all.**"

—TINA BROWN

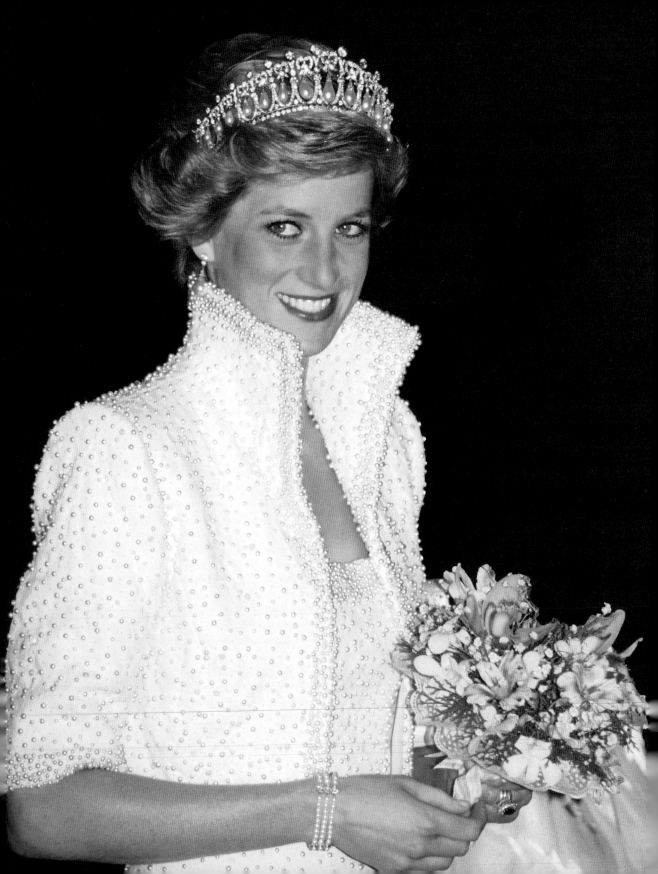

In 1989, Diana wore a pearl-decorated dress and a matching bolero with a pointed collar to an event in Hong Kong—she dubbed it her "Elvis" dress. Years later, when she put it up for auction with Christie's, Prince William didn't think it would attract bidders. "Mummy, that's too awful to sell," he reportedly said.

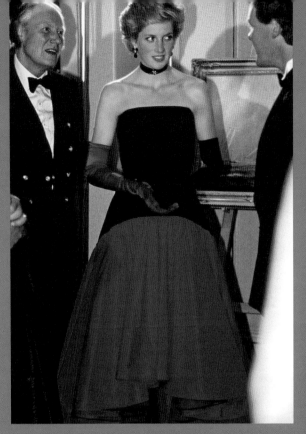
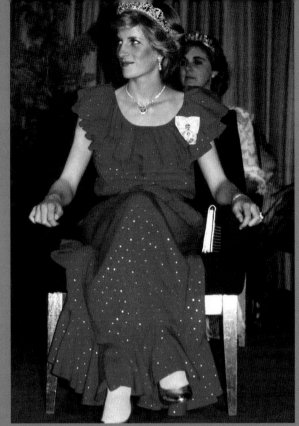
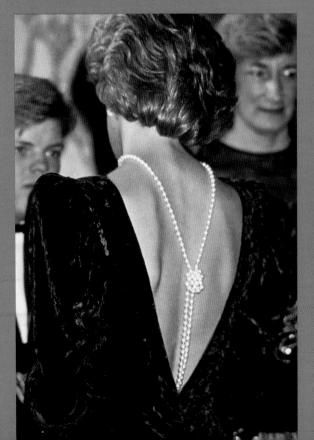
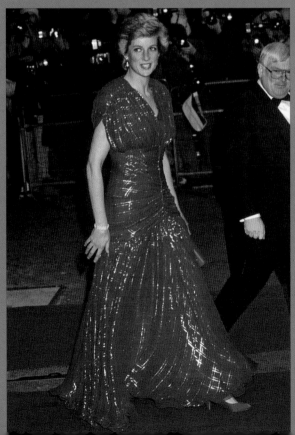

LADY IN RED

The color of love and war:
these are some of Lady Diana's best scarlet looks . . .

(Clockwise, from Top Left)

Flamenco-style dress with mismatching gloves by Murray Arbeid.

Two glistening red gowns with metallic detailing by Bruce Oldfield.

Revenge details aren't always practical—Diana hung this string of pearls, seductively, down the centerline of her back to a film premiere. Afterward, she reportedly regretted her decision because the knot of pearls dug into her spine throughout the entire movie. As the cascading pearls drift suggestively downward and disappear from view, they contribute to her elusive, untouchable image. To me, they say, "That's what you'll see as I walk out that door . . . and that's *all* you'll see."

> "Revenge details aren't always practical."

Diana's Nineties Revenge Looks

"The fairytale had come to an end, and most importantly our marriage had taken a different, different turn."[97]

In 1992, Princess Diana ushered her courtiers out of the photo for this symbolic solo picture. Seated alone, in front of the Taj Mahal—a monument symbolic of power and lost love—Diana signified a turning point and made clear her intention: she was ready to go out on her own. "Diana had learned the language of clothes,"[98] wrote Suzy Menkes.

THE
REVENGE LOOK

What's a revenge look?

I'm often asked what defines a revenge look. It can be a shit-hot outfit, a great haircut, or even just a wicked expression. It should scream, "I'm better off without you!" The idea of a revenge look is that it says a million words without you having to say anything at all.

But isn't revenge bad?

The bitter and jealous woman, we've all heard of her. In my view, the desire for revenge is an inevitable and essential process in every story of rejection. It's transportive, it moves you from a place of self-doubt and insecurity to a place of self-trust, and it is critical to healing.

Who am I getting revenge on?

Anyone who's made you feel worthless. It could be an ex-boyfriend, an old boss—anyone whose toxicity has harmed you.

What's the purpose of a revenge look?

To make them rue the day they were born! Ok, maybe not that extreme . . . but it should make them very sorry for how they treated you and, at the very least, a little jealous of your newfound independence.

What's the ultimate goal?

To make you feel a hell of a lot better and confident in yourself. As they say out here in the USA, *You've got to fake it until you make it, baby.*

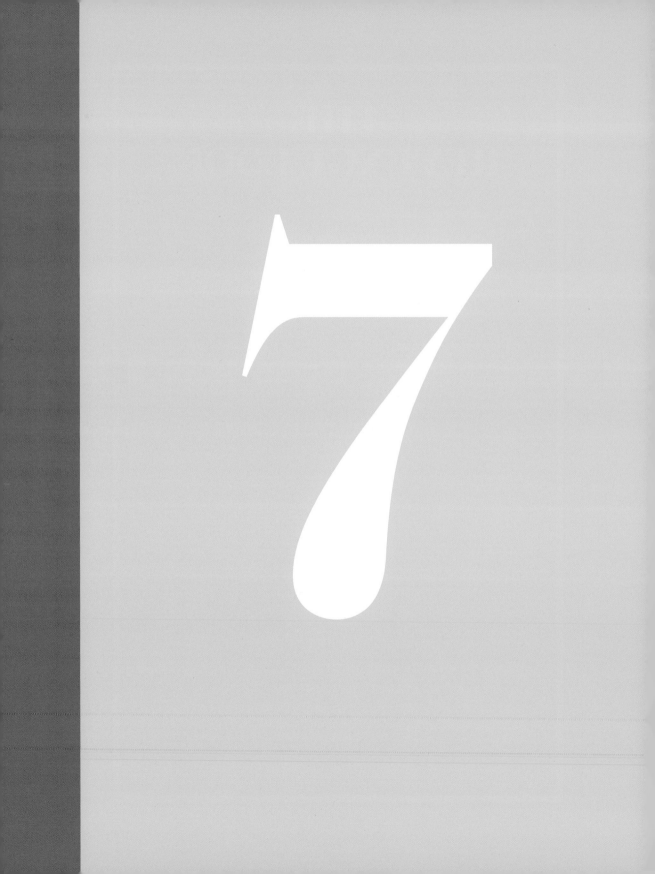

THE FUCK-YOU DRESS REVENGE LOOK

"When her chance for revenge came, all humankind was on her team."

—*VANITY FAIR*

Diana had a clear strategy when wearing her Christina Stambolian off-the-shoulder cocktail dress that summer evening in 1994. Simultaneously, Charles was appearing on national television to announce, in a shameful confession to broadcaster and presenter Jonathan Dimbleby, that he had been cheating on Princess Diana since 1986 (although Diana believed the date was closer to 1984). The dress, with its revealing sweetheart neckline, helped her reclaim the narrative of her publicly unraveling marriage in one single night. She wore the same pearl choker with a diamond-set sapphire that she'd worn to her formal royal engagements in the eighties—a badge of honor as much as a relic of her past.

For the few years prior to 1994, the British public had faced the most brutal recession since the 1930s and grew increasingly resentful toward the Queen and the royal family, who paid no income taxes on their wealth. When Windsor Castle partially burned down in November 1992, just two months after the biggest market crash since the Great Recession, the government suggested that the British taxpayer could foot the bill to rebuild the castle, which was estimated to be over £60 million. The response? Fury. The Queen, who grew up in her own Camelot, came across as utterly tone-deaf. By the time tapes exposing lurid conversations between Charles and Camilla were leaked to the press in 1993, the British people had had enough. This wasn't the fairy tale they were looking for.

When Diana bravely stepped out of the car, wearing her little black dress, she became the shining hero the country was pining for. She, unlike her in-laws, knew very well how to read the room.

Diana wasn't meant to wear this dress. Originally, she had bought a Valentino gown for the Serpentine event, but the Italian fashion house prematurely released a press statement about what she had planned to wear. A *Vogue* article described the consequences of such a *faux pas*, saying, "Diana's designers knew that if they breathed a word to the press, jettisoning from the charmed service would be swift and irrevocable."[99] Infuriated by the presumptuous press statement, Di changed her mind and opted for a revealing little black dress by the lesser-known Greek designer Christina Stambolian as her choice of outfit on the night the public would finally know the truth about Charles's infidelity. The message was clear: she was in control of her own decisions and was ready to surprise more than a few people that evening.

The consequences of the Jonathan Dimbleby documentary for Charles? He lost close to all public sympathy. According to reports in the *Daily Express*, a furious bystander spotted Camilla outside of her local Wiltshire supermarket (probably stocking up on that week's supply of chicken Kiev) and began pelting her with bread rolls. They say justice comes in many forms.

That evening marked the turning point in Diana's personal narrative. According to *The Sun's* front-page headline the day after the Serpentine gala, she was "the thrilla he left to woo Camilla," and she wasn't about to let up. There were plenty more revenge dresses to follow. One year later, she was in need of another black dress.

If Diana's *revenge dress* isn't enough to convince you that her clothes were a part of a carefully considered strategy, then the Jacques Azagury dress she wore the night of her tell-all *Panorama* interview might convince you otherwise. Jacques told me that on the morning the interview was to be broadcast, he received a call from the Princess herself saying she needed to see him, that she wanted a new black dress (if you remember, black, a color of mourning, was off-limits to her as a royal). Jacques recalled that on the phone call, Diana said, "I haven't said anything bad, I've just said things the way they are," and that she was going to need a "really good, sexy dress."[100]

At the exact time the *Panorama* interview aired, she had a benefit to attend and had one goal: "She wanted to look sensational," said Jacques. "It was her way of saying, 'I can wear black now, I can do what I want to do.'"

For Diana, every dress was semi-autobiographical, telling the tale of a battle well fought. "If you want to be like me, you must suffer,"[101] she once said. "For every diamanté necklace and cleverly embroidered bodice, there must be a tale of woe—a tiff with Charles, a rumble between their opposing camps of courtiers, a frosty standoff with her implacable mother-in-law," wrote *Vanity Fair*.[102]

Azagury, known as the designer of the "famous five"—gowns best known for their sexy, modern silhouettes—along with her Versace and Catherine Walker looks, defined Diana's revenge dressing era. She loved her Azagury nineties dresses so much, in fact, that she intentionally left them out of her Christie's charity auction in 1997.

There was one last Azagury dress, more sensational than anything Diana had ever worn before, that, crushingly, she never got the opportunity to wear. Designed for a movie premiere, it was black, hand-embellished with bugle beads all the way to the floor, with a high front slit and a deep-V neckline. He described it to me as "real Hollywood," and it would have "pushed the princess to the left a bit" as the red carpet star that she had become. Today, the unseen gown remains in Azagury's private collection. Twenty-five years after her death, he still doesn't feel quite ready to show it. "It would have catapulted her into another era, and it suddenly didn't happen."

At the Serpentine gala in 1994, Princess Diana stepped out to a round of deafening applause. She exited her Rolls Royce smiling and immediately planted two kisses on the cheeks of the man who greeted her. No curtsies, no pomp; Diana was a superstar who wanted to live in the real world. She wore a Christina Stambolian chiffon little black dress, accessorized with a pair of Manolo Blahnik heels and a Ferragamo Vara clutch. The mini-train of her dress fluttered behind her somewhat symbolically, standing in contrast to the twenty-five-foot train of her wedding dress. She was visibly lighter, and how could she not be? This time, she was walking down the aisle toward freedom.

Like the plunging black gown she wore to her first royal event in 1981, this little black cocktail number represented a fresh stab at freedom. Symbolically, the two dresses bracketed an era in her life that was no more. Black, a hue attributed to mourning, is also the color of sexual sophistication. Her message was clear: her marriage was dead, she was moving on, and the next day's front pages belonged to her.

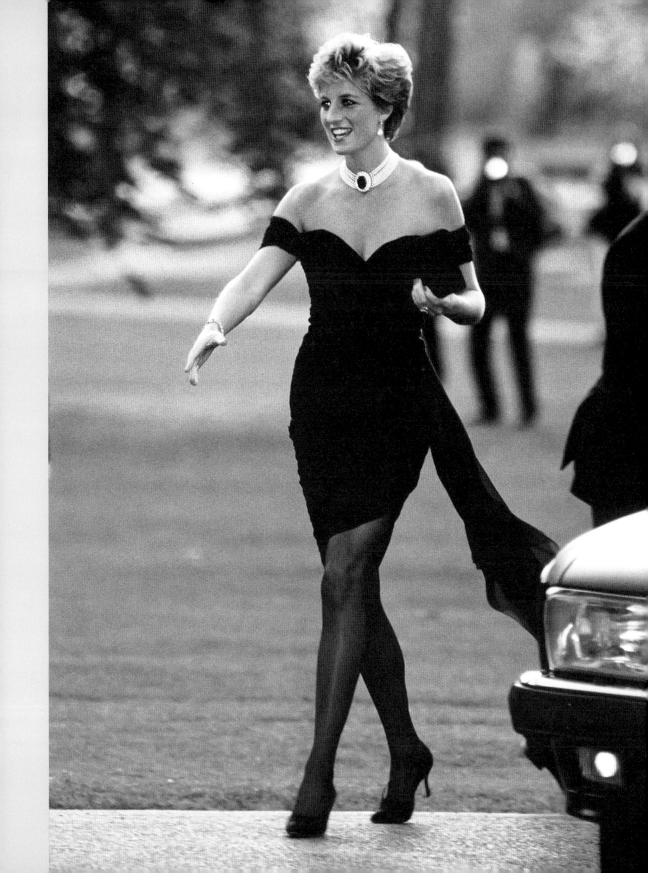

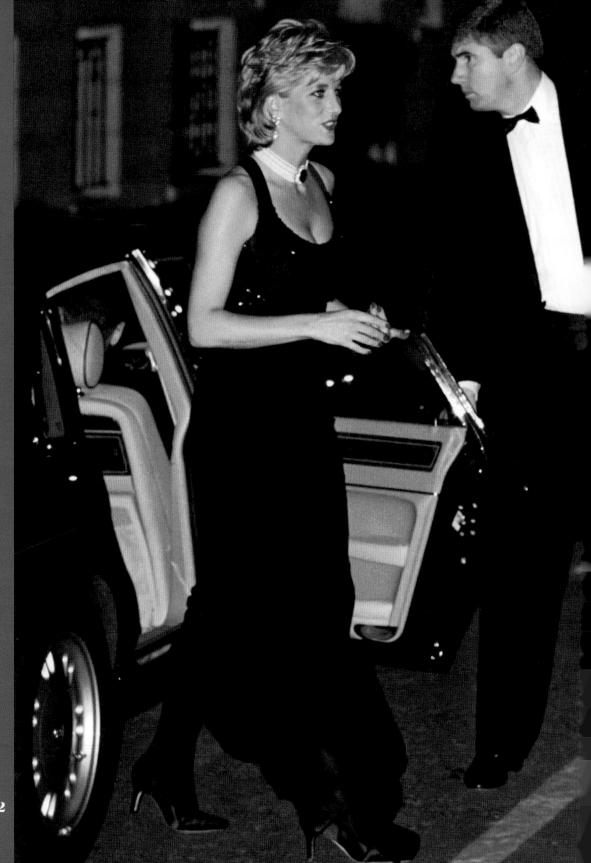

"Diana reinforced her break with married life by stuffing a heavy-duty bin bag with her entire set of Prince of Wales china and then smashing it with a hammer."

—TINA BROWN

In 1995, the night of the sensational *Panorama* interview, Diana appeared in this black Jacques Azagury georgette dress with beading at the top. "That was the start of her road out," the designer told me.

Diana knew that the "fuck you" dress was the most important revenge piece in her wardrobe.

THE LITTLE WHITE REVENGE DRESS

"As she became more independent, the heels got higher, the skirts shorter—it was almost a semaphore of clothes to signal her state of mind (as she well knew)."

—ANNA HARVEY

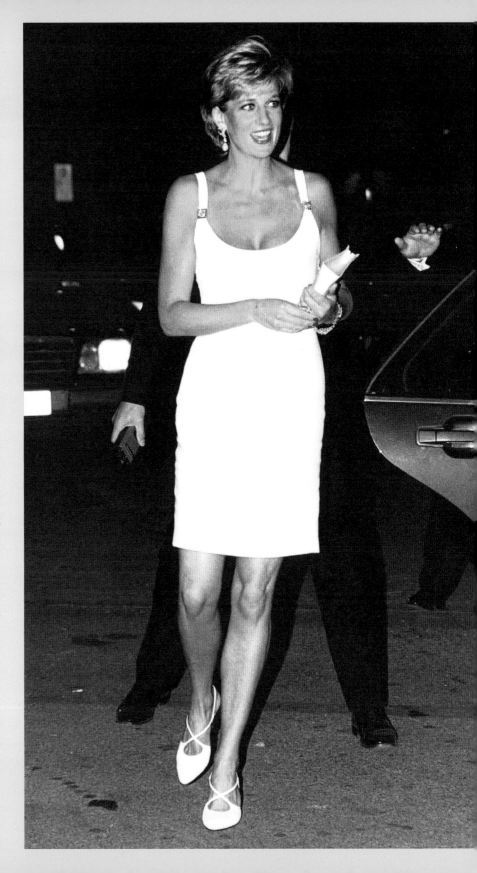

Diana appeared in this little white dress by Versace (the original bad-girl designer), sans wedding ring, at an Italian concert in 1995. Paired with simple, strappy Jimmy Choo sandals and delicate diamond and pearl drop earrings, this divine look is gloriously minimal. Revenge need not be complicated.

As the estranged royal's confidence grew, so did her heels. Jimmy Choo recalled that at the start of their seven-year friendship, Diana always ordered flats, then as her marriage started to crumble, the heels got higher. "First she went up to 2in, then 3in, then 3½ in, then ¾ in. They just kept creeping up and up,"[103] said Choo.

THE LITTLE BLACK REVENGE DRESS

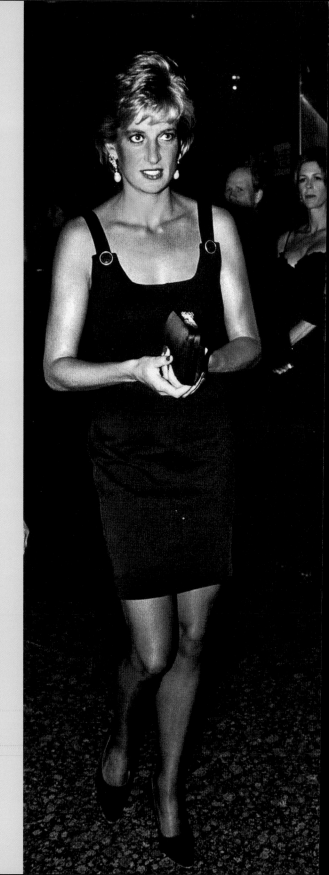

(Left to Right)

If you can't say anything nice, say it in a flawlessly constructed little black Versace dress, and enlist Pavarotti as your wingman. Donatella Versace told *Vogue* in 2018 that the one trend she never, ever wanted to see return was minimalism. But Donatella—you and Gianni were so good at it?

In Rimini, Italy, in 1996, wearing a Catherine Walker black shift dress with her signature pearls.

Diana schmoozed with the newspaper editors at the *Sunday Times* holiday party in 1996, wearing a long-sleeve LBD.

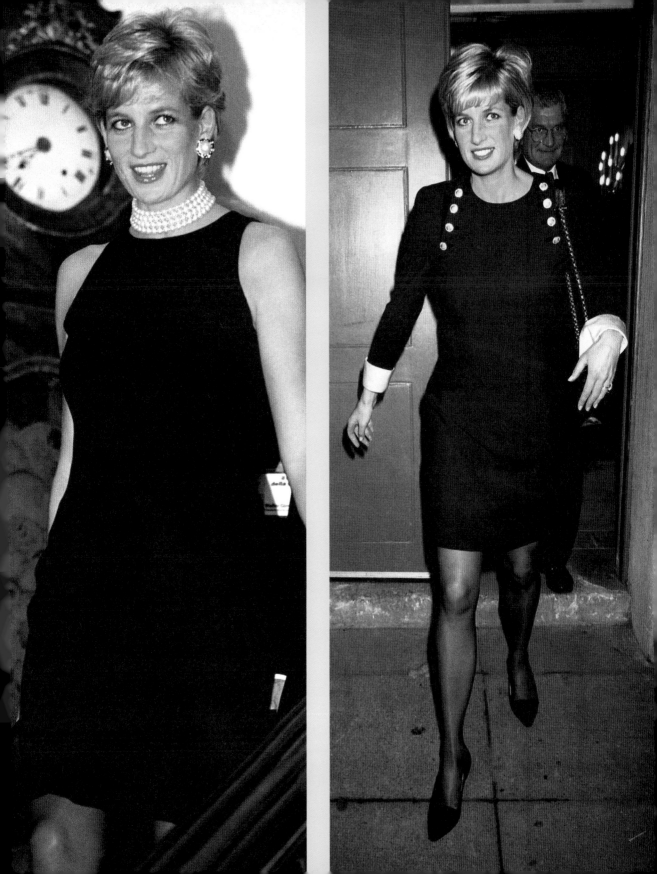

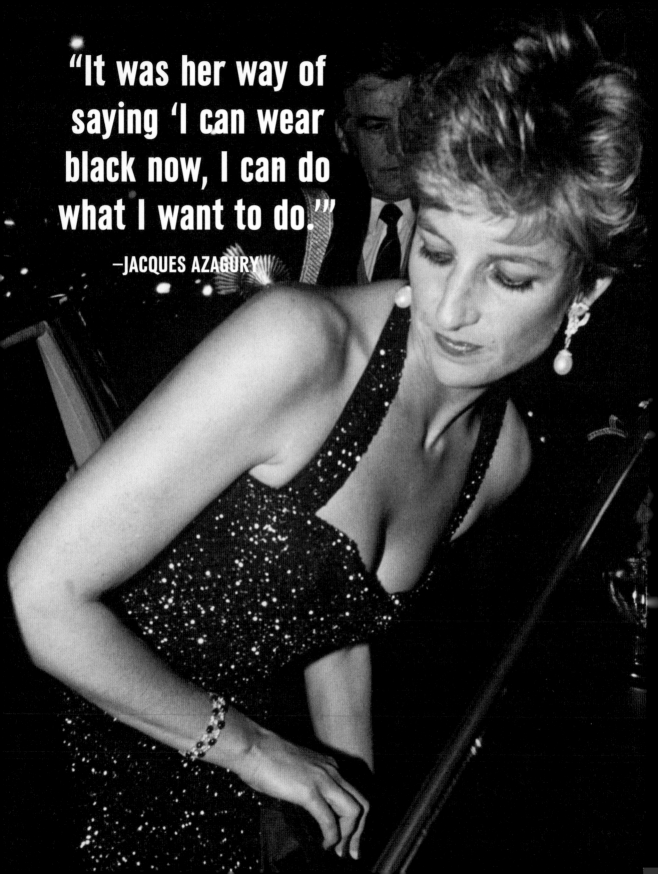

"It was her way of saying 'I can wear black now, I can do what I want to do.'"

—JACQUES AZAGURY

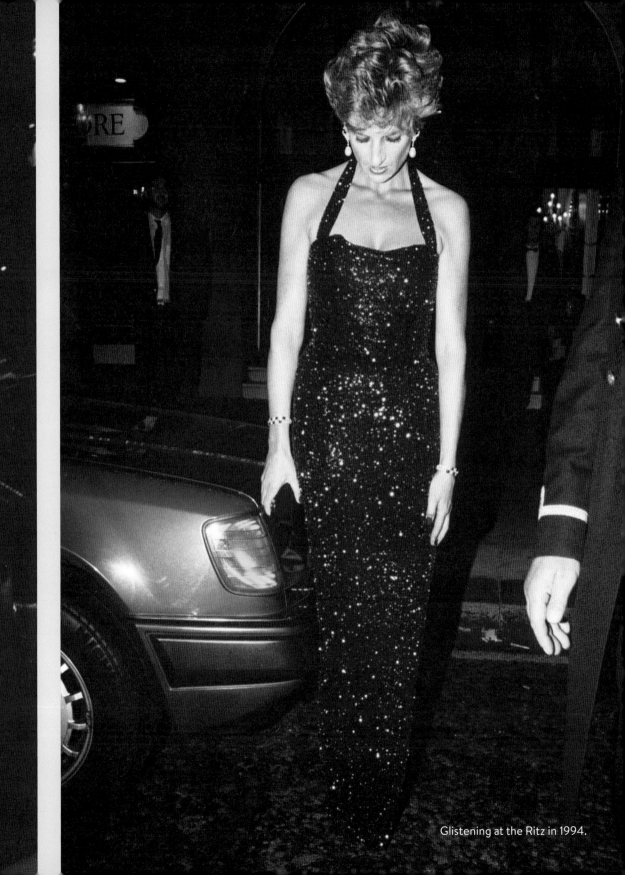

Glistening at the Ritz in 1994.

(Left)

Jacques Azagury gifted this hand-beaded Chantilly lace dress—one of his "famous five"—to Diana for her 36th birthday. The fabric was handmade in Paris. She'd already had a dress planned for the Tate centenary party that night, so Jacques was amazed when she stepped out wearing the dress he'd given to her. "I think that was a kind of thank you—that was the kind of person she was."

(Opposite)

Diana is every inch the American Dream in an elegant ivory lace gown by Ralph Lauren—standing next to the man himself and *Vogue* editor Anna Wintour. The Princess and the iconic Bronx-born designer struck up a close relationship, and he soon had Diana wearing oversized sweatshirts from his sportswear label Polo Ralph Lauren.

To her famous dress auction at Christie's New York, Diana wore a peach and ivory beaded shift dress by Catherine Walker—a dress that symbolized yet another fresh start for the Princess. Standing next to an exhibition of voluptuous ruffles and shoulder pads of the seventy-nine dresses she was donating to charity, and without any of the typical diamond or pearl chokers, Diana looked naked. But that was the point. To bring publicity to the auction, a glamorous, stripped-down Diana was photographed by Mario Testino for a piece *in Vanity Fair*, titled "Diana Reborn"—a far cry from a piece in the same magazine from five years prior to that, headlined "Diana's Revenge." Testino described teaching Diana to catwalk. "Imagine, the most celebrated woman of our time—glamorous princess, champion fund-raiser, benefactor to the poor, mother of England's future King—learning to strut like a runway queen!"[104]

Two runway queens unite. Princess Diana shakes hands with Kate Moss at the Christie's auction in 1997.

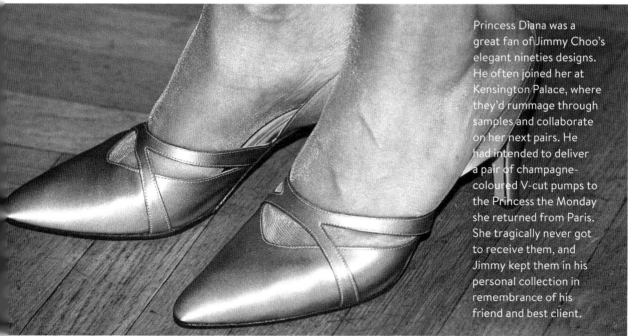

Princess Diana was a great fan of Jimmy Choo's elegant nineties designs. He often joined her at Kensington Palace, where they'd rummage through samples and collaborate on her next pairs. He had intended to deliver a pair of champagne-coloured V-cut pumps to the Princess the Monday she returned from Paris. She tragically never got to receive them, and Jimmy kept them in his personal collection in remembrance of his friend and best client.

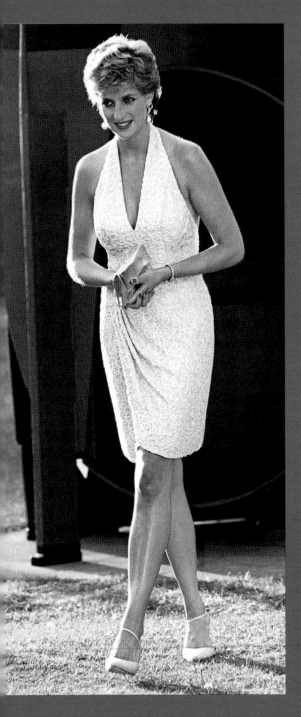

(Left)

Having to trump her own revenge dress for the previous year, Diana wore a pale blue beaded silk Catherine Walker dress to the Serpentine in 1995—this time featuring a risqué plunging neckline, breaking the biggest royal rule going: never display boob. Diana, ever the rebel, supposedly had silk pillows in her Kensington Palace apartment embroidered with "Good girls go to heaven, bad girls go everywhere"—a mantra for us all.

(Opposite)

"She taught women that you don't have to be just one woman, you can be many," Jacques Azagury said of Diana's style in the nineties. He designed this enchanting beaded shift dress for Diana to wear to see *Swan Lake* in 1997. She paired it with a Garrard necklace made with one hundred and seventy-eight diamonds and pearls and a clutch by British accessories designer Anya Hindmarch. She looked almost like an art-deco ornament, streamlined and glistening—her toned arms and sleek hairstyle reflected the movement in her life, away from the stasis that had consumed her past.

The ice-blue color of the dress was chosen to match the color of her eyes and complement her bronzed skin. In fittings at the Palace, Jacques recalled an enthusiastic Diana asking to make the length of the dress even shorter. Both the designer and her butler, Paul Burrell, had to remind her that she already had trouble getting out of the car and had to shield her dignity from photographers with her clutch bag. "We always had a laugh," he said, recalling one fond moment in particular. "She put a dress on and catwalked for me the way Mario had taught her."

Anya Hindmarch designed this particular satin bag and said that Diana called the clutches her "cleavage bags,"[105] due to their dual function as both chic accessory and modesty shield.

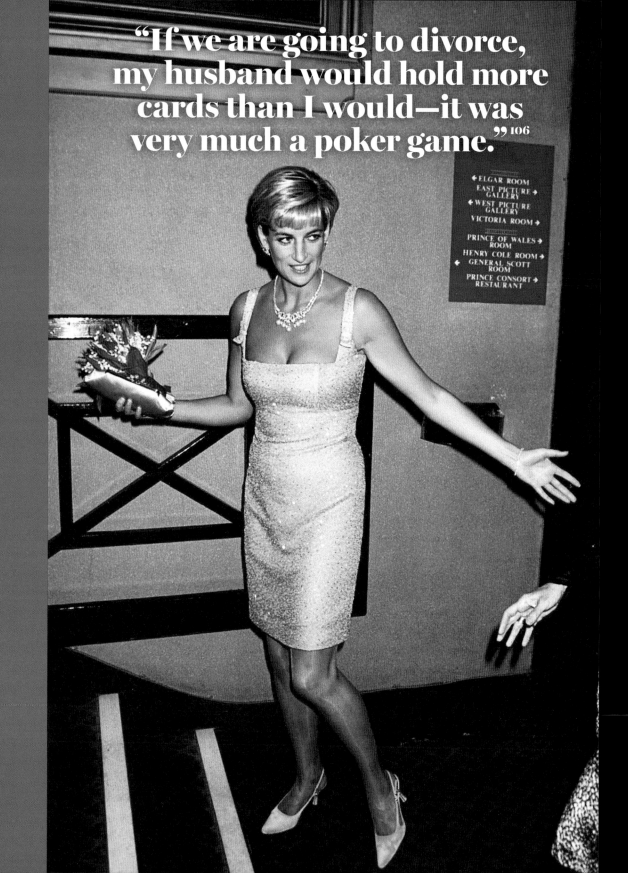

"If we are going to divorce, my husband would hold more cards than I would—it was very much a poker game."[106]

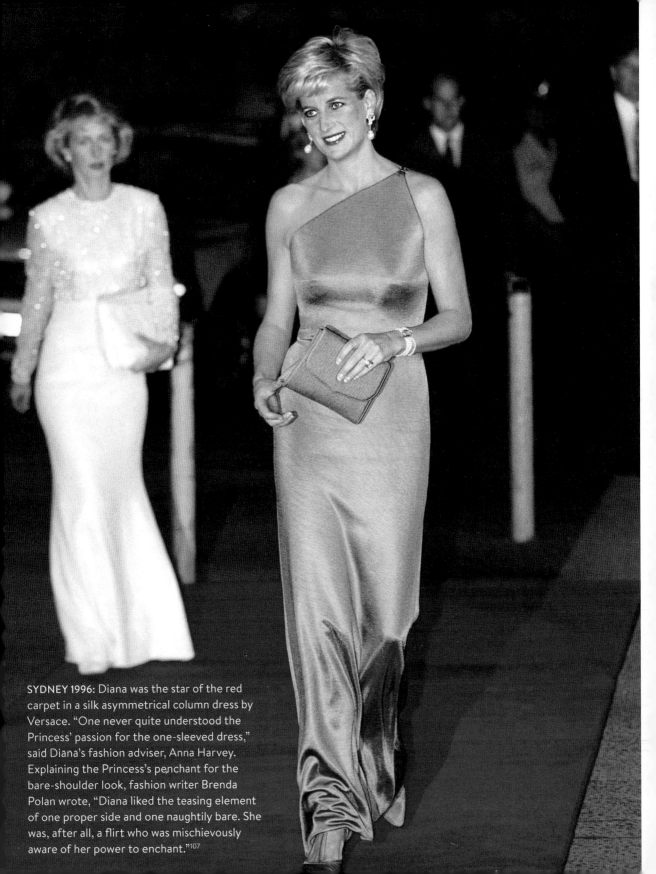

SYDNEY 1996: Diana was the star of the red carpet in a silk asymmetrical column dress by Versace. "One never quite understood the Princess' passion for the one-sleeved dress," said Diana's fashion adviser, Anna Harvey. Explaining the Princess's penchant for the bare-shoulder look, fashion writer Brenda Polan wrote, "Diana liked the teasing element of one proper side and one naughtily bare. She was, after all, a flirt who was mischievously aware of her power to enchant."[107]

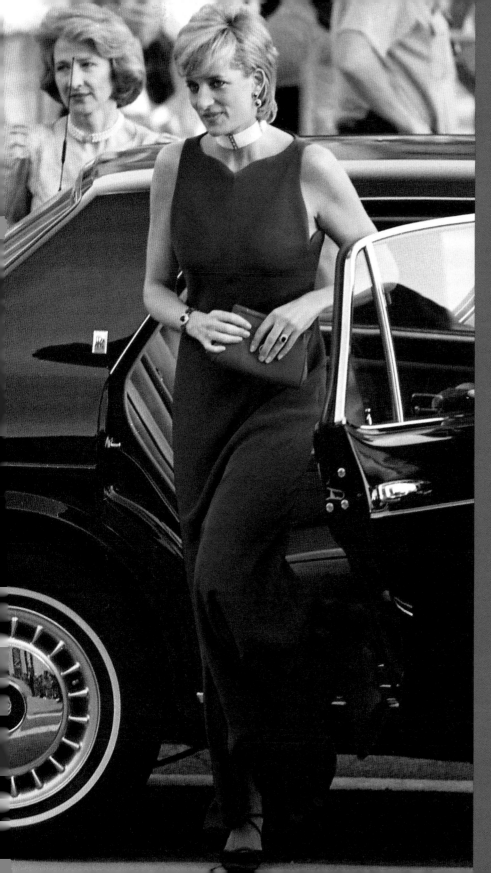

Gianni Versace's gowns had a transcendental power to them, especially when worn by Diana—she looked at her very best when wearing designs by the Italian maximalist. On this trip to Chicago in 1996, Diana wore a figure-skimming gown in regal purple, with strappy satin heels and a clutch by Jimmy Choo. Although this was the year of her divorce, you may notice she's still wearing her sapphire-and-diamond engagement ring— the ring that her son Prince William would later propose to Kate Middleton with.

177

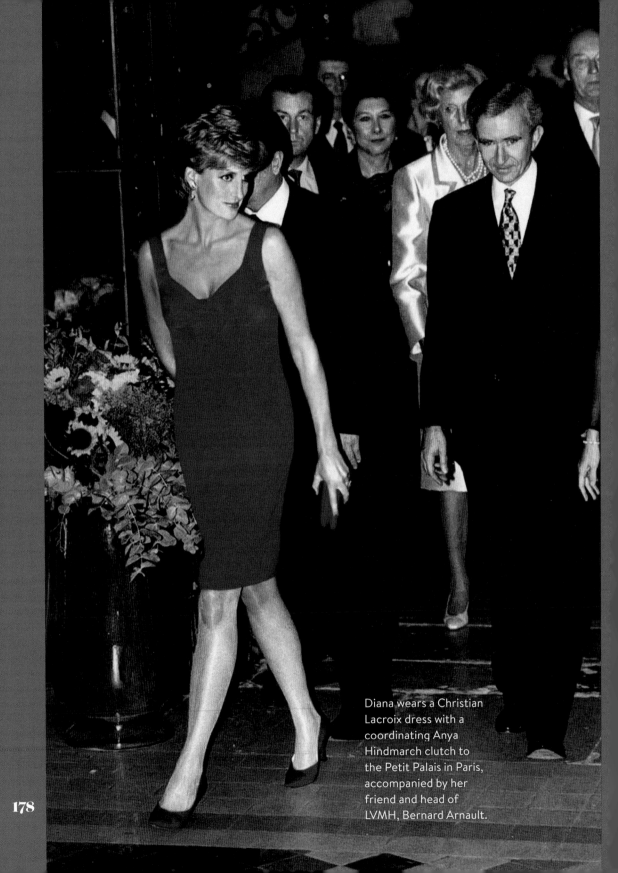

Diana wears a Christian Lacroix dress with a coordinating Anya Hindmarch clutch to the Petit Palais in Paris, accompanied by her friend and head of LVMH, Bernard Arnault.

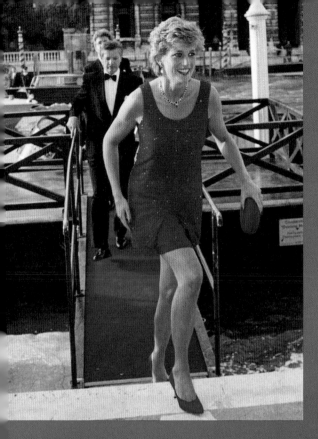

Some people think revenge is best served cold. I, however, believe it's best served red hot, with a lot of leg showing. Diana wore this Jacques Azagury beaded silk crêpe de chine two-piece on a trip to Venice in 1995. The Casablanca-born designer is known for blending opulent fabrics with sexy, minimal silhouettes. "It was the first time we'd gone shorter than normal," Azagury told me. Through the center of the top ran an invisible zipper, which Diana teased she was going to unzip to flash a little negligée before the press. "No way, absolutely no way," advised Jacques. She was still a Princess, after all.

(Right)

Diana wore this brilliant red Jacques Azagury dress to the Red Cross Gala in 1997, where she made an impassioned speech imploring the U.S government to join her in supporting a worldwide ban on the use of landmines. Jacques considered the serious topic of her speech when creating her gown. From the front, it was simple, conservative and "at the back we slit it right down to the waist, because we knew she was going into party mode afterwards, she didn't want a *really* serious dress," he said.

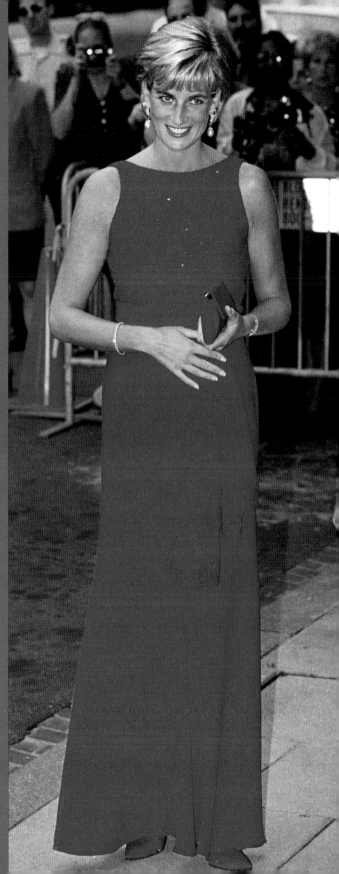

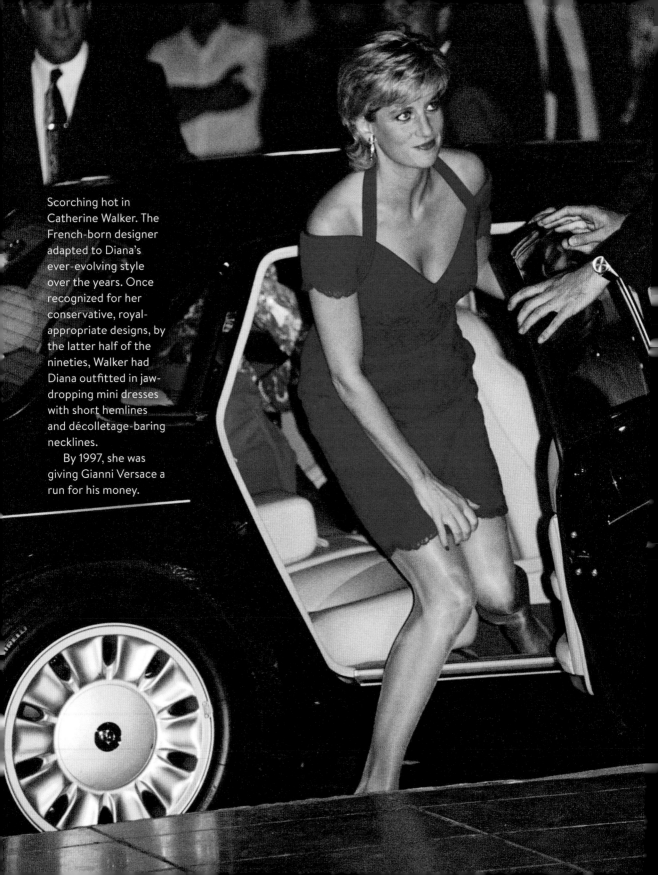

Scorching hot in Catherine Walker. The French-born designer adapted to Diana's ever-evolving style over the years. Once recognized for her conservative, royal-appropriate designs, by the latter half of the nineties, Walker had Diana outfitted in jaw-dropping mini dresses with short hemlines and décolletage-baring necklines.

By 1997, she was giving Gianni Versace a run for his money.

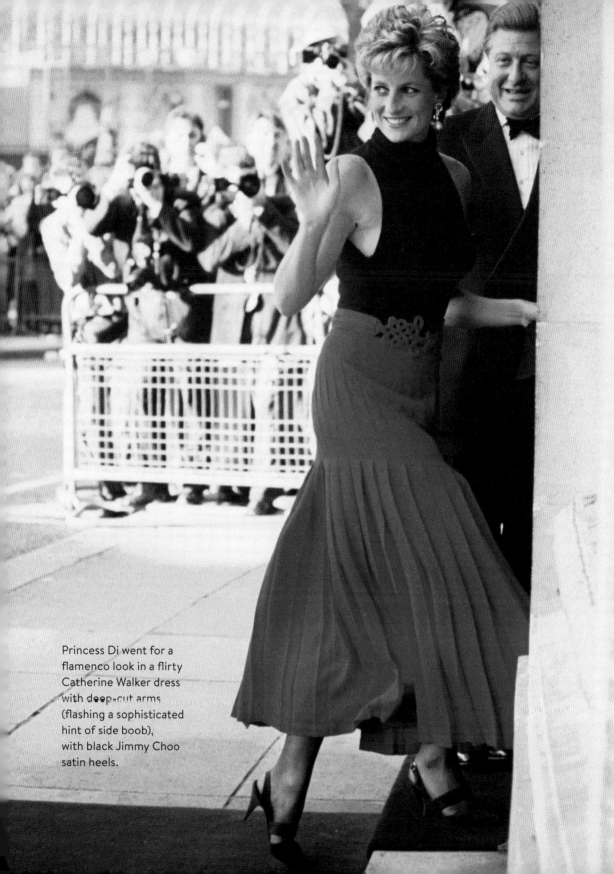

Princess Di went for a
flamenco look in a flirty
Catherine Walker dress
with deep-cut arms
(flashing a sophisticated
hint of side boob),
with black Jimmy Choo
satin heels.

REVENGE IS IN THE FINER DETAILS

Diana opted for flattering midnight blue and seductive back details that resembled lingerie for her trips to New York in the late nineties—sexy nightwear for the city that never sleeps.

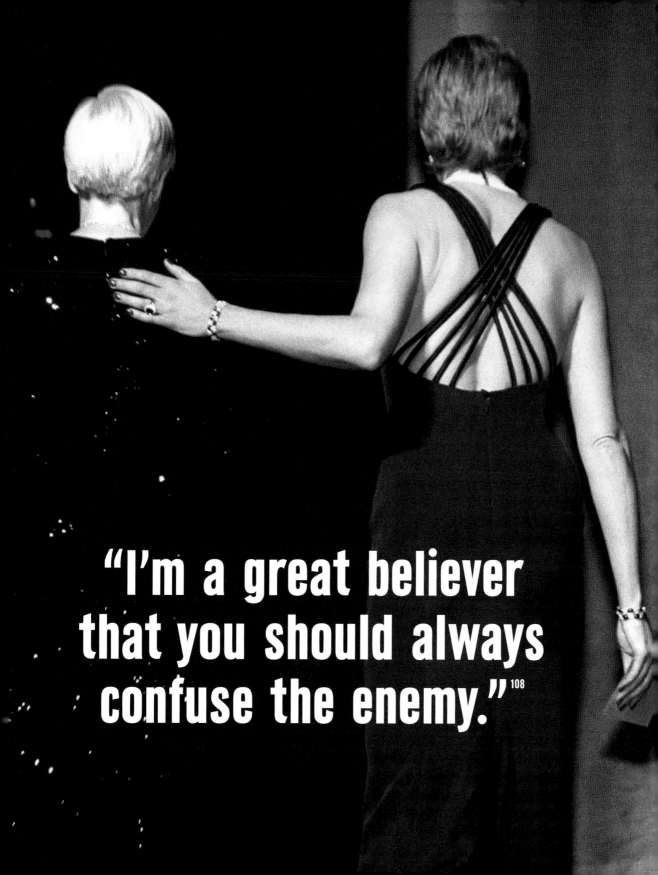

"I'm a great believer that you should always confuse the enemy."[108]

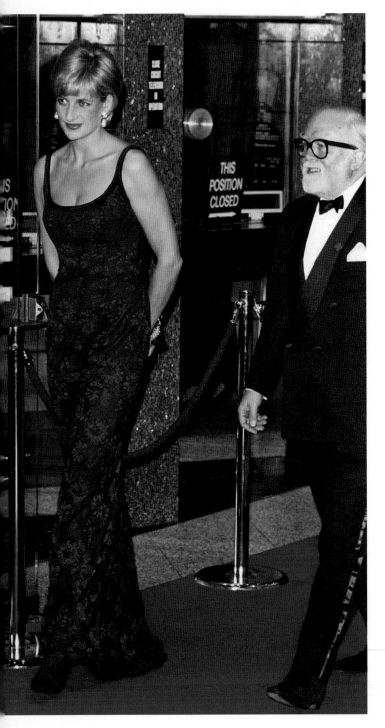

(Left)

Diana wore this sleek navy lace gown by Catherine Walker to the film premiere of *In Love and War*, accompanied by the ultimate gentleman—Sir Richard Attenborough.

(Opposite)

In 1995, Diana flew by Concorde to New York to present Liz Tilberis, editor-in-chief of *Harper's Bazaar*, her friend and confidante, an award for her contributions to the fashion industry. It was the first time she ever did a public speech in the United States, and unlike her typical attire for her public speaking, she opted for a figure-skimming midnight blue gown by Catherine Walker, with her signature pearl-and-sapphire choker, a gift from the Queen Mother, and she slicked her hair back with gel. While some critics said it looked as though she "just got out of the shower," others applauded the fashionable look and compared Diana to Sharon Stone. That night, the royal superstar rubbed shoulders with American fashion and Hollywood royalty—her tablemates included Calvin Klein, Kate Moss, Donna Karan, and Isaac Mizrahi, and in a tribute to Diana in November 1997, Liz Tilberis wrote, "The 'been there done that' fashion crowd stopped dead in their tracks."[109]

When Diana got up to present the award, a stranger in the gallery shouted, "Move to New York!" It seems that New Yorkers felt that Diana—the estranged royal—would be more at home in the Big Apple with her steamy wet-look hairstyle, than within the confines of her Kensington Palace fortress. It was her fifth trip to the city that year, and the socialite city was alive with chatter that she was possibly considering a move across the pond.

"The 'been there done that' fashion crowd stopped dead in their tracks."

—LIZ TILBERIS

When Diana wore John Galliano's first-ever dress for Dior to New York's Metropolitan Museum of Art in 1996, with her namesake Lady Dior bag, it was described as "the greatest publicity coup in fashion history."[110]

Just a month after the young, flamboyant creative director debuted his first runway show with the esteemed French fashion house, the press could barely contain themselves when reporting on this extraordinarily risqué look. The general consensus was that the dress's bias cut and delicate lace straps didn't suit Diana's figure. My thoughts? What better way to express your sexuality, embrace your femininity, and enrage your ex-husband than stepping out in a midnight-blue negligée.

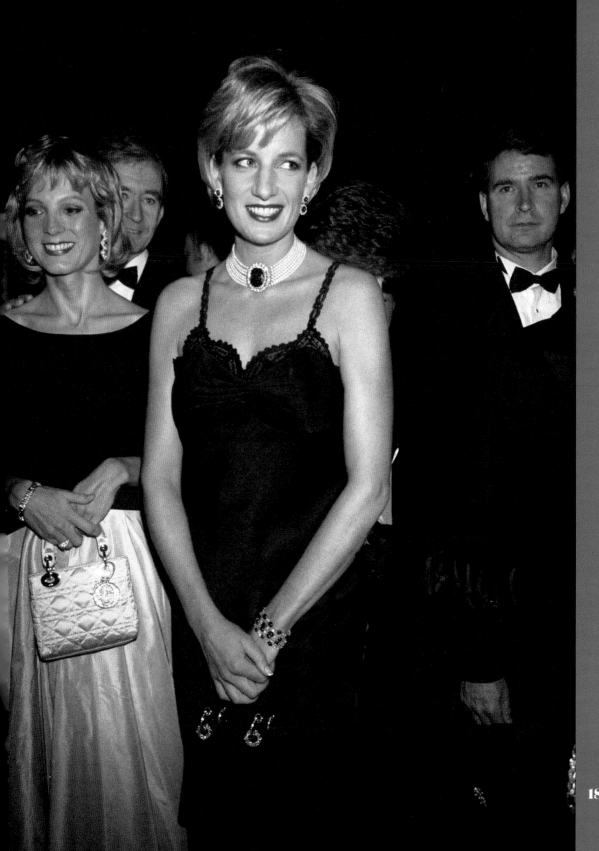

THE ATHLEISURE REVENGE LOOK

"I like it as normal as possible. Walking along the pavement gives me a tremendous thrill.""

can confidently credit Lady Di for being the first to make athleisure wear *a thing.* She was unquestionably the first major figure to mix a casual sportswear wardrobe with what I like to call "fuck-off" handbags—a Gucci Bamboo suede tote, a Tod's *D* leather shoulder bag, and a one-of-a-kind Versace crocodile bag were among her favorites— her pieces of very expensive armor. (Later, after Lady Diana's death, the Versace brand reproduced the Princess's exclusive handbag and named it the "Diana," in honor of the late princess and dear friend of Gianni Versace who was killed the same summer—1997 was a rough year).

Although some of Diana's famous workout outfits have become somewhat of a style phenomenon over the past few years, the Princess purposefully recycled her gym outfits over and over, in the hopes that the press couldn't get any new photographs of her, leaving her to work out in peace. She couldn't understand the fascination or frenzy behind her engaging in such an ordinary thing. Yet, to the press, it was a sensation. Here was a member of the royal family stepping out amongst commoners showing off a lot more than just her calves and ankles. It was simply unheard of at the time for any British princess to be caught in workout gear other than the usual equestrian togs, not to mention in Polo Ralph Lauren sweatshirts emblazoned with giant "USA" logos—signifying her ties to foreign allegiances, plus her adoption of a new ambassadorial role. Perhaps she also looked to the US, a place where hard work rewards all your wildest dreams (supposedly), as a symbol of somewhere she aspired to be—a place of liberty and freedom to say, do, and wear what one pleases.

Multiple days a week, the Princess, a self-titled "frustrated dancer," exercised at the Sloane-friendly Chelsea Harbour Club with her personal trainer, Jenni Rivett, who began working with Diana in 1990. Eventually, Jenni introduced her to Earl's Court Gym because it was "a serious gym, without a social purpose," which is what Diana found refreshing—no velvet hairbands there. The place was known for its queer clientele, and the gym's owner, entrepreneur Jeremy Norman, said he believed Diana wanted to work out there because she "really liked gay guys." He said, "She really felt at ease with gay men, she could relate to them and she didn't feel threatened by them in any way."[112] Her social circle of Gianni Versace, Elton John, and Wham! singer George Michael certainly backs this theory up.

When Diana, who was known for her uncontainable energy, wasn't in the gym, you could find her rollerblading through Kensington Gardens with her trainer. "We were known to ignore some of the 'no rollerblading' notices," said Jenni. "Once, a police car spotted us, slowed down, and then realising who it was, glided away."[113]

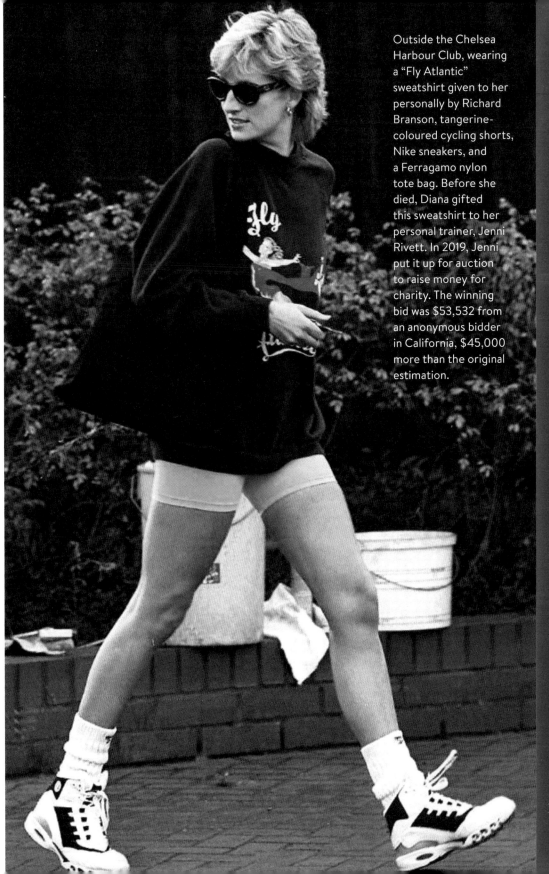

Outside the Chelsea Harbour Club, wearing a "Fly Atlantic" sweatshirt given to her personally by Richard Branson, tangerine-coloured cycling shorts, Nike sneakers, and a Ferragamo nylon tote bag. Before she died, Diana gifted this sweatshirt to her personal trainer, Jenni Rivett. In 2019, Jenni put it up for auction to raise money for charity. The winning bid was $53,532 from an anonymous bidder in California, $45,000 more than the original estimation.

191

Thanks to a healthy diet (apparently she was into juicing!) and exercise routines from popular nineties step aerobics workouts (Mr. Motivator, anyone?) to power walking through the royal gardens, by 1994, just in time for her Serpentine appearance, she had physically peaked. She was fit, strong, and growing more confident by the minute.

"I just encouraged her with healthy eating and I honestly believe the exercise helped her manage her bulimia," Jenni explained to the *Daily Mail*. "I believe as her body became fit, strong and healthy, she felt empowered and ready to face those bad times head-on."[114] In Diana's 1995 *Panorama* interview with Martin Bashir, she insisted, "I'm free of it (bulimia) now." Although we will never know for certain if Princess Diana had conquered her battle with the disease, she appears visibly healthier than in the photos of her looking gaunt and frail from just six years before.

While Camilla was tucking into the Princess's sloppy seconds (I of course mean Charles, not those garlicky chicken Kievs—although I'm sure she was enjoying those too!), Diana was working on her revenge body, hitting the gym in sweatshirts by London-based athleisure label Sloppy Joe Essential Clothing, founded in 1993 by athletics designer Jackie Harris. Fresh out of a divorce herself, Harris decided to open a shop and start making her own sportswear, with the name inspired by her father's favorite, oversized sweatshirt, which her mother used to call his "Sloppy Joe."

Harris told me about the morning Diana was first pictured wearing her sweatshirt: "My phone was ringing off the hook with my mates saying, 'Have you seen the front page? Diana's in your shirt.'" On the front page, accompanied with a headline about the Princess's latest dalliance with the rugby player Will Carling, was a shot of Diana wearing a Sloppy Joe, her cycling shorts indiscernible. She paired this sporty sweatshirt with a pair of Nike Air sneakers, a Versace crocodile bag, and the Italian label's iconic metal-rim sunglasses. It was a timeless blend of low- and high-end fashion, which symbolically matched her status as a regular and relatable citizen but still a Princess with a lifestyle entirely unattainable to most.

In the past few years, Harris's small independent brand has seen the "Diana effect" come full circle, with a whole new generation preordering the brand's namesake sweatshirts, wanting to get an authentic piece of the Diana look. Fans of the brand are often delighted to see that the sweatshirts are still made exactly the same way as they were when Diana first wore them in 1996.

The following looks are my selection of some of her best exercise outfits. As I did my research (cue Carrie Bradshaw voice), I couldn't help but wonder . . . was Diana the British, nineties answer to American workout sensation Jane Fonda?

HOW TO GET THE ATHLEISURE REVENGE LOOK

- A large "fuck-off" handbag (preferably by an Italian designer and crafted from an exotic leather)

- A Sloppy Joe or Polo Ralph Lauren oversized sweatshirt

- Cycling shorts

- Designer sunglasses (vintage Versace or Moschino are bang on the money)

- A pair of nineties Nike Air or Reebok Aerostep sneakers and white socks (always glistening white and brand-new)

- A sturdy Prince Extender tennis racket, for the next time you hit the courts to play a game of "Pretend the ball is your ex"

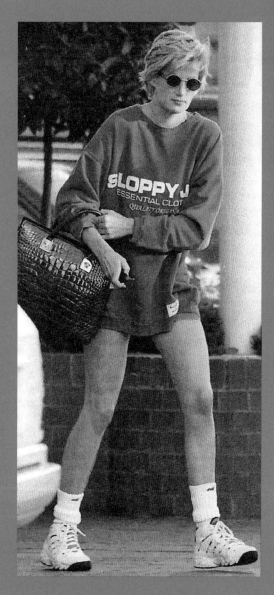

Diana in a Sloppy Joe sweatshirt. The brand still makes this exact style today. I like to think of Diana rolling up to the palace in this look to pick up the kids. On her arm is a Versace crocodile-skin bag decorated with two of the brand's signature Medusa-head medallions—a symbolic emblem. Diana's sunglasses shield her from the waiting paparazzi. Perhaps she wished they'd look her in the eyes so she could turn them all into stone.

THE COLLEGIATE REVENGE LOOKS

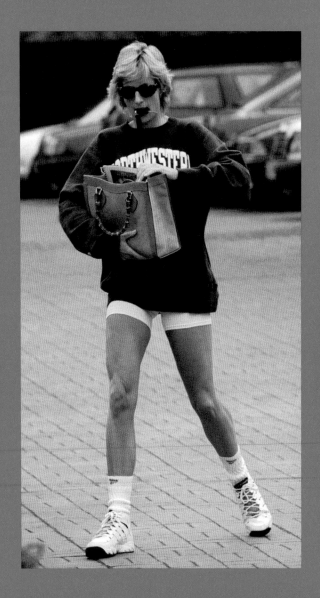

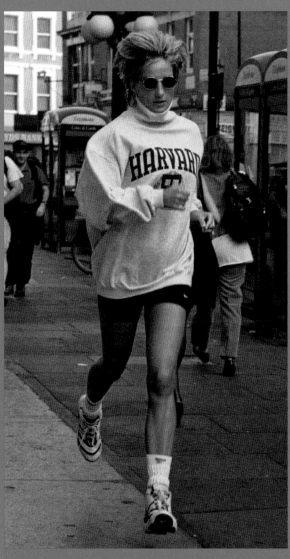

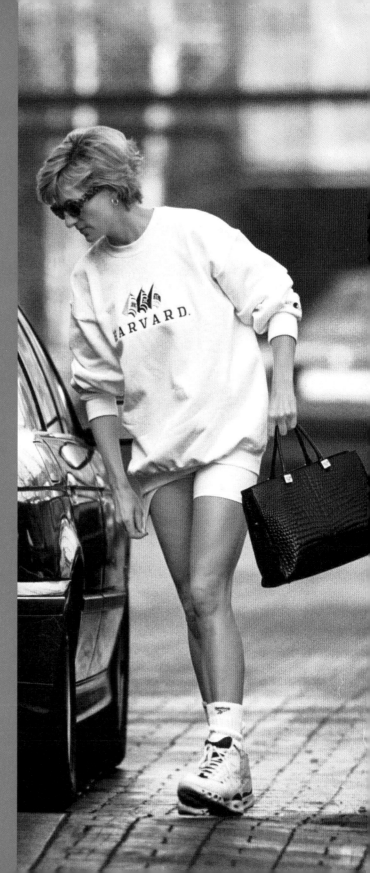

(Left to Right)

Diana wore a Northwestern University sweatshirt to the gym in 1996—coincidentally, or somewhat forebodingly, the alma mater of Meghan Markle, Diana's future daughter-in-law, who attended the school between 1999 and 2003. (Diana always believed she was a little psychic.) She paired it with brave white cycling shorts (everyone knows that white Lycra is not exactly the easiest fabric to pull off) and accessorized with her staple Gucci Bamboo suede bag and classic nineties Nike sneakers. Her car keys clenched between her teeth signified she was on the move—"Get out of my way!"

AUGUST 1997: Princess Diana was photographed dashing from the gym to her car, wearing a Harvard University mock neck sweatshirt, Versace sunglasses, Nike cycling shorts, and sneakers. "They are the least designed, the cheapest, the humblest clothes in everyone's closet," wrote Joan Juliet Buck about Diana's Harvard sweatshirts. "These are what she chose to wear to get on with it."[115]

Wearing another Harvard sweatshirt from her extensive collegiate collection. She accessorized with a crocodile-embossed handbag from Versace, Reebok socks, and her favorite Nike footwear. "Exercise gives you endorphins. Endorphins make you happy. Happy people just don't shoot their husbands, they just don't," said Harvard law student Elle Woods, played by Reese Witherspoon, in the revenge-movie classic *Legally Blonde.*

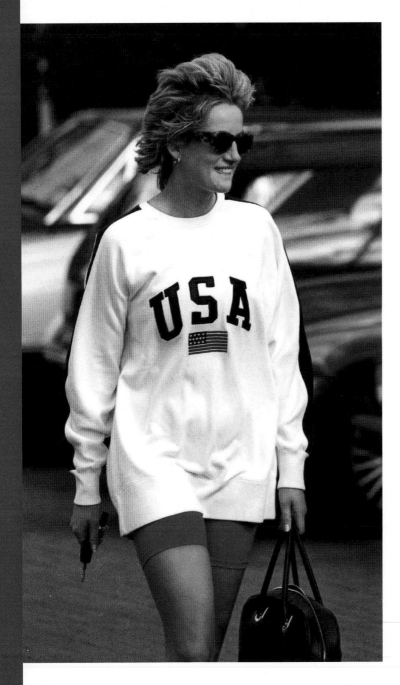

A declaration of independence! Wearing a Polo Ralph Lauren oversized sweatshirt, hot pink cycling shorts, and a pair of tortoiseshell sunglasses on her way to the gym. Name a better gym outfit. You can't? Me neither . . . except maybe the Virgin Atlantic sweatshirt look, or Harvard. Don't make me choose.

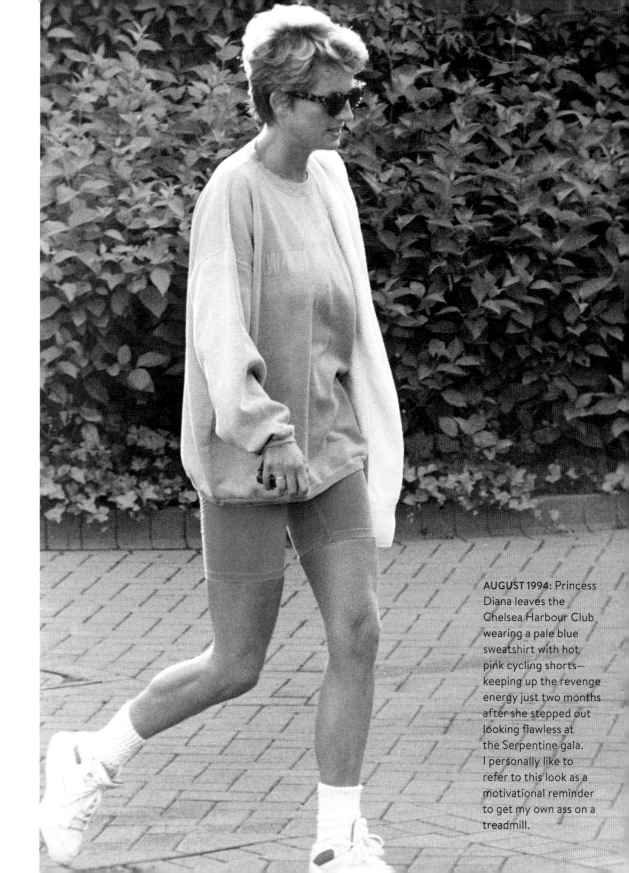

AUGUST 1994: Princess Diana leaves the Chelsea Harbour Club wearing a pale blue sweatshirt with hot pink cycling shorts— keeping up the revenge energy just two months after she stepped out looking flawless at the Serpentine gala. I personally like to refer to this look as a motivational reminder to get my own ass on a treadmill.

(Left to Right)

Wearing a cerise-coloured cable-knit cardigan with a pleated tennis skirt, Diana is seen here playing a jolly good game of "Pretend the ball is your ex," at Chelsea Harbour Club in 1993, one year after her unofficial split from Prince Charles. I've taken up this game recently, and I can't recommend it enough—very therapeutic. On a separate 1993 trip to Majorca, the Princess was seen shielding herself from photographers with a squash racket, with a logo that read "Prince Extender," in large capital letters across its cover. Coincidence? I think not.

Lady Liberty, leaving Chelsea Harbour Club wearing a stars-and-stripes sweatshirt and Reebok sneakers and carrying a tote by Paloma Picasso, a Spanish and French accessories designer and daughter of none other than Pablo Picasso himself.

This is one of my all-time favorites. No, really, this time. In 1996, the year Diana got divorced from Prince Charles, she wore this scarlet tailored coat (she'd worn it before to many royal engagements) over a cream oversized sweatshirt and ultra-short cycling shorts. She accessorized with an ivory cashmere scarf, Nike sneakers, and a C.E.P. (short for Chief Executive Princess, if you didn't know) black leather tote.

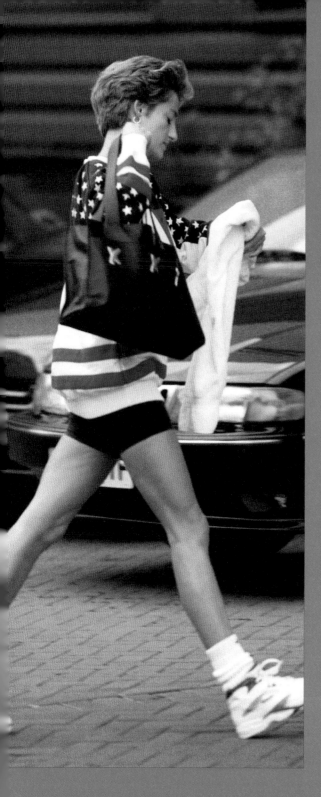
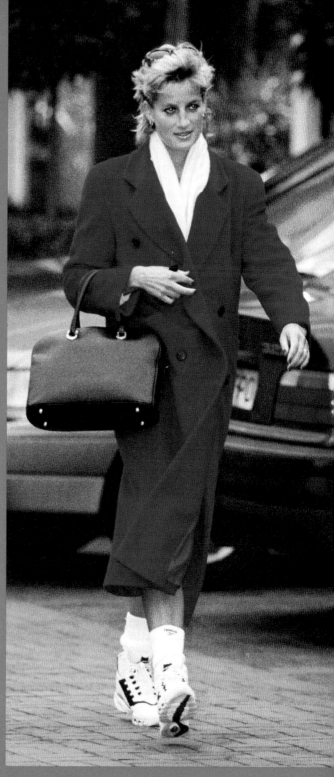

THE CHIEF EXECUTIVE PRINCESS REVENGE LOOK

"People think that at the end of the day a man is the only answer; actually, a fulfilling job is better for me." [116]

hief Executive Princess is what I've dubbed Diana's nineties' business wardrobe of pinstripe power suits, pastel Versace skirt suits, and flawlessly tailored shift dresses. "A convincing party line has emerged," wrote Anthony Holden in *Vanity Fair*. "Diana is much brighter than people have yet had the chance to realize.[117] Yes, she is highly manipulative, with more than her share of feminine wiles, but she is neither the dumb blonde, nor the tempermental hysteric painted by her foes (Charles's much-quoted friends.)"

In 1992, the year Andrew Morton's bombshell book *Diana: Her True Story* was published, Diana and Prince Charles were living very separate lives in private, while being forced to play happy families on behalf of the Queen in public. On their final tour as a couple in South Korea, the estranged couple couldn't bear to look at one another. The War of the Waleses had begun.

Diana was dealing with the uproar after Morton's biography was published and had taken blow after blow of hit pieces in the press, orchestrated by Team Charles. That same summer, a private, risqué conversation was leaked between the Princess and her old friend, British gin heir James Gilbey. In what became known as the "Squidgygate" tapes (Gilbey called Diana "Squidgy," a cringe-worthy grand total of fourteen times), the Princess complained about an uncomfortable lunch she'd had at the Palace that day, saying, *"Bloody hell, after all I've done for this fucking family."*[118] In between the idle gossip and whispers of sweet, silly nothings, Gilbey asked what she'd been wearing that day: "And what on your feet?" To which Diana replied that she'd been wearing some flat black pumps. "Very chic," he said. He also referenced a photo he'd come across of Diana in *The Express*, enthusiastically pointing out that she had been wearing "that excellent pink top" he liked. When Diana recognized the photo he was describing, Gilbey said, "Very good. Shit-hot actually." The Princess burst out laughing. "Shit-hot?" she said. Without a single beat, Gilbey, a love-sick puppy dog, responded, "Shit-hot."

The Princess's popularity momentarily took a hit—after reports of her desperate unhappiness in the press, people regretted the sympathy they'd lent her. That was, until a few weeks later, when tapes between "Fred" and "Gladys" were leaked to the press. Charles said, among other X-rated things, that he wanted to be where Camilla's tampon was (*bleurgh*, yuck).

In Squidgygate versus Tampongate, Diana and Gilbey—a starry-eyed

Romeo and Juliet—were clearly the much lesser evil. Diana was back on top, and, in December of 1992 (the final month of the Queen's annus horribilis), the warring Waleses finally announced their separation to the world.

Diana's first order of business was the re-jujuing of Kensington Palace after Charles moved out. "Her first decision was to throw out the mahogany double bed she had slept in at Kensington Palace since her wedding eleven years before. Then she had the bedroom painted and new locks fitted, and changed her private telephone number. Her new life alone had begun,"[119] wrote Morton. Then she went ahead and did what many of us wish we could do with our ex's belongings: she ordered them to be burned in a bonfire at Highgrove. Many collective gifts from the estranged couple's married years were reduced to a pile of ashes.

"There is a new bounce in her step, a cheekier smile on her face, a new gleam in those flirtatious eyes,"[120] wrote Anthony Holden for his 1993 *Vanity Fair* article, "Diana's Revenge." Indeed, from this moment, something shifted in Diana. The conservative dresses from her formal duties were replaced with professional trouser suits, while shoulder bags that hung from delicate gold chains were swapped for masculine briefcases and

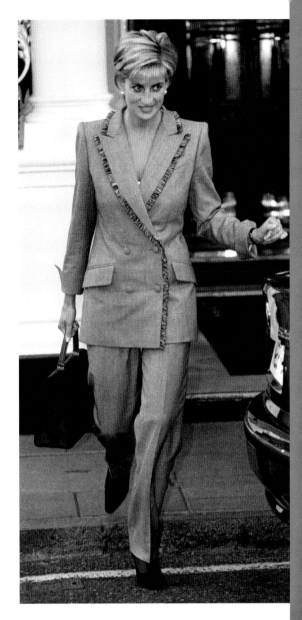

Diana wore this John Galliano for Dior fringe lapel suit featuring a Prince of Wales check in March 1997—perhaps her attitude was "because I can do what I want." Galliano told British journalist Suzy Menkes that he believed Diana used her clothes as a language, "the way a movie star in the silent films did."[121]

leather tote bags. Sam McKnight, who was introduced to the Princess on a shoot with the photographer Patrick Demarchelier, was responsible for her modern new hairdo. "She wanted independence, and to appear strong—the hair cutting was part of this. I think in some way, she didn't want to hide behind her hair or her heavy fringe anymore"[122] he said. It was Coco Chanel who once famously declared, "A woman who cuts her hair is about to change her life," and indeed, by Diana's saying goodbye to her trademark feathered cut, she welcomed in a new, serious era. Sam McKnight was her hairdresser for seven years and said the only time they argued "was when she would get a sneaky perm done" while he was away. "She thought it was easier to manage," he said.

It was an executive-style new look for a woman walking down a brave new path—the trophy wife clotheshorse had transformed into a determined workhorse: "As if emerging from a golden chrysalis, the decorative bubblehead has metamorphosed into a dynamic, concerned, contemporary career woman, eager to use her drawing power to make the world a better place."[123]

The stripping back of 1980s excess and the arrival of 1990s minimalism worked perfectly for Diana's new chapter. When she bared her soul to Martin Bashir in 1995, she wore a simple black skirt suit, layered over a plain white T-shirt, with not a single frilly distraction in sight. Her makeup was minimal, except for a telling layer of kohl eyeliner—her warpaint. It was an interview that covered all bases, and for the first time, the public got to hear Diana's side of the story. She spoke of her battle with bulimia and cripplingly low self-esteem, Charles and Camilla's affair ("there were three of us in this marriage, so it was a bit crowded," she infamously said), and her goals to become an ambassador for the nation. She sensationally undermined her ex-husband by sharing her doubts that he'd be up to the role of king. "The top job, as I call it, would bring enormous limitations to him, and I don't know whether he could adapt to that," she said. Perhaps a veiled response to an event from 1989, where a reporter had asked Diana what she'd be doing on a working tour (she was at this point immersed in the work of hundreds of charities). Charles interrupted and snidely remarked, "Shopping, isn't it, darling?"[124]

Martin Bashir ended the interview by suggesting, "Some people might interpret this as you simply taking the opportunity to get your own back on your husband." Like any good CEO, the Princess barely blinked and diplomatically responded, "I sit here with hope because there's a future ahead, a future for my husband, a future for myself and a future for the monarchy." In other words, she didn't intend on going anywhere, and if the Palace wanted peace, then they would have to agree to bow down and coexist with the queen of people's hearts.

HOW TO GET THE CHIEF EXECUTIVE PRINCESS REVENGE LOOK

- A briefcase (no need to put anything in it; it's simply a tool for intimidation)

- Trouser suit

- Skirt suit (skirt should be three inches above the knee)

- Opaque tights for the winter (60 Denier is chic)

- Ballet flats or Chanel two-tone court shoes for the summer

- A fuck-off handbag (Versace croc, Gucci Bamboo, or a Lady Dior are all very acceptable choices)

- A revenge whip, convertibles preferred (no Hondas, Toyotas, or Nissans—sexy cars only)

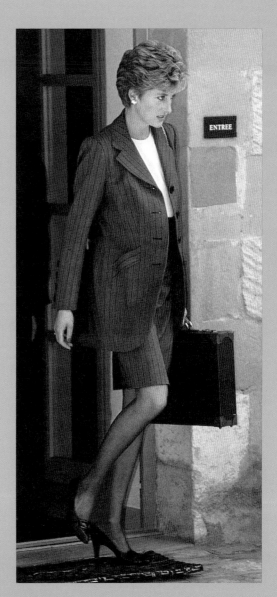

In 1994, a few months before she stepped out at the Serpentine gala, Diana wore this executive-gray pinstripe suit by Catherine Walker, with a briefcase by Tanner Krolle. "She was desperate to get a more serious image and Catherine Walker was indispensable in helping her forge one. She always felt more comfortable in tailored clothes,"[125] explained Anna Harvey, Diana's style advisor.

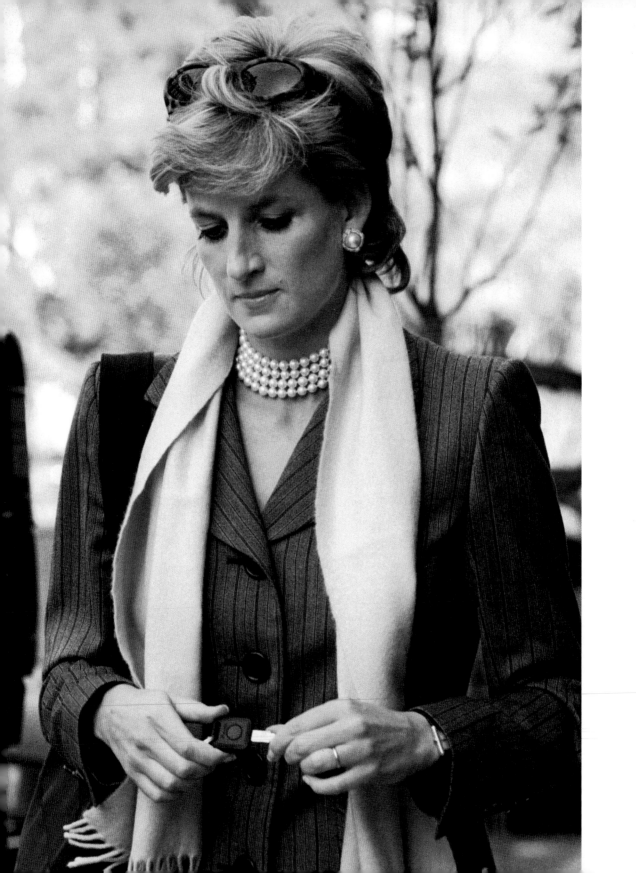

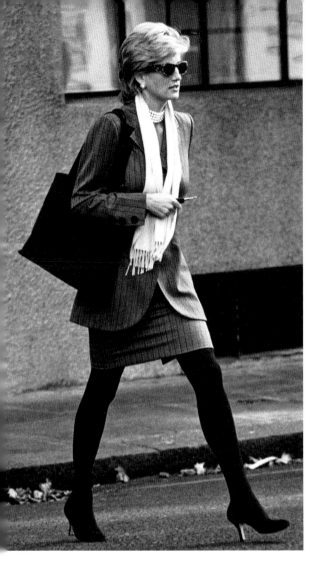

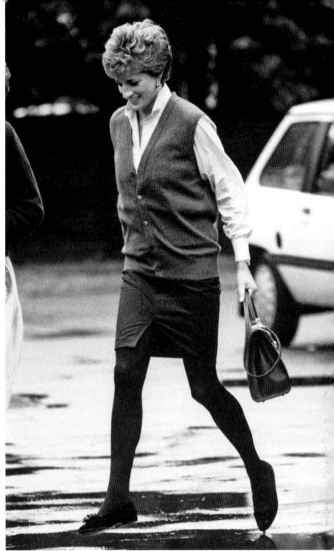

(Opposite and Above)

Like most working women, Diana recycled her business suits frequently. This time she paired her Catherine Walker suit with a sensible Ferragamo tote bag, perfect for those exhausting commutes from the palace to the office! In true princess fashion, she accessorized with large pearl clip-ons and a multistrand necklace. "I couldn't get her out of big jewelry,"[126] said Anna Harvey. Notably missing is any sort of shirt collar (or shirt for that matter)—her bare décolletage is even more stark against her ultra-matte black tights. Not only was Diana embracing the updated working fashions of the nineties, but she was rebelling against the monster collars of her past.

(Above, Right)

The nine-to-five revenge look. This is the kind of look you wear when you're whining by the water cooler about train delays.

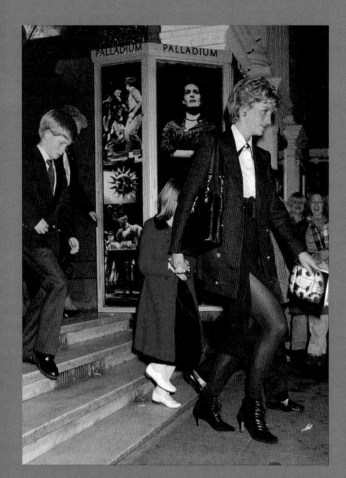

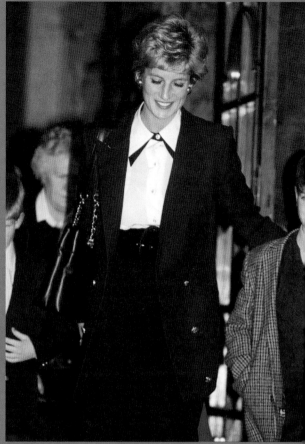

(Above)

Androgyny comes back to play with a mean, nineties vengeance—Diana wore this gender-ambiguous look to the West End premiere of *Oliver!* Her skirt, with its revealing slit, was described as a faux pas by the *Daily Mail*: "[She was] showing more than she intended," they said. Her bondage-style, suede, lace-up boots make it clear she was flashing exactly as much leg as she wanted to.

(Opposite)

Diana showed us she was the queen of business casual with a Ralph Lauren classic pink shirt, pea coat, skinny jeans, and brown suede boots with an elegant French heel. This outfit's crowning glory? The Versace crocodile "fuck-off" handbag, followed by the car keys for the woman eternally on the move and now in the driver's seat.

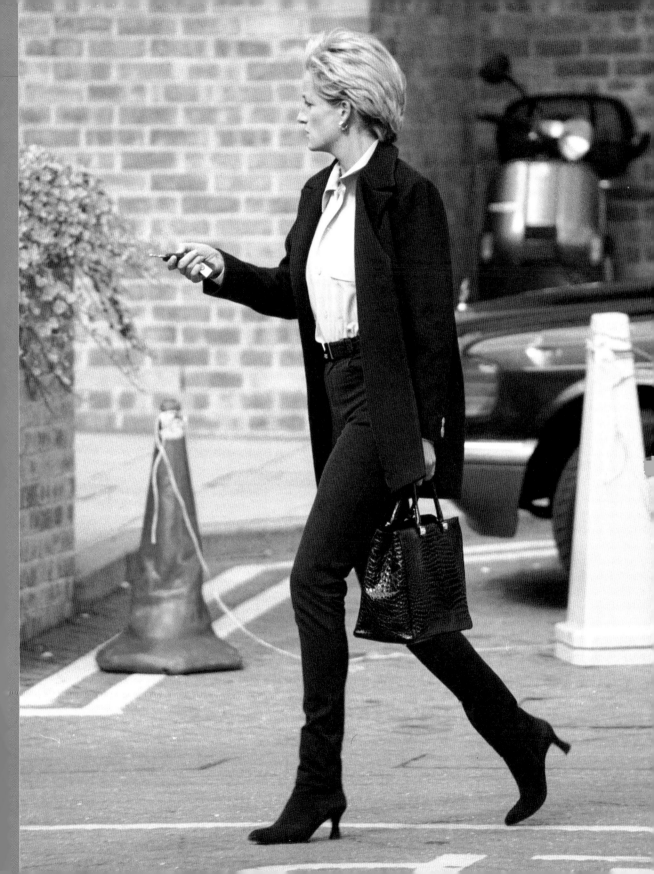

Tailoring on tailoring on tailoring.

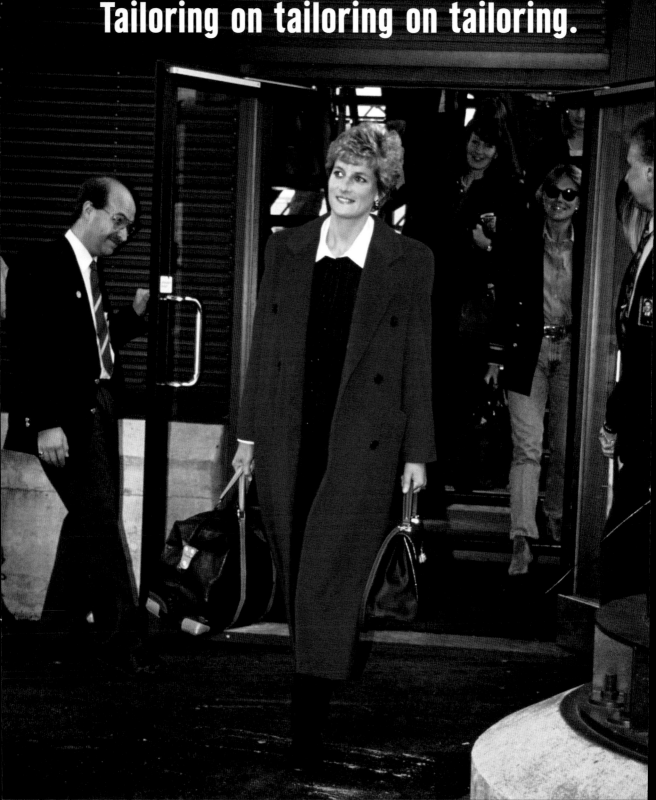

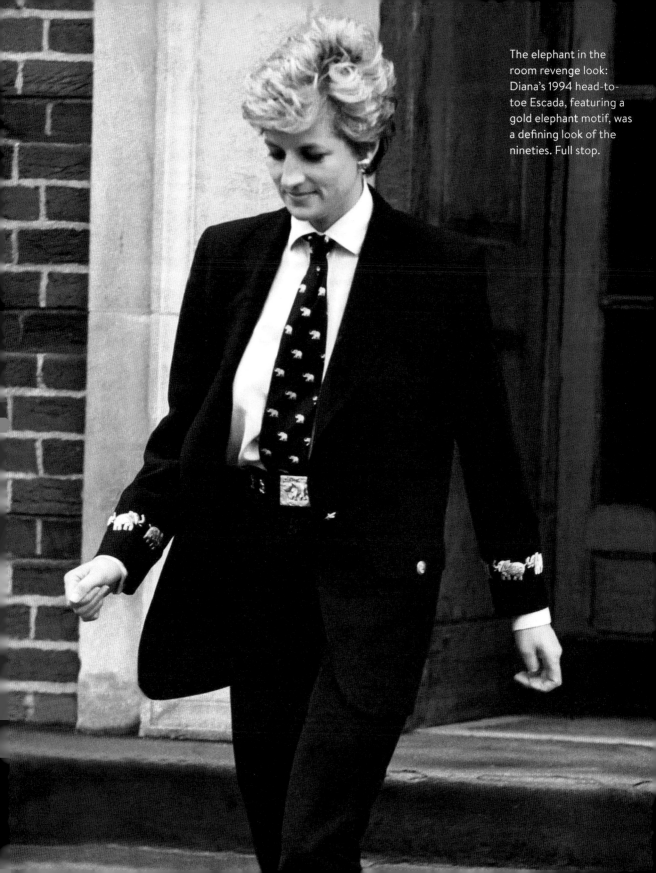

The elephant in the room revenge look: Diana's 1994 head-to-toe Escada, featuring a gold elephant motif, was a defining look of the nineties. Full stop.

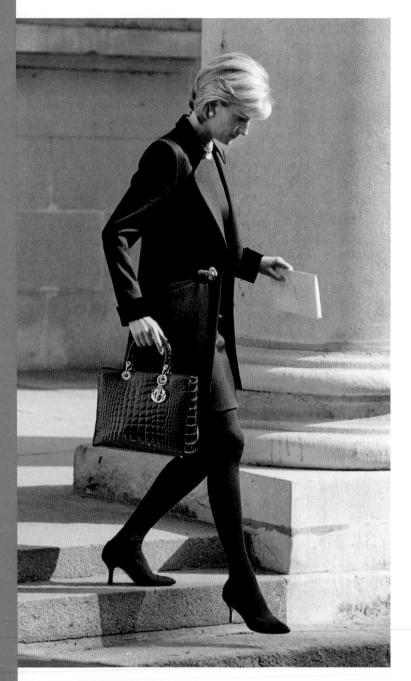

(*Left*)

Diana wore black—this time, appropriately, for mourning—to the memorial service of British fashion photographer and her official royal portraitist, Terence Donovan. She clutched a crocodile version of the Lady Dior bag—named, naturally, after the Princess herself.

(*Opposite*)

Chic, sleek, and in control: Diana wore a figure-hugging dotted shift dress with ballet flats on a trip to Hong Kong in 1995.

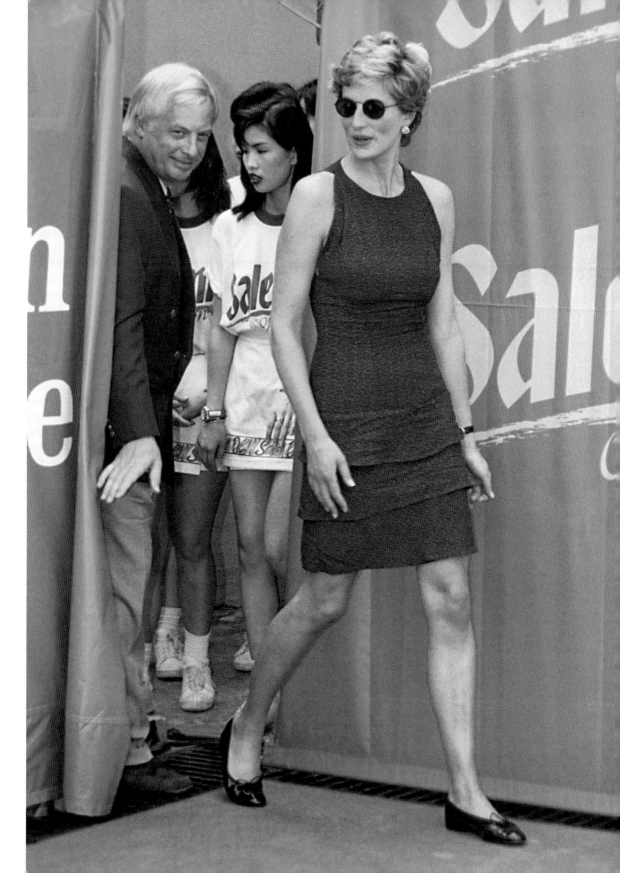

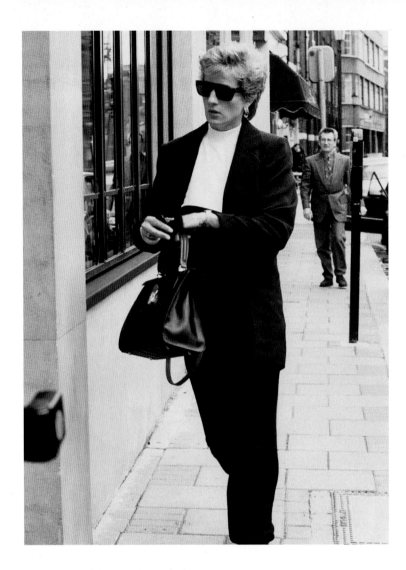

THE WORKING GIRL REVENGE LOOK: Diana adopted a business-casual look even for her lunch dates. Her go-to lunch spots were San Lorenzo in Knightsbridge and Le Caprice near St. James's Park. Another of her haunts was a small cafe in Notting Hill, named Café Diana, where she'd pop in for a coffee after dropping her boys to school. Ken Wharfe, her bodyguard, remembered that she liked it there because she was mostly undisturbed.

"She won't go quietly, that's the problem. I'll fight to the end, because I believe that I have a role to fulfill, and I've got two children to bring up."[127]

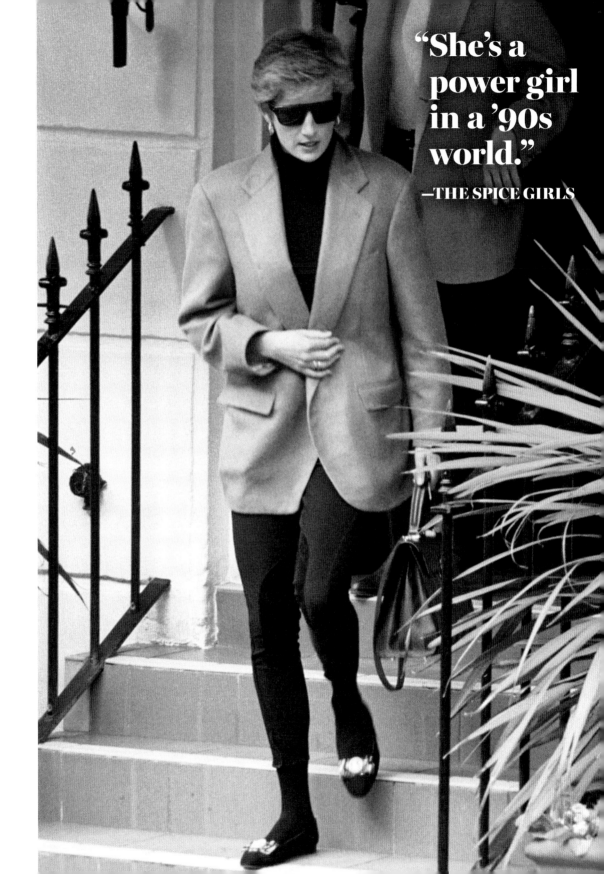

"She's a power girl in a '90s world."

—THE SPICE GIRLS

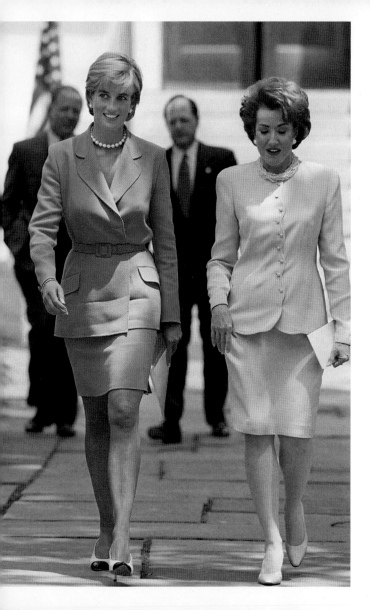

When worlds collide: Diana took on DC with head of the Red Cross, Elizabeth Dole (whose outfit seemed to be strategically coordinated with Diana's revenge look), to campaign against the use of landmines. She wore a lilac belted Versace suit with timeless Chanel court shoes, plus a string of pearls, à la women in Washington.

"I'll fight to the end, because I believe that I have a role to fulfill."[128]

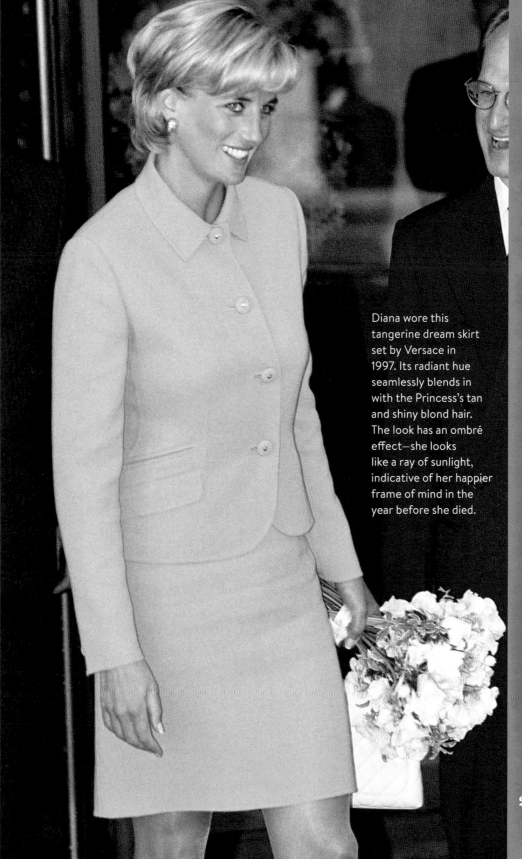

Diana wore this tangerine dream skirt set by Versace in 1997. Its radiant hue seamlessly blends in with the Princess's tan and shiny blond hair. The look has an ombré effect—she looks like a ray of sunlight, indicative of her happier frame of mind in the year before she died.

THE LITTLE WHITE SUITS

"Fear is always with us but we just don't have time for it."

—HILLARY CLINTON

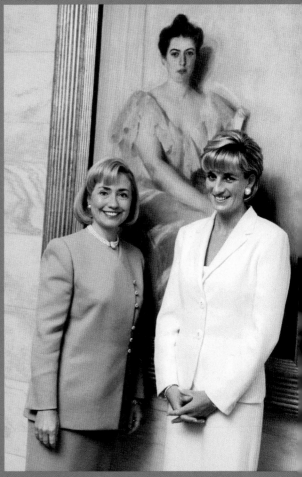

WHITE: a color of political resistance, suffrage, and solidarity. Like all political women, Diana often made a statement in a white suit, cut two and a half inches above the knee, just because she could.

(Above)

Nasty women: Hillary Clinton and Princess Diana at the White House in 1987.

Say it loud in a Versace cocoon coat and a Lady Dior bag.

In 1993, officially separated from Prince Charles, Diana attended a royal event at Windsor in a glorious pink skirt suit by Catherine Walker, with a Salvatore Ferragamo clutch.

(Far Right)

Although Diana was known to rebel against the royal dress code in Britain, on her trips abroad, especially to religious countries, she wore modest clothing with conservative necklines and longer hemlines. On a solo visit to Nepal in 1993, she wore a polka-dot pleated dress by Paul Costelloe, with a coordinating pink blazer.

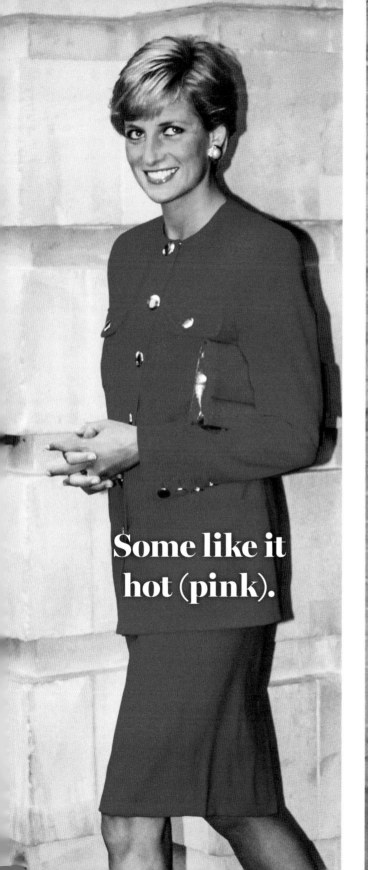

Some like it hot (pink).

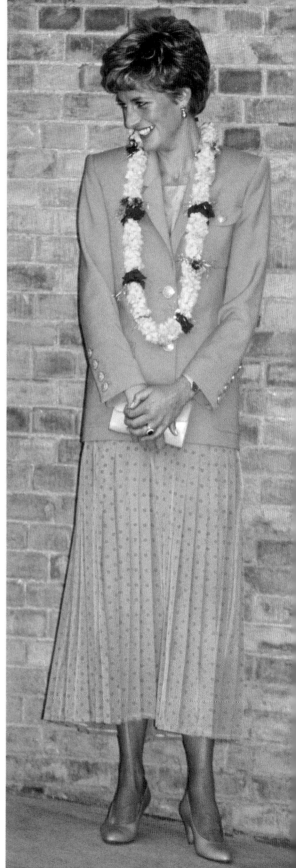

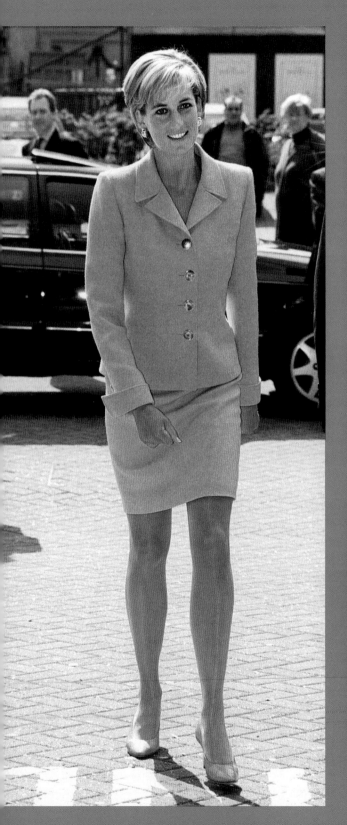
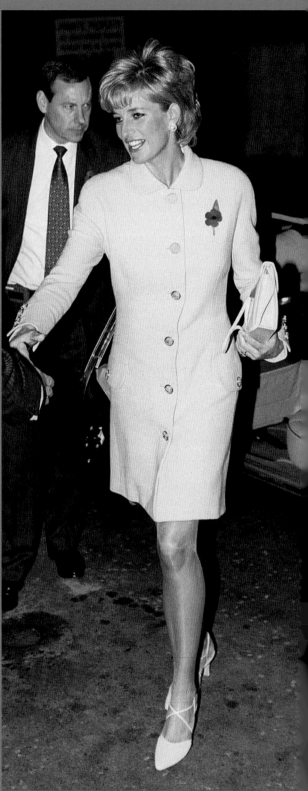

(Opposite, Left)

When you don't have anything nice to say, say it in a baby-blue skirt suit with buttons that resemble large, shiny gold bullets. Lady Di wore this buttery outfit by British designer Amanda Wakeley to the Royal Brompton Hospital in 1997—the hospital her on-again, off-again boyfriend Hasnat Khan had worked at just the year before.

(Opposite, Right)

For an effortless revenge look, wear a duck-egg-blue cardigan-style stress with satin point-toe shoes by Gina.

"She was rebelling against the monster collars of her past."

THE SHIFT DRESSES

(*Clockwise, from Right*)

LA DOLCE VITA REVENGE LOOK: On a trip to Rome in 1996, Diana wore a Versace shift dress with zipper pockets and carried a Gucci bamboo suede tote.

In Argentina, Diana wore a Catherine Walker shift with a Dior bag—the same accessory I mentioned earlier, gifted to her by Bernadette Chirac at the opening of a Cézanne exhibition in early 1995. Diana began to wear it everywhere, causing women across the world to run into Dior stores, asking for the "Lady Di." Soon afterward, Dior renamed the bag the "Lady Dior," in tribute to its ambassador.

In 1997, Diana threw away yet another constriction—her bra. Exposed nipples, a classic feminist statement, are perhaps top of the list when it comes to royal no-nos. It seems that the Princess was embracing a new bohemian sensibility (or was just an early advocate for the #freethenipple movement). She was, after all, leaving the Hale Clinic on London's Harley Street, where she'd been to see her energy healer—maybe her bra was disturbing her chi?

On a West London shopping trip in 1997, Diana wore a Catherine Walker shift dress with Gucci bamboo tote and simple ballet flats.

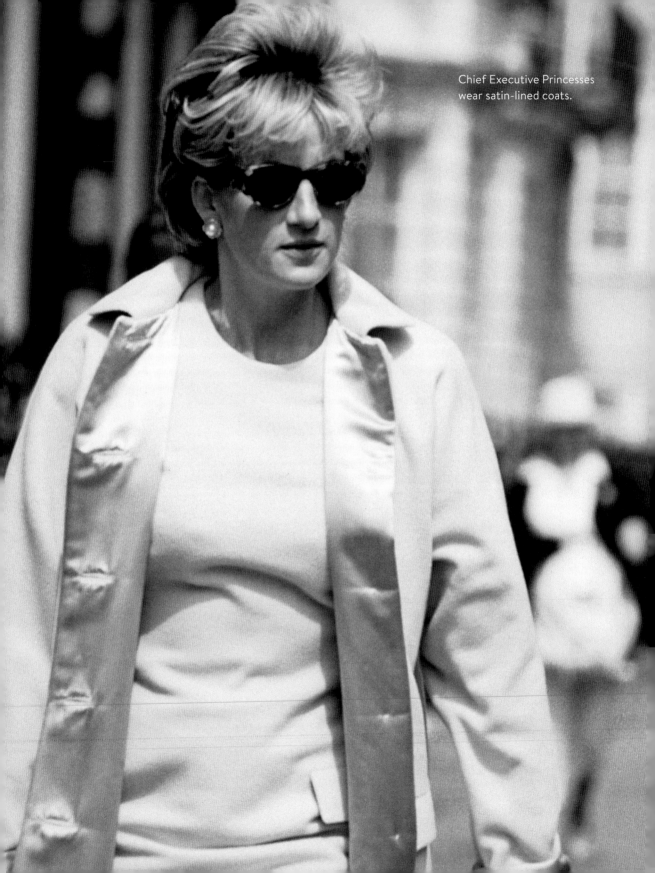

Chief Executive Princesses wear satin-lined coats.

"I've gone down deep, scraped the bottom a couple of times and come up again, and it's very nice meeting people now and talking about tai chi and people say: 'Tai chi—what do you know about tai chi?' And I say: 'An energy flow,' and all this and they look at me and say, 'She's the girl who's supposed to like shopping and clothes the whole time. She's not supposed to know about spiritual things.'"[129]

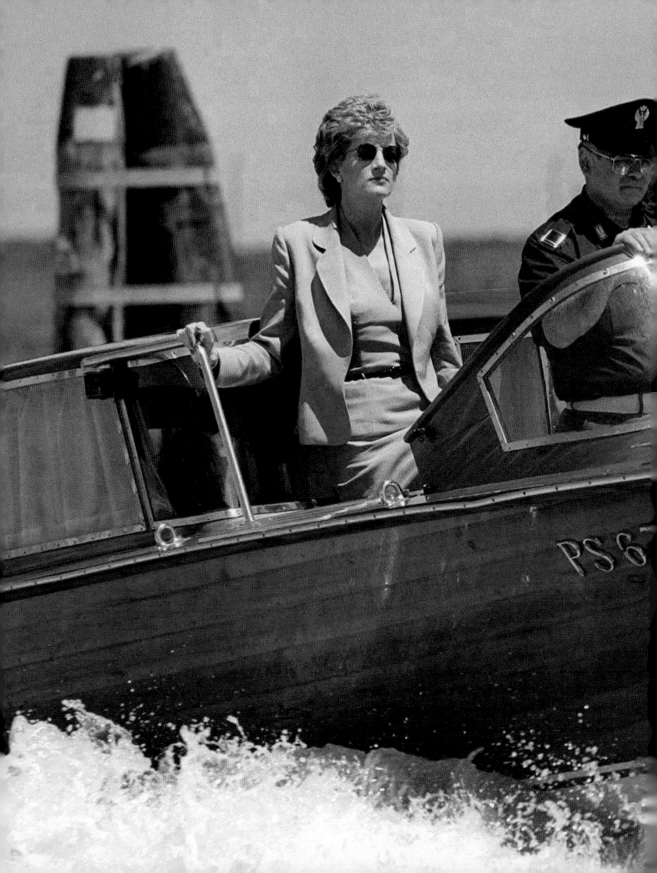

This should be the only mode of post-breakup transportation.

"The mantle of her friend Mother Teresa will do for starters. Then there's the First Lady dimension—more Jackie than Hillary, with the best of Barbara thrown in. Add a pinch of UNICEF, a la Audrey Hepburn, and you have a glamorous roving ambassador for British exports, British aid, British culture and British style."[130]

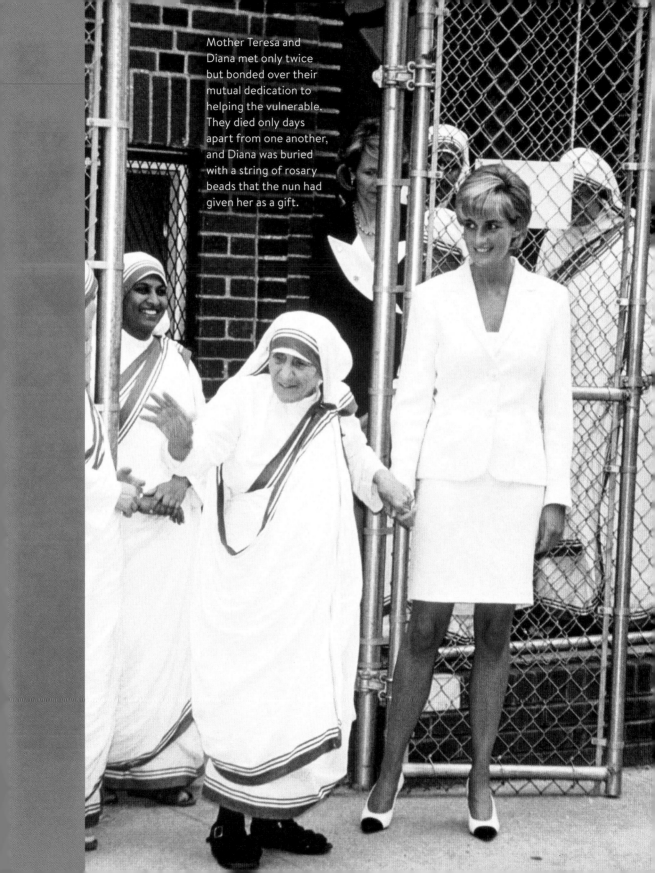

Mother Teresa and Diana met only twice but bonded over their mutual dedication to helping the vulnerable. They died only days apart from one another, and Diana was buried with a string of rosary beads that the nun had given her as a gift.

A NEW MEANING OF "CC"

Diana, the eternal uptown girl, wore head-to-toe Chanel on a trip to New York in 1997. (She once shied away from it because she found its iconic "CC" emblem too triggering.) Note the quilted bag with its "CC" turnlock held literally at arm's distance. Perhaps it was a "keep your friends close, keep your enemies closer" type of message—or maybe, she was just over it and no longer haunted by the world's most tasteful brand.

"Elegance is refusal."

—COCO CHANEL

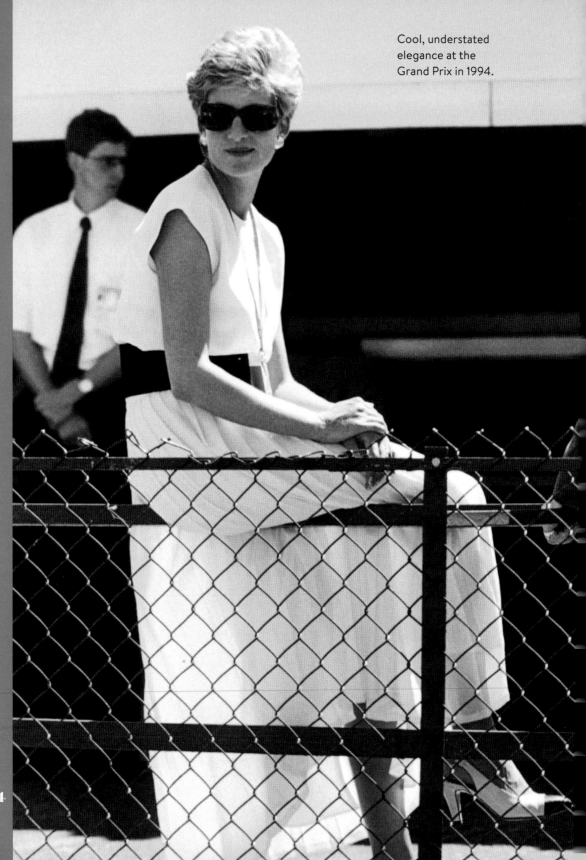

Cool, understated
elegance at the
Grand Prix in 1994.

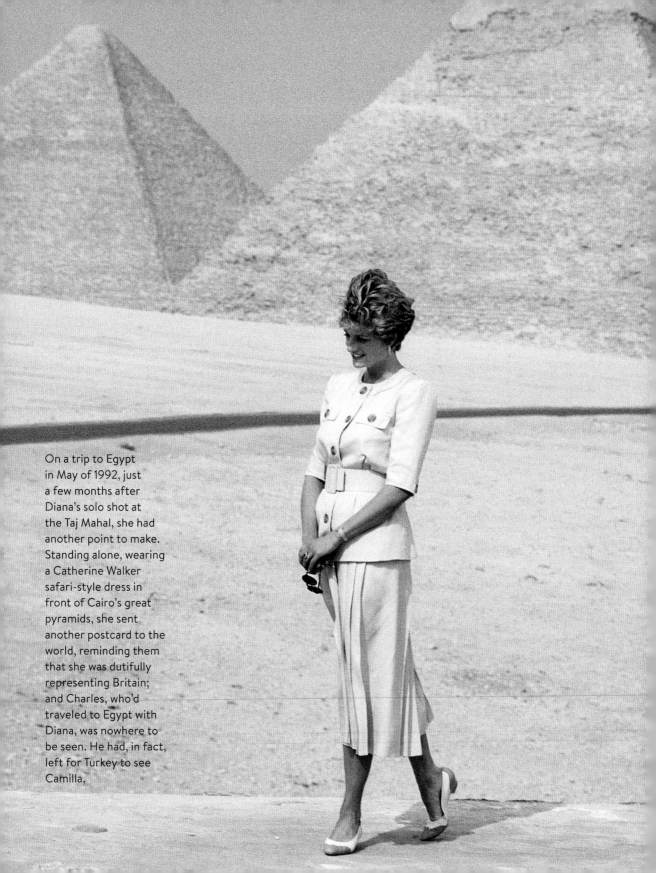

On a trip to Egypt in May of 1992, just a few months after Diana's solo shot at the Taj Mahal, she had another point to make. Standing alone, wearing a Catherine Walker safari-style dress in front of Cairo's great pyramids, she sent another postcard to the world, reminding them that she was dutifully representing Britain; and Charles, who'd traveled to Egypt with Diana, was nowhere to be seen. He had, in fact, left for Turkey to see Camilla.

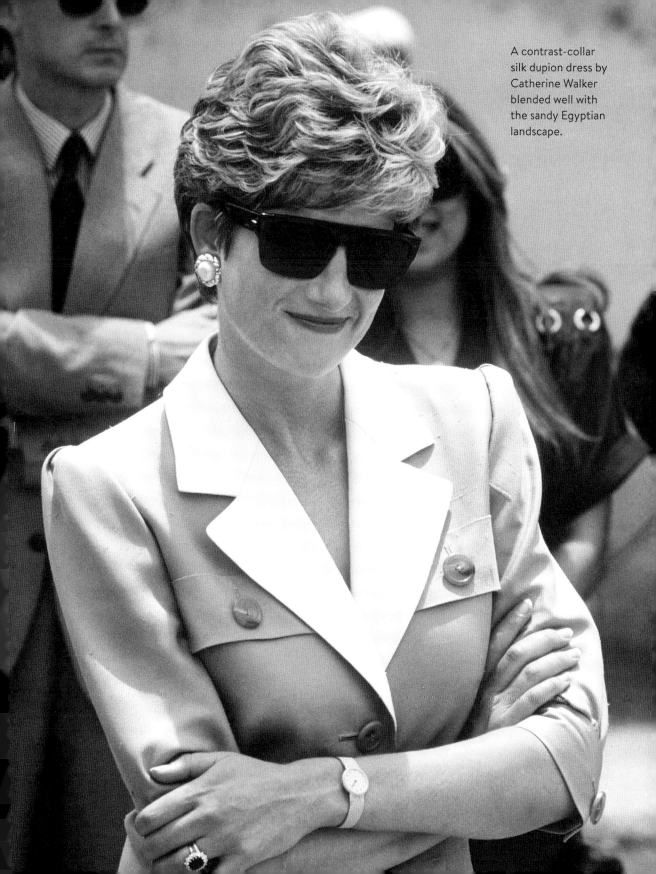

A contrast-collar silk dupion dress by Catherine Walker blended well with the sandy Egyptian landscape.

THE ALICE BANDS

Although Princess Diana wouldn't be caught dead in a velvet hairband (the name she once gave to her Sloaney peers in the eighties), on a couple of occasions, she paired a tan pantsuit with jersey Alice bands—the style complemented her chic, modern haircut by her longtime hairdresser Sam McKnight.

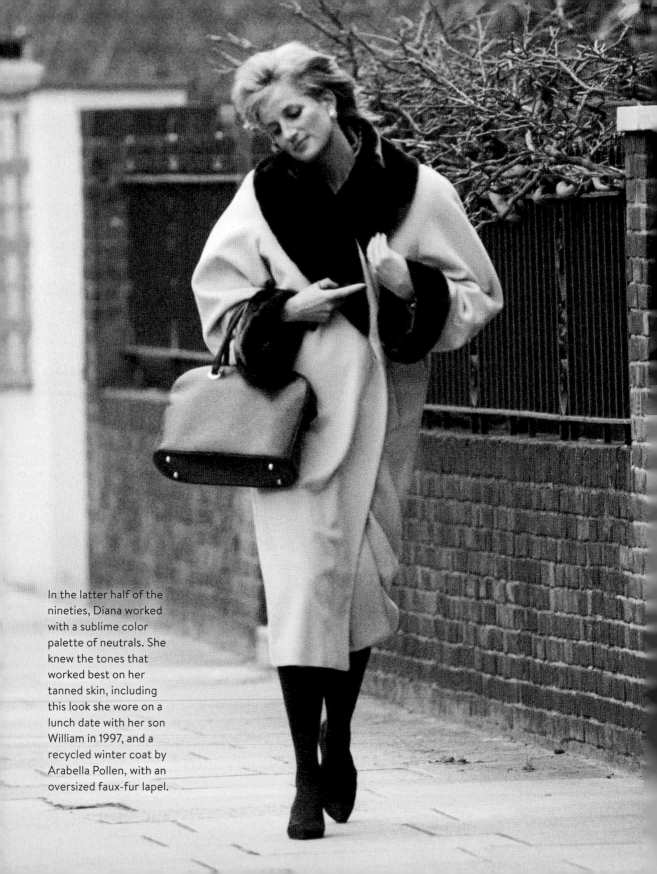

In the latter half of the nineties, Diana worked with a sublime color palette of neutrals. She knew the tones that worked best on her tanned skin, including this look she wore on a lunch date with her son William in 1997, and a recycled winter coat by Arabella Pollen, with an oversized faux-fur lapel.

PRINCESS ANNE REVENGE LOOKS

Here's why I like Princess Anne: the woman's got balls. Although a less-often-credited style star of the royal family, she had a revenge streak in her too. She's also a divorcée, which earns her cool points from me. Once a fan of sheep sweaters (sans the black sheep, you may notice) and bandanas, today you might find her with her trademark bouffant, wearing *Matrix*-style sunglasses and talking into her burner flip-phone.

She got Diana's vote of approval, too. "She's very independent, and she's gone her own way,"[131] she once said of her sister-in-law.

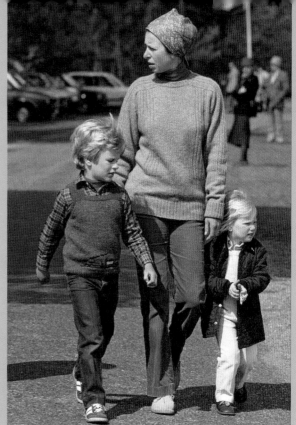
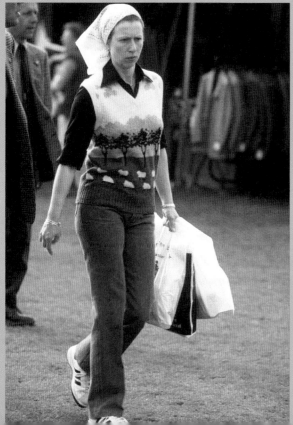

10

THE OFF-DUTY REVENGE LOOK

Revenge doesn't sleep, even when one is off duty. Although Diana was never truly off duty, and every look could be considered somewhat "public," she did adopt an expressive casual wardrobe for when she was going about her everyday business—from dropping princes William and Harry to school, to grabbing lunch at some of her favorite West London haunts. She zipped around London, taking black cabs or even the public bus whenever she could. Her bodyguard was always in tow.

In her prior life, Diana faced "slapped wrists" from the "men in grey" whenever she dared to step outside the boundaries of the royal dress code, and of course from a censorious press, who watched with beady eyes, waiting for her next royal slipup (you might remember the diaphanous skirt and leg-flashing episode from her nannying days, which of course made her all the more likeable and relatable).

According to Morton, "The smallest breach of royal behavior was deserving of a complaint."[132] In the nineties, however, Diana realized that keeping up with the Windsors was an impossible task and began to discover dressing for herself. Others' disapproval only served as motivation. "Whatever I wear, I'll be criticized, so let's go for it,"[133] she told the French designer Roland Klein when demanding he shorten the hem of her skirt.

Diana was enthralled by the supermodels of the nineties, although she knew that she would never be able to dress in the revealing way they did at and after work. Mario Testino taught her how to catwalk, and although the Princess couldn't exactly dress like Linda Evangelista or Naomi Campbell (she was the exact same height as they were), the sidewalk became her runway—a place she could experiment in all the glamorous, knee-baring shift dresses she once had to shy away from. Anna Harvey insisted that Diana wasn't so much interested in setting trends, but rather following them. "She wanted to be modern rather than fashionable,"[134] she said. This made sense for a woman who had been subjected to an archaic royal dress code for most of her adult years. Ironically, as I write this twenty-five years on, Diana's off-duty style is considered both modern *and* extremely fashionable, with the supermodels of today from Gigi Hadid to Hailey Bieber paying tribute in their everyday style to many of Diana's most carefree looks.

In the first half of the nineties, Diana's newfound freedom was displayed via a more international aesthetic, inspired by her travels among all the major fashion cities, including Paris, New York, and Milan, and her new elite fashion

circle from Gianni Versace to Valentino Garavani and Giancarlo Giammetti. Many of her go-to British designers were exchanged for the sleeker, sexier designs of their Italian counterparts. Diana's wardrobe of blazers, cashmere knits, tapered jeans, and "fuck-off" handbags proved she didn't belong to just the UK anymore. They said, "I'm now a woman of the world."

By 1995, Diana had discovered a more focused sense of style. She knew her color palette, as well as the shapes that worked for her, and leaned toward an all-American, nineties New Jersey soccer-mom aesthetic courtesy of Polo Ralph Lauren. "Everything became more streamlined and somehow athletic, in line with her role as a committed charity worker, and she moved to navy blue, greys and pastels,"[135] said Anna Harvey. Diana was inherently herself in her most casual clothes, and this bled into her work too. In her final year, Diana discovered where her efforts were best spent: on the ground and helping the people who needed it most. As Diana decluttered her life, both personally and professionally (Diana famously did a clearing out of dozens of the charities she believed used her only for her status), she understood that her approachable, everyday style worked well for her new working chapter too.

HOW TO GET THE OFF-DUTY REVENGE LOOK

- V-neck (cashmere recommended)
- Tapered jeans (always ironed with a perfect center crease)
- All-American varsity jacket (Liberty! Grace! Land of the free!)
- Polo Ralph Lauren anything
- A crisp white shirt
- Cowboy boots (for strutting up to the palace to pick up the kids)
- Gold hoop earrings

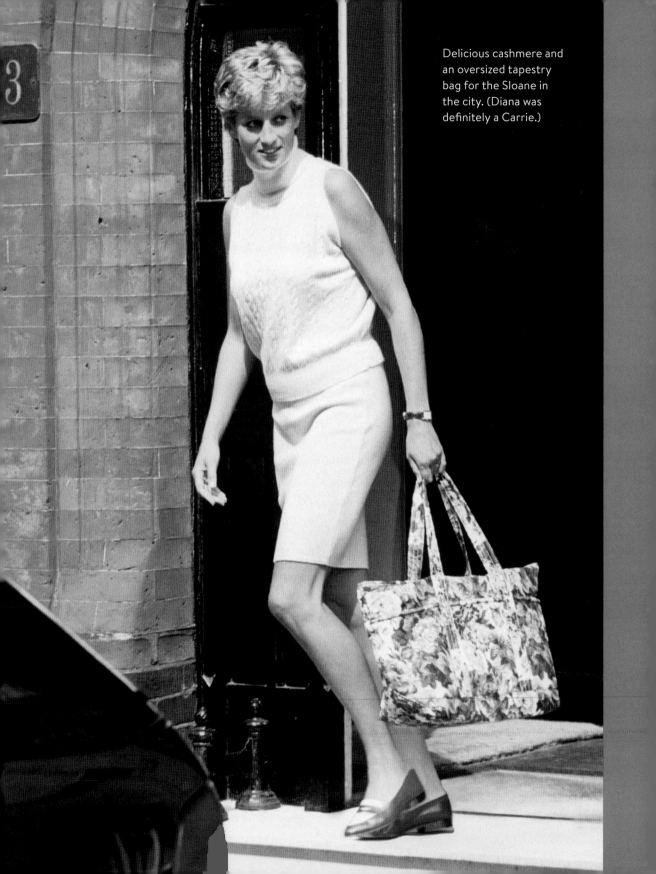

Delicious cashmere and an oversized tapestry bag for the Sloane in the city. (Diana was definitely a Carrie.)

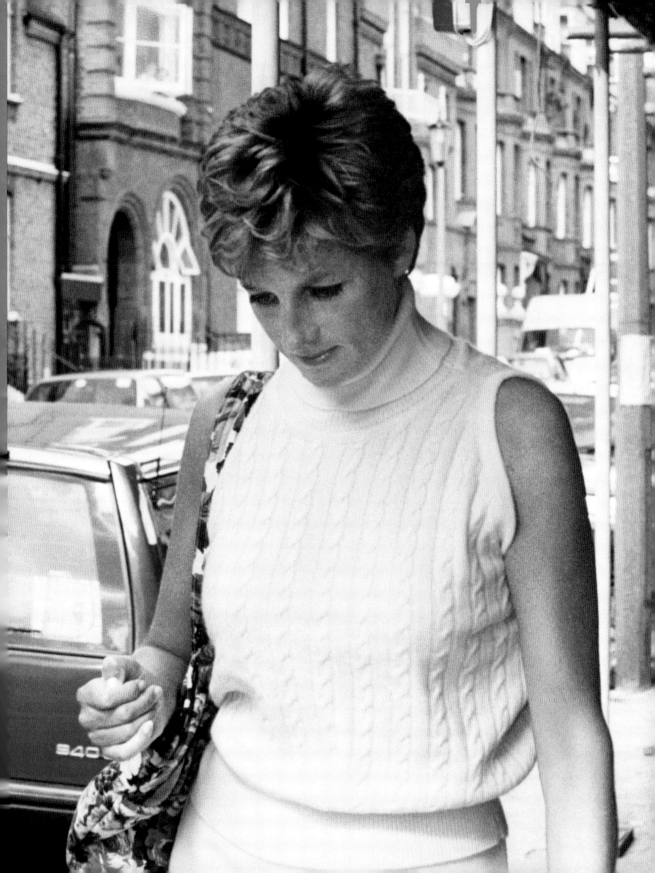

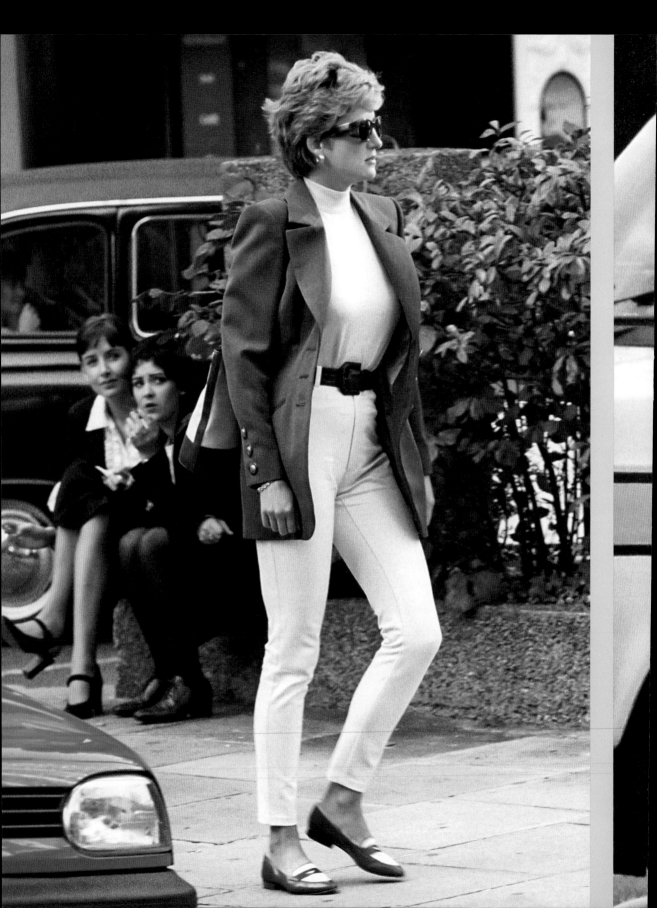

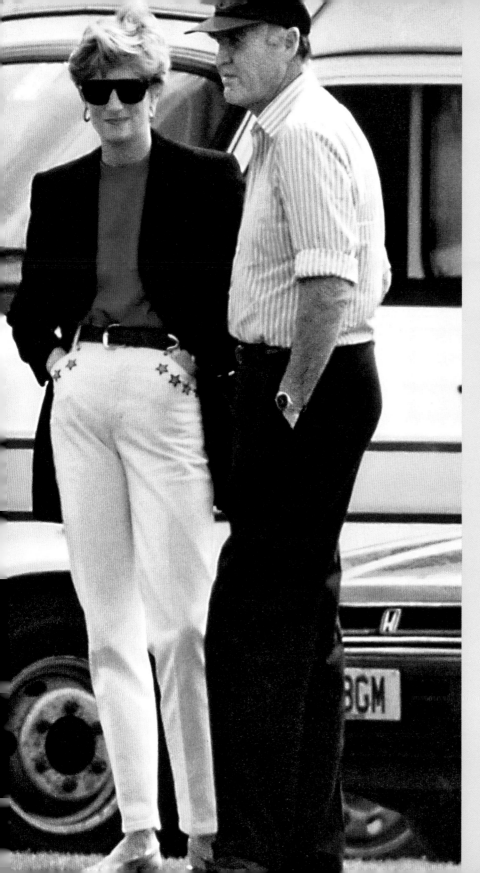

(Far Left)

When you walk the walk and they talk the talk.

(Left)

Diana often wore denim by the luxury German brand Escada, including the white jeans pictured, featuring appliqué gold stars around the pockets. She had an extensive denim collection, including pairs from Gucci, Armani, Margaret Howell, Versace, and regular ol' Levi's.

BLACK
AND
WHITE

Black and white became
a more regular feature in
Diana's nineties wardrobe—
she finally could wear
the forbidden colors that
she didn't dare to while she
was married.

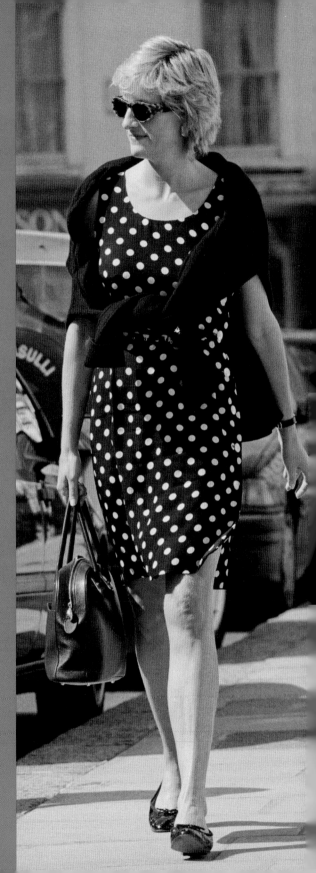

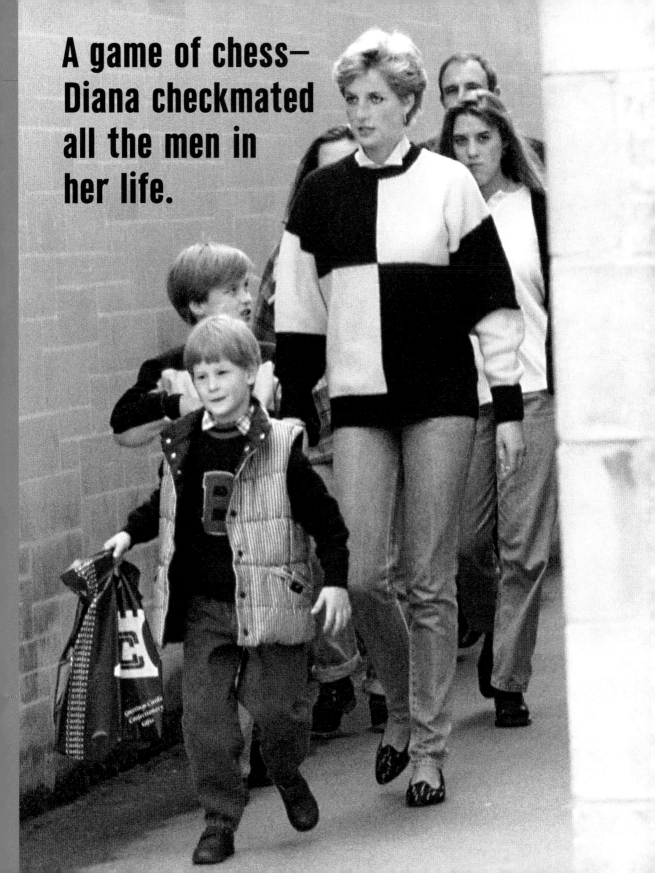

A game of chess—
Diana checkmated
all the men in
her life.

A CASUAL WORKING UNIFORM: On a trip to Bosnia and Herzegovina in 1997, Diana wore a simple pink Ralph Lauren shirt, tucked into a pair of black jeans with Tod's loafers. Her message was clear: she was there to get her hands dirty, with no distractions. Diana's uniform for her trips to Angola and Bosnia fused together both her on- and off-duty styles for a polished, down-to-earth look—perfect for her "on the ground" humanitarian missions.

"Because I do things differently, because I don't go by the rule book, because I lead from the heart, not the head, albeit that's got me into trouble in my work, I understand that. But someone's got to go out there and love the people and show it."[136]

SOCCER MOM

(Below)

The ultimate nineties duo. Diana wears a Polo cable-knit with tapered jeans* and Reebok sneakers. The Princess wanted as much normalcy for her children as possible, so she made sure to dress them in clothes any other stylish kid in the nineties would wear.

(*Royalty only wear perfectly pressed jeans with a visible crease.)

"Her instinct to move to America was dead on. She would only ever feel at home now in the culture that invented fame the size of hers."

—TINA BROWN

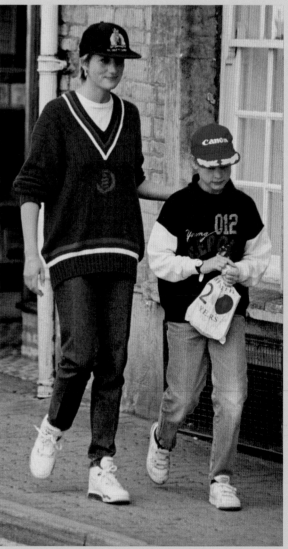

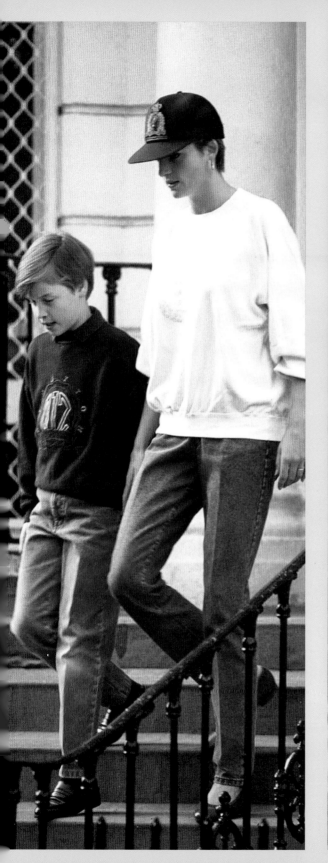

Princess Diana at Thorpe Park amusement park in 1992.

"Whenever she was with her kids, that's when she'd laugh the most."

— SAM McKNIGHT

THE COWBOY-STYLE BOOTS

Gone were the days of dainty dresses on the sidelines—she now dressed for the frontlines. Stick 'em up, Charles!

In 1992, the year that Charles's and Diana's separation was finally agreed to by the Queen, Princess Diana strutted around the polo town of Cirencester in her most practical pairs of brown western-style boots, which she repeatedly teamed with a casual red puffer jacket. The ex-husband may have had some skills on a pony, but cowgirl Diana was swift on her feet in her trusty tan boots.

(Opposite)

The need for speed revenge look: A leather bomber jacket, mom jeans, and sneakers for a go-karting trip in 1992 with Princes William and Harry.

(Right)

A pared-back princess wearing a Hard Rock Café bomber jacket to an amusement park in 1993.

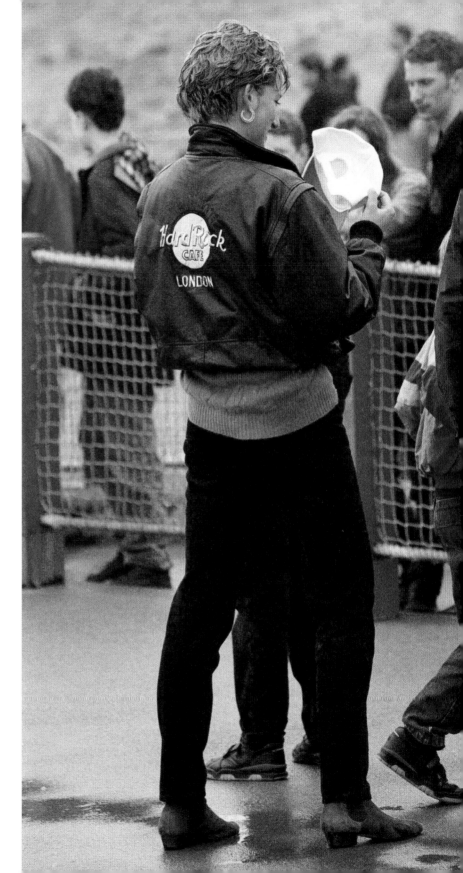

AMERICANA

Diana embraced the all-American varsity jacket in her quest for a new independent life.

(Right and Center)

Wearing a red varsity jacket, brown leather cowboy boots, and Escada jeans featuring a horseshoe pocket appliqué, the Princess became even more relatable to working mums everywhere when, running late to school, she raced up the steps with Prince William to drop him off.

(Far Right)

An unlikely Philadelphia Eagles fan: This American football varsity jacket was gifted to the Princess by Jack Edelstein, statistician for the Philly team. The story goes that he met Diana at Grace Kelly's funeral and explained to her the differences between British soccer and American football. When she asked what the team's colors were, Jack responded "silver and green," to which she replied, "Those are my favorite colors." A few weeks later, she was gifted a trunk-load of Philly Eagles merch and adopted this jacket as one of her go-to relaxed styles, the ones she wore over and over again.

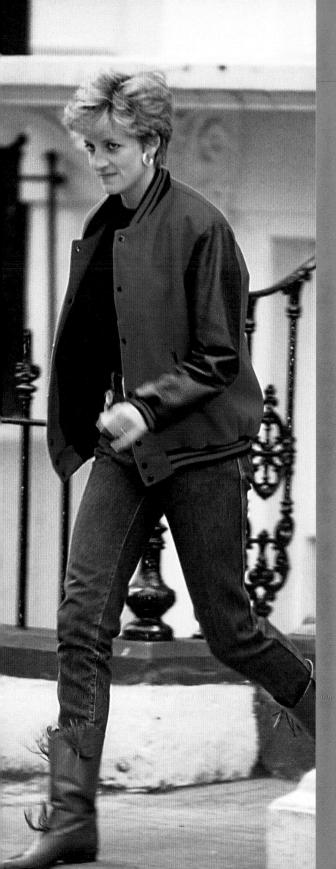
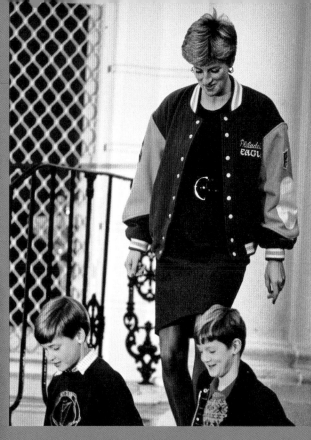
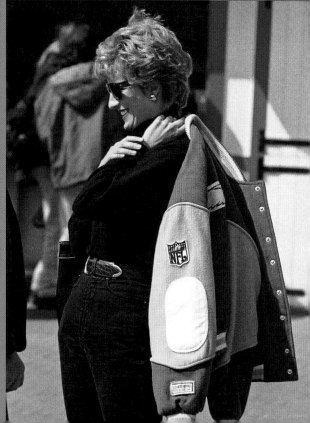

11

THE SKI
REVENGE
LOOK

"**L**ast Christmas, I gave you my heart but the very next day you gave it away"—sang George Michael in the beloved 1985 holiday hit by Wham! Every time I see a photo of Diana decked out in her colorful eighties ski wear, I automatically begin humming the melody of this nostalgic holiday classic, singing along to Michael's delightfully bitchy lyrics about getting over a heartbreak by moving on to someone who is more deserving. With all of Diana's romantic disappointments and betrayals— from James Hewitt, who wrote a tell-all book about his five-year-long affair with the Princess, to the ex-husband who was in love with another woman—this Wham! song feels even more relevant to Diana's story. She was known for cutting out those she felt betrayed by (sounds like healthy boundaries to me) and persevering on with the quest to find someone who wouldn't seek to capitalize on her international fame.

For Diana's trip to the Austrian alpine town of Lech in 1993, she wore recycled ski suits from her eighties trips to Klosters with Charles and Fergie. Her classic Head, Bogner, and Kitex one-pieces, originally bought from Harrods, were taken to a whole new altitude with fresh, updated nineties accessories, more fitting to her jet-setting, newly single, working-woman lifestyle. The après-ski looks were even more glorious, featuring a shoulder-padded red puffer jacket, Escada Canadian tuxedos, and suede Chelsea boots.

Diana always looks immeasurably happy on the slopes, but, of course, the press were camped out in the snow, waiting to stalk every move of her private vacation with her sons. She retreated into a nearby shop one day, and, to her surprise, the owners gifted her a pair of lightning-fast, personalized skis. "These are the very best. She will ski much faster and safer and it gives her an edge over the photographers," the shop owners said.

(Opposite)

In the Austrian mountain town of Lech, Diana sported a Canadian tuxedo—her jeans, embellished with gold appliqué pocket detailing, were by Escada. In classic Sloane fashion, she tucked her freshly creased denim into a pair of Moon Boots (you can take the woman out of Sloane Square, but you can never take the Sloane out of the woman).

THE LADY DI LOOK BOOK

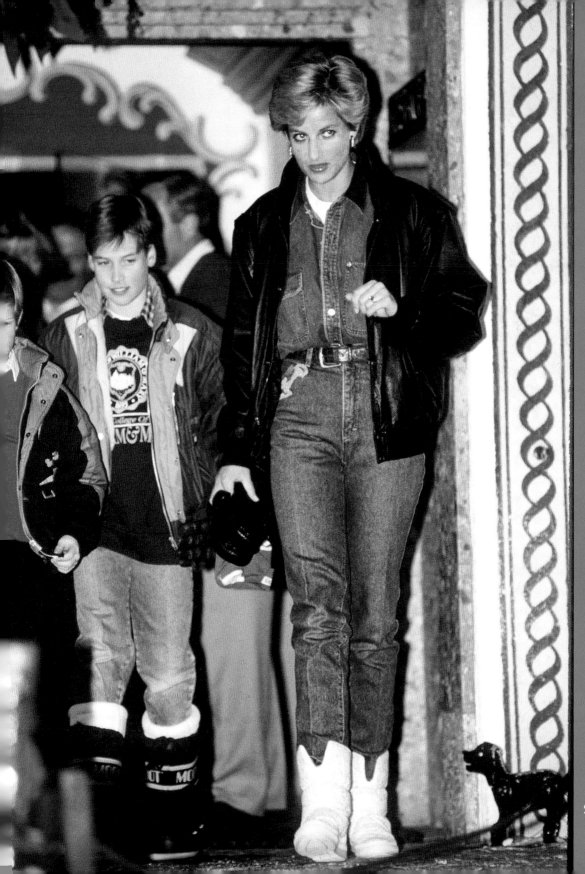

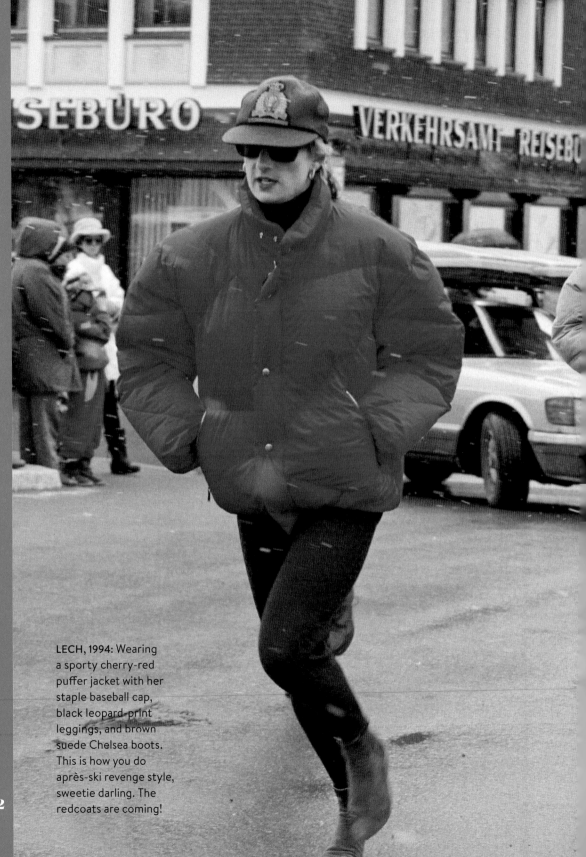

LECH, 1994: Wearing a sporty cherry-red puffer jacket with her staple baseball cap, black leopard-print leggings, and brown suede Chelsea boots. This is how you do après-ski revenge style, sweetie darling. The redcoats are coming!

272

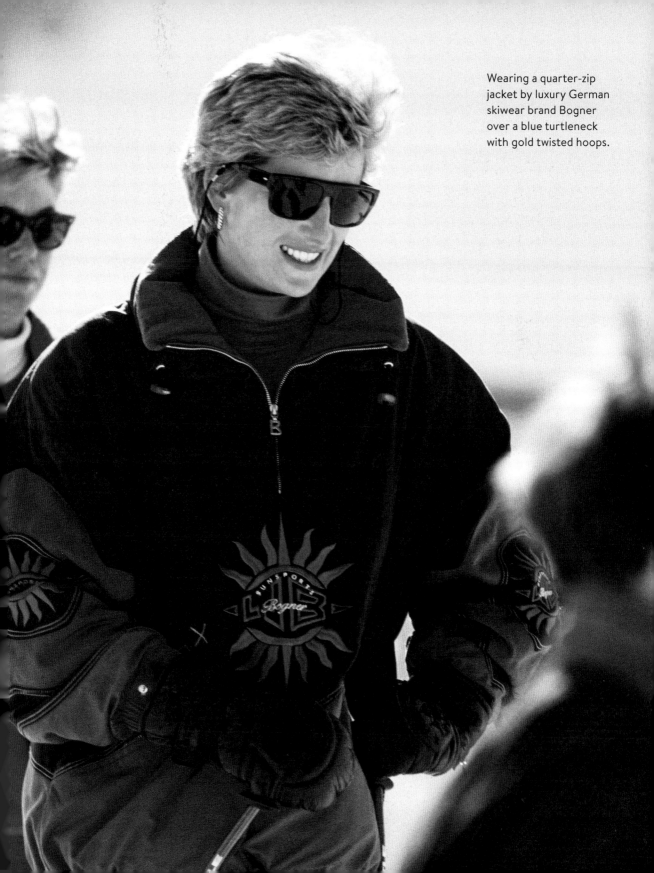

Wearing a quarter-zip
jacket by luxury German
skiwear brand Bogner
over a blue turtleneck
with gold twisted hoops.

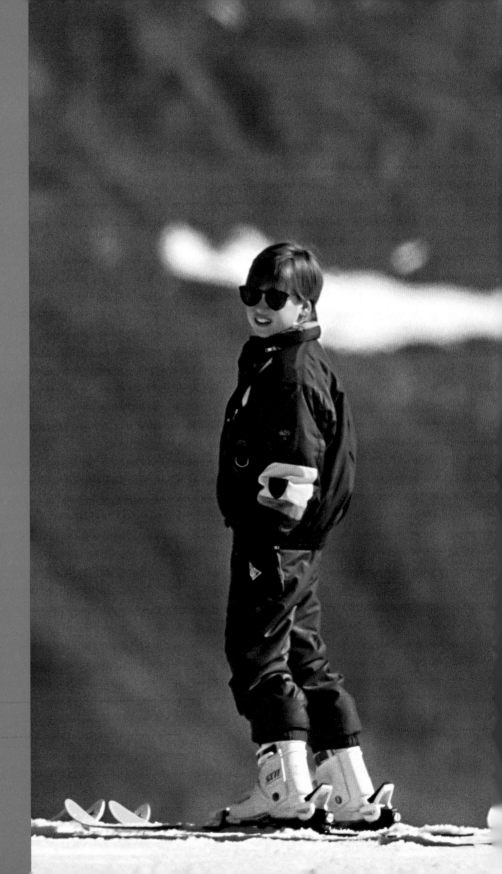

The ultimate nineties pop band. Diana wears a one-piece ski suit by Head with Nordica ski boots.

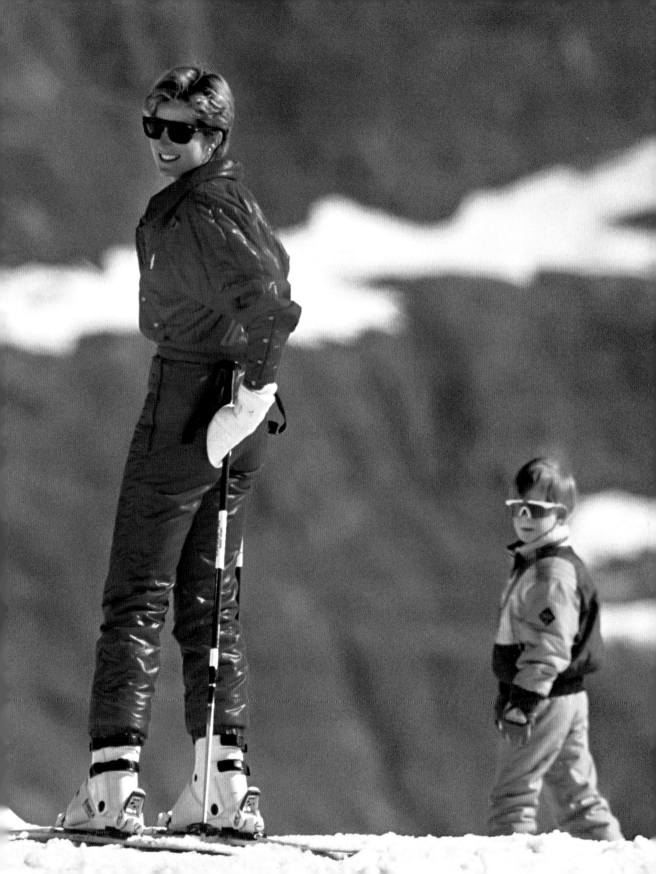

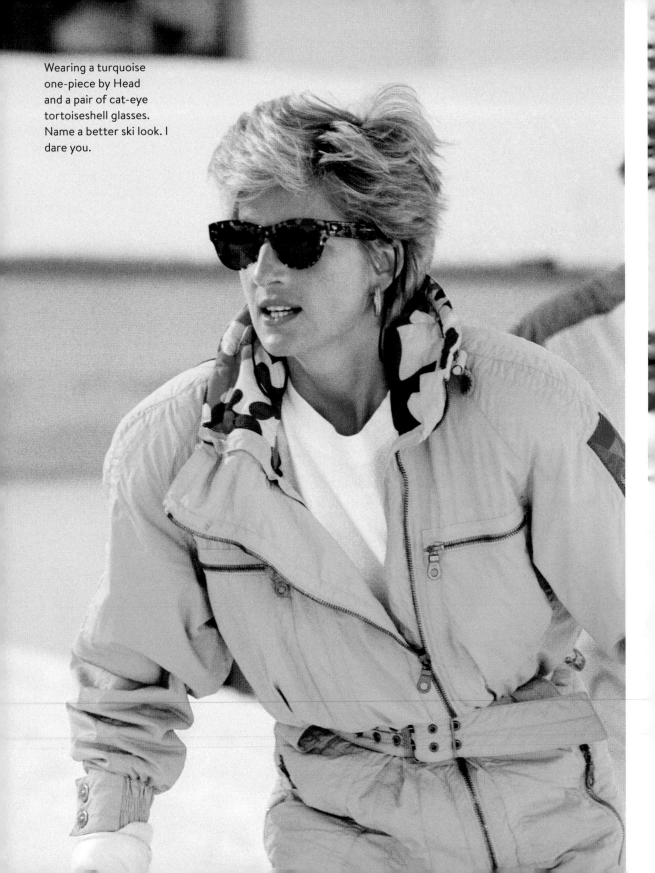

Wearing a turquoise one-piece by Head and a pair of cat-eye tortoiseshell glasses. Name a better ski look. I dare you.

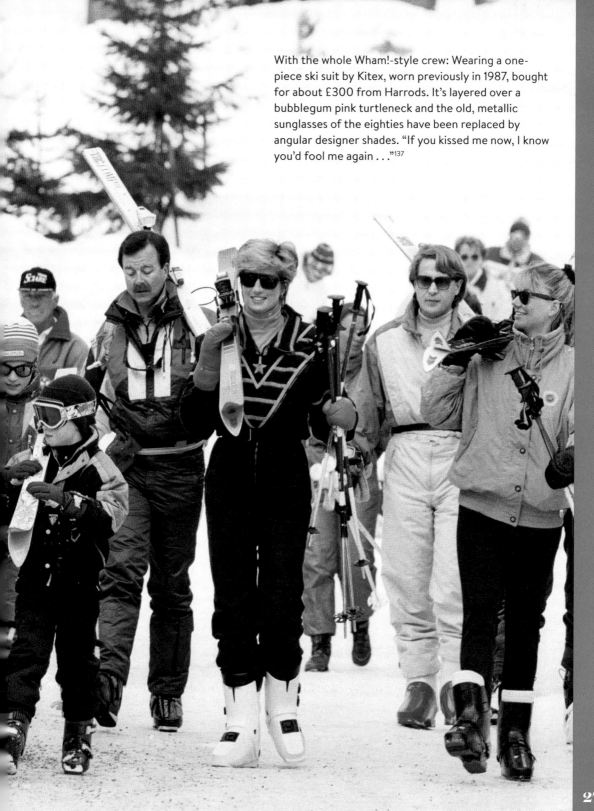

With the whole Wham!-style crew: Wearing a one-piece ski suit by Kitex, worn previously in 1987, bought for about £300 from Harrods. It's layered over a bubblegum pink turtleneck and the old, metallic sunglasses of the eighties have been replaced by angular designer shades. "If you kissed me now, I know you'd fool me again . . ."[137]

12

THE MR. WONDERFUL REVENGE LOOK

"Hasnat is the one person who will never sell me out."[138]

There was one "good guy" in the story of Princess Diana. Hasnat Khan, a Pakistani heart surgeon, met Diana in 1995 while he was on duty at the Royal Brompton Hospital—just weeks before she sat down with Martin Bashir for that notorious *Panorama* interview. When introduced to the Princess, he nodded respectfully, if disinterestedly, and went back to work. Diana was instantly smitten; it wasn't so often that she didn't immediately enchant someone she was newly introduced to. She reportedly said to her friend who was also there, "Isn't he drop-dead gorgeous?"

Diana, ever aware of her magical allure, began to pursue the doctor, who was an unlikely romantic companion. He was a workaholic, a little on the plump side, and by no means of international acclaim—he was just a "normal" guy, who worked exceptionally hard. She called him her "Mr. Wonderful." Symbolically, Khan, a former subcontinental constituent, was the perfect royal rebound for Diana. He was the total opposite of her ex-husband: a working man with no interest in ceremony or press attention. For Diana, this was the ultimate breath of fresh air. While normalcy was an intangible concept, it was something she desperately craved. She deeply respected the work that he did, and, to Diana, Hasnat was everything she had never known. Khan later explained to the *Daily Mail* why their dynamic worked so well: "There wasn't any hierarchy in our relationship. She wasn't a princess and I wasn't a doctor."[139]

She began to visit the hospital every day in the hope she would catch his attention. One fateful afternoon, they locked eyes in the elevator, and that was the start of what became an on-again, off-again two-year romance. On their first time alone together, Hasnat asked if she'd like to join him on a visit to see his aunt and uncle, and to his surprise she said yes. They began dating in secret, mostly seeing each other late in the evening at the hospital or in the shielded confines of Kensington Palace. Diana gleefully threw herself into Hasnat's very ordinary life, even washing dishes and folding his laundry, a striking parallel to her old days at Coleherne Court, when she'd deliver freshly laundered shirts to her male friends and clean her sister's friends' houses—her last memory of what "normal" felt like.

As she fell more in love with her doctor boyfriend, the press picked up the trail. The lovers discussed marriage and having children, and she even visited Pakistan twice, wearing various colorful *shalwar kameez* each time to win over Hasnat's conservative Pashtun family. Jemima Khan, Diana's friend and

then-wife of Imran Khan, explained to *Vanity Fair,* "for a son to marry an English girl is every conservative Pashtun mother's worst nightmare."[140] Still, Diana believed if she made every effort, her charm would prevail and that by winning their approval, it would convince a hesitant Hasnat to marry her.

"Diana gleefully threw herself into Hasnat's very ordinary life, even washing dishes and folding his laundry."

On July 4, 1996—symbolically, American Independence Day—Diana was finally granted a divorce. Most would assume that she'd immediately step out wearing something black, as she did in the other milestone moments during her ill-fated marriage. The royal color of mourning seemed the more obvious choice for finally closing the bracket on a purgatorial four-year era between her separation and divorce. By now, we all know that Diana wasn't ever one to be predictable. She wore ivory in tribute to her liberation, and a divine pearl-embellished shalwar kameez. The pearls were an emblem for her gained wisdom and a new dawn, while the traditional Pakistani silhouette was evocative of her love and loyalty to Khan, a man she believed would never betray her—and she was right; he never did.

Diana's declarations of commitment were not enough for Hasnat. He was an intensely private man of strong faith who wanted a simple life, away from the prying binoculars of the media. "I did not want to have to look over my shoulder all the time,"[141] he said. Shortly after they parted ways in 1997, Diana became reacquainted with Dodi al-Fayed, the perfect rebound and distraction from her heartbreak.

It's impossible not to think about what might have been had Khan proposed, although his fears about stepping into the hunting ground of the press proved to be tragically prophetic.

Diana used her trips to Pakistan to woo Hasnat Khan's family. She believed that if they approved of her, it would convince him to marry her. This turquoise shalwar kameez was created by Indian designer Ritu Kumar, who was introduced to Diana by Jemima Khan.

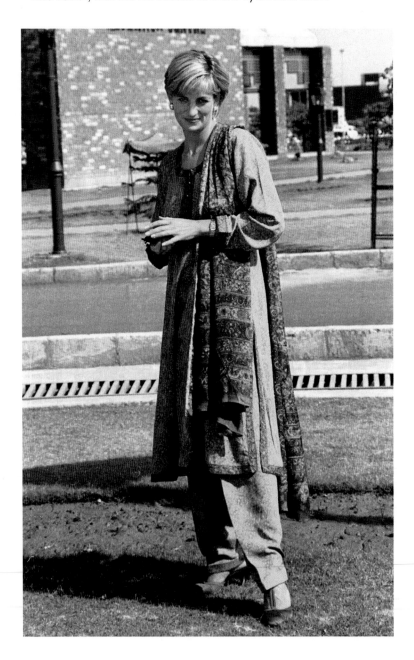

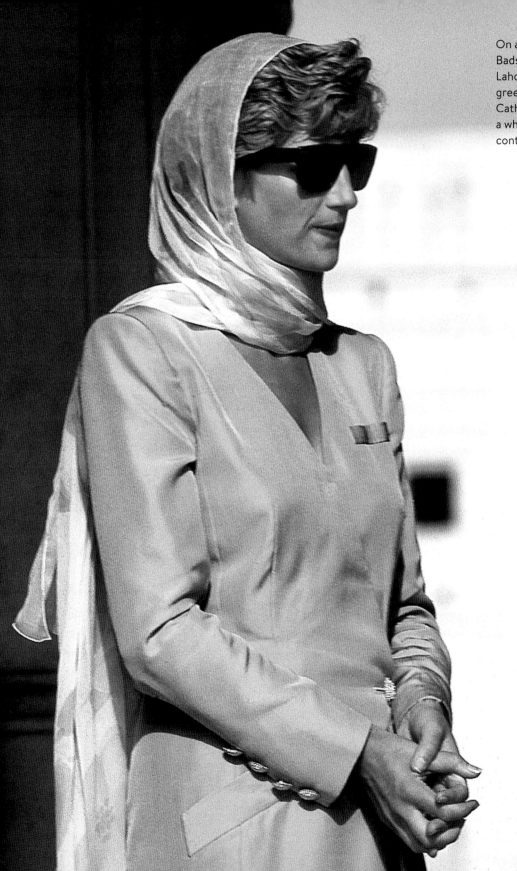

On a visit to the
Badshahi Mosque in
Lahore, Diana wore a
green coat dress by
Catherine Walker with
a white silk scarf and
contemporary shades.

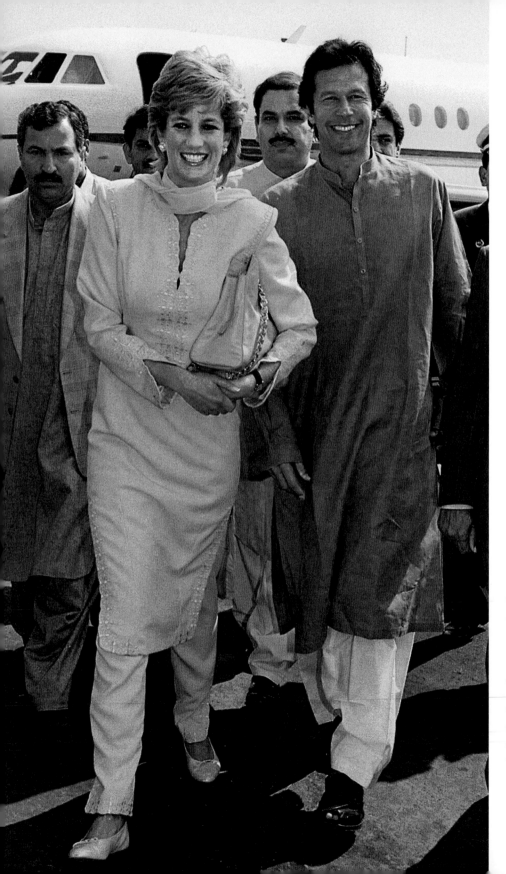

Diana wore a traditional shalwar kameez in powder pink and matching *dupatta* by Pakistani designer Rizwan Beyg as she arrived in Lahore, Pakistan—seen here with Imran Khan, certified hottie and a distant cousin of Hasnat.

On July 4, 1996, Diana
received her offer of
a divorce settlement
from Charles's camp:
£17,000,000 with an
extra £400,000 per
year to live on. That
same evening, Diana
went to a charity
fundraiser at London's
Dorchester Hotel,
wearing a pearl-and
gold-embellished
couture shalwar kameez
by Rizwan Beyg—a
modern look that
blended two cultures
with its traditional
silhouette worn by
Pakistani women and
its ivory hue attributed
to brides in the west. A
hint to everyone, and
a nudge to Khan. "Last
August a friend said to
me that I'm going to
marry somebody who's
foreign, or who has got
a lot of foreign blood in
them," Diana shared in
her earlier secret tapes,
"I thought it was always
interesting."[142]

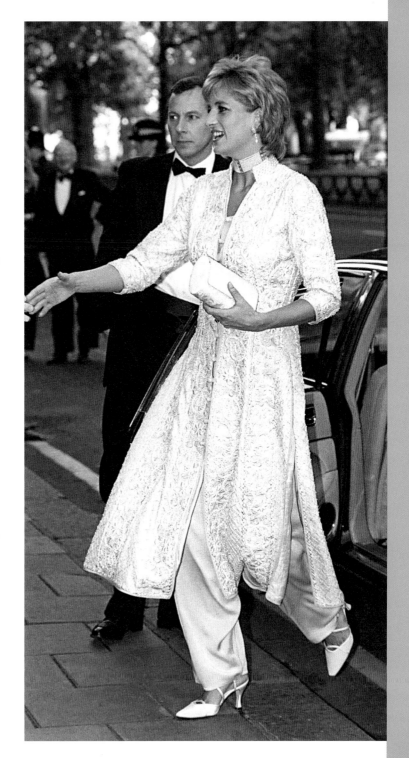

13

THE VACATION REVENGE LOOK

"I am a free spirit, unfortunately for some."[143]

n July 1997, with word that her ex-husband was to host Camilla's fiftieth birthday party at Highgrove, Diana accepted a conveniently timed request from Harrods owner Mohamed al-Fayed to join him and his family at their Saint Tropez villa. "Wouldn't it be funny if I suddenly came out of the birthday cake?" she teased.

Instead, Diana decided to take the high road and a summer holiday. She hopped aboard al-Fayed's private jet with Princes William and Harry and joined the billionaire and his family at their sprawling beachside mansion on the Côte d'Azur. It was there she was reacquainted with Dodi, al-Fayed's son, whom she'd first met in 1986 at a polo match, where he played on the opposite team to Diana's ex-husband.

Like Diana, Dodi was a fellow divorcé, and he was dating the American model Kelly Fisher at the time, whom he unceremoniously dumped just days after he was reunited with the Princess at his father's house. Lúcia Flecha de Lima, a friend of Diana's, explained Dodi's appeal: "[He was] a man who had no full-time occupation and could dedicate all his time to her."[144] To some, that might sound like the stuff of claustrophobic nightmares (I mean, who wants an unemployed man constantly doting on you? Good lord, get a job or a hobby!), but Diana had never had this kind of devoted attention before, and she was charmed by it. (On second thought, perhaps I could be convinced if this hypothetical unemployed man owned a house in the French Riviera, a 200-ft yacht, and had an unlimited charge account to Harrods. Definitely pros and cons to both.)

Some of my favorite off-duty photos of Diana are from her vacations in the nineties. From the leopard-print one-piece by Oregonian label Jantzen that she wore on Richard Branson's Necker Island, to the Gottex neon ombré bathing suit that lit up the Mediterranean seascape, some of the happiest photos that exist publicly of Diana are those that show her lounging on a beach with her sons; frolicking around on yachts with tanned foreign playboys; and sporting a wardrobe of bikinis, oversized T-shirts, Versace shades, and baseball hats. She started the decade on a trip to Majorca with her estranged husband and their boys, looking utterly subdued, but by the summer of 1997, Diana appeared to be wholeheartedly herself—her eyes sparkled with uncontainable joy.

Still getting over her breakup with Hasnat Khan (I *really* was rooting for him) and disappointed that their two-year romance failed to convince him to propose, the queen of revenge was on a whole new mission: to show her new ex

what he was missing. Khan was "as understated as Dodi was flashy, as remote as Dodi was public, as somber as Dodi was carefree,"[145] wrote Sarah Ellison for *Vanity Fair*. In other words, for better or worse, Dodi was everything Khan wasn't.

It's very much disputed whether Diana was actually in love with Dodi. He gifted her a ring from Repossi the day before their untimely deaths after the accident in Paris's Pont de l'Alma tunnel, and many speculated that it was the engagement kind. Of course, after the tragedy, the press decided to create their own fairy-tale ending, perhaps to soothe a grief-stricken public or to continue telling the sensational story they had always wrestled to dictate. For Diana, giving gifts was her love language. Diana's bodyguard, Ken Wharfe, said, "She loved to shower her men friends with gifts, and it all went on the Prince of Wales's account."[146]

Rosa Monckton, a close friend of Diana's, believed that her summer dalliances with Dodi were to make Hasnat jealous enough that it would force his hand, as she still loved him. On her final cruise around the Mediterranean, there were multiple reports of Diana colluding with the paparazzi by telling them where she'd be. A famous *Mirror* front page—bearing the headline "The Kiss"—showed Diana in a fluorescent pink floral bathing suit, locked in a passionate embrace with her Egyptian boyfriend. The whole world went wild, and poor Hasnat tried to call Diana on her cell phone, but she had, rather brutally, already changed her number.

Now, although most of us can't really relate to conspiring with the paparazzi to get the perfect post-breakup revenge shots (although this would be such an iconic way to inflict revenge, I wish I had this capability in my back pocket), it isn't too dissimilar from the Instagram breakup-revenge mentality of today. Raise your hand if, after a breakup, you've curated your own reality via a series of painstakingly strategized "candids" on social media? Of course you have! Diana went through the exact same motions as the Instagram generation of today, except she was able to enlist the slightly elaborate help of the international media.

Whether she was simply on the rebound with Dodi, seeing him with the intention of manipulating Hasnat, or truly in love, we'll never know. Diana had a whirlwind summer fling, and in her final weeks of life, she looked genuinely happy and free. The media responded to her freedom with pushy suggestions that Diana was about to get another ring on her finger—perhaps she was just happy to be single, "normal," and receiving attention from a man that desired

her? Couldn't we have allowed Diana a no-strings summer of sun, sea, and sex without putting her into another box?

What we do know is that Diana wrote the book on manipulating the men in her life, whether it was for her own amusement, power, control, or even for an inner sense of security. She'd reclaimed her power, and for all that she'd been through, I'm sure she secretly delighted in keeping those men on their toes.

Diana *did* have love in her life that summer: the love of her boys and a palpable love of life and self. She was in her element during her final weeks on earth, something her brother, Earl Spencer, found solace in, saying in his eulogy that before she passed away, she was "at her most beautiful and radiant and when she had joy in her private life." Instead of wanting the alternate fairy-tale ending of a could-have-been engagement for the Princess, perhaps we can take comfort in what we do know to be true: the Princess had found peace and happiness on her own terms.

"I know one day if I play the rules of life—the game of life— I will be able to have those things I've always pined for and they will be that much more special because I will be that much older and I'll be able to appreciate them more."[147]

An apple a day keeps the ex-husband away.

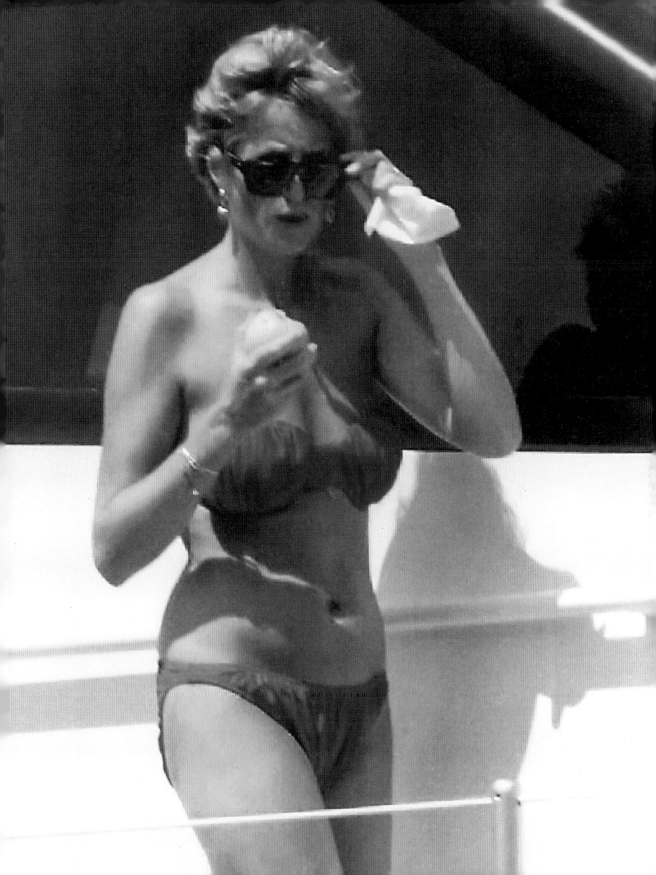

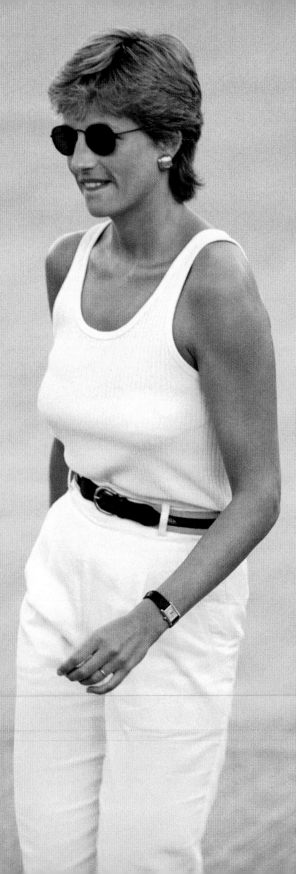

SAINT BARTHÉLEMY, 1995: Black round sunglasses, a simple ribbed tank top, white cotton pants, tanned (if not a little rouge) skin, and a pep in her step. This is how you do vacation revenge dressing. Take notes.

(Opposite)

Gianni Versace once described Diana as the "Mother Teresa and Cindy Crawford of our time," and, certainly, there's both a beatific and supermodel-like quality to Diana in this photo. Clutching on to a pair of K. Swiss sneakers, the Princess, with her slick haircut, sported a classic nineties vacation look: black tank top, white shorts, a Louis Vuitton monogram clutch tucked beneath her arm, with her new man trailing behind her (two steps behind always, remember).

The *joie de vivre* revenge look. Washin' that man right out of her hair in St. Tropez, 1997.

Alone in the wild wearing leopard print. Princess Di wore this bathing
suit and matching sarong by Portland-based label Jantzen while on
vacation at Richard Branson's Necker Island in 1990. Supposedly the
Princess would negotiate with the paparazzi to make sure she was
ready with a revenge look before they got their photos.

Wearing another sexy animal-print
bathing suit by Israeli designer Gottex.
I love to imagine that she was listening
to "*Sisters Are Doin' It for Themselves*" by
the Eurythmics and Aretha Franklin.

THE LADY DI LOOK BOOK

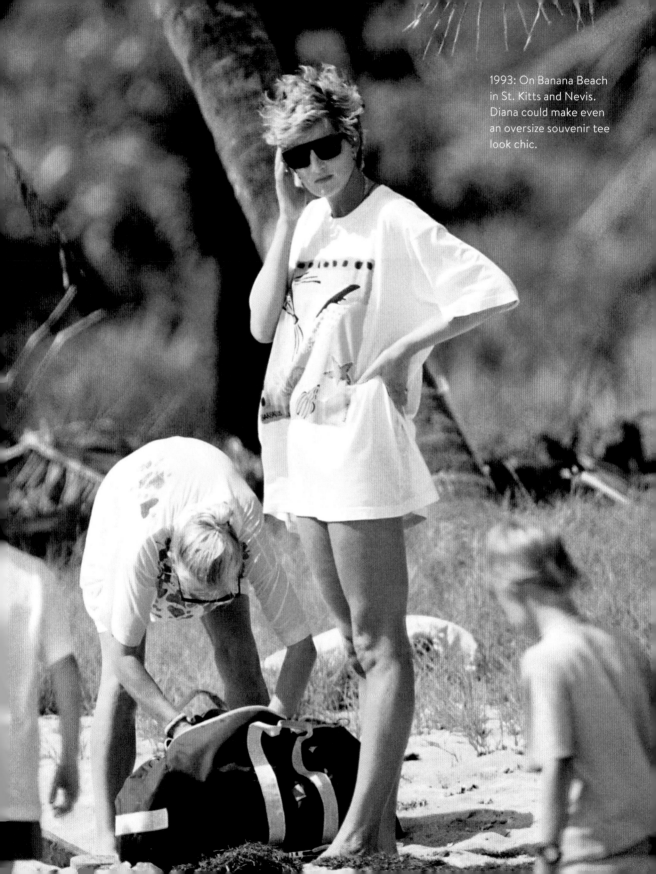

1993: On Banana Beach in St. Kitts and Nevis. Diana could make even an oversize souvenir tee look chic.

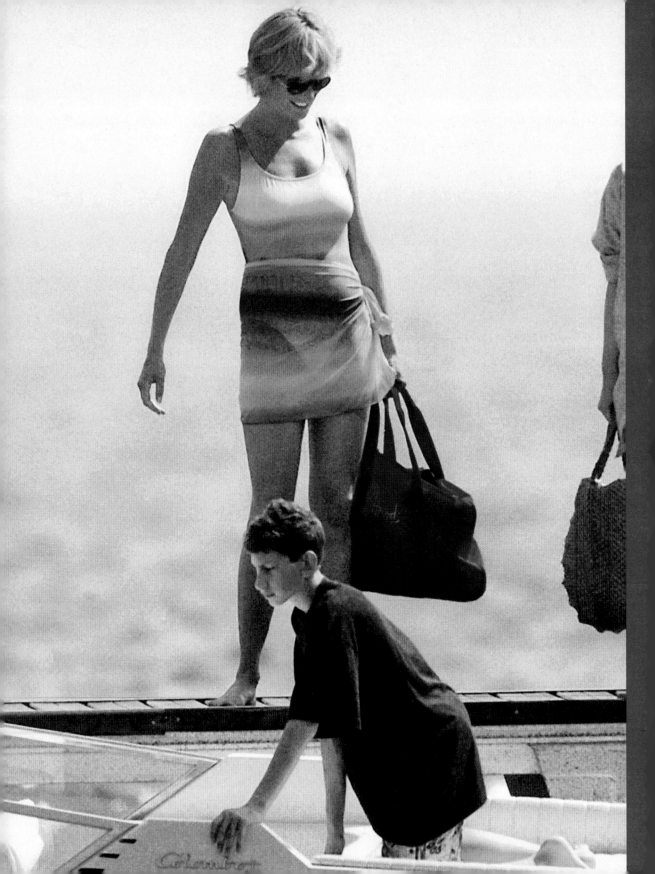

Diana wears a neon ombré bathing suit and matching sarong custom-made by Gottex, paired with a red Harrods nylon tote bag.

La vita nuova.

"What they say behind my back is none of my business, but I come back here and I know that when I turn my light off at night I did my best."[148]

PART III

The Final Revenge, Then Peace, at Last

"There is a kind of serenity" said Gianni Versace in 1997, "she's found herself—the way she wants to live."[149] Her many metamorphoses, from Shy Di to Dynasty Di, revenge queen to casual citizen, were merely chapters in a very feminine, almost Sisyphean quest to understand herself and shake off the shackles. Each outfit she dressed in was a means of curious self-expression—it was protective armor, her secret walkie-talkie to the regular ol' Josephine on the street.

Initially Diana was dubbed a clotheshorse, a bimbo by the Palace and even by her own husband. One of the biggest ironies was that in the end, the labels they used to discredit her became their biggest threat.

"Throughout her life, Diana was dominated by men; Prince Charles shaped her private life, the 'men in grey' her public life and newspaper editors her international image."[150] In the end, she'd played them all. What Prince Charles and courtiers failed to recognize was that through her clothes came an ability to directly connect with the people from the very start. They weren't her subjects, but her equals, which she always made clear. They understood her and they could relate.

The Firm and the press didn't just underestimate Diana; they completely failed to understand the immense power of clothes.

Not only was Diana able to turn around the public perception of a woman's place in society, but she was able to make divorce look like utter utopia. As she pranced around Mohamed al-Fayed's 200-ft yacht, the *Jonikal*, in a turquoise bathing suit and shared a passionate kiss with her tanned lover, Dodi, she made a Shirley Valentine–like case to women everywhere. She might as well have been booming through a megaphone: *Leave ya husbands now, ladies.* Certainly, there was nothing more terrifying to a balding male establishment than that.

In her final days, Diana was exquisite. Healed and happy, it was time to let go—she was ready to step out from behind the shadow of her heavy eighties fringe, away from the distractions of her dazzling Hollywood frocks. She even removed the kohl eyeliner, most memorable from her *Panorama* interview, and replaced it with just a natural lick of mascara, allowing her eyes to sparkle with unquestionable self-assurance. She was ready to be seen.

Of course, no breakup rite of passage can conclude without a major closet clear-out. For most, that means binning (or burning) the sweatshirt that might still have the triggering scent of your ex. For Diana, it meant auctioning off seventy-nine cocktail dresses at Christie's New York, which she did in July 1997,

raising a record total of $3.26 million for five charities. Each gown reflected more than the nine different lives she'd lived. *The New York Times* called it a "soap opera through clothes."[151]

"Ultimately, they're empty shells," wrote Cathy Horyn for *Vanity Fair*. "Beautiful, shiny, marvelous to look at, but still . . . shells. And the fabulous creature who once occupied them? She's packed up and moved on."[152]

Diana's final revenge was ultimately in rebuffing the long-held perception of her as a clotheshorse. She no longer had to communicate through her clothes, because she'd finally found her voice. She was a serious working woman, ready to get behind the steering wheel. All she needed were jeans, a button-down shirt, and a very practical pair of Tod's driving moccasins for that. "From now on I am going to own myself and be true to myself. I no longer want to live someone else's idea of what and who I should be," she said.

"I am going to be me."[153]

Heartbreakingly, the bitter tragedy was that Diana lost her life when she was most comfortable in herself as a woman, even though the Palace had done everything—including stripping her of her royal title—to prevent that from happening. Liz Tilberis, the late editor in chief of *Harper's Bazaar* and confidante to the Princess, explained that Diana had concerns she'd be ineffective to her causes without her official royal title. "She had been so worried, particularly when her HRH title was taken away, that she wouldn't be able to maintain the kind of structure as a leader that she had begun to achieve in the charity world," wrote Tilberis. "She was afraid she had lost it all. But in her death it was clear that she had really won it all."[154] It seems that even Diana, the first high-profile woman to publicly hug an AIDS victim, could not comprehend that her dizzying level of stardom had nothing to do with her royal title. Diana "Duch" Spencer was idolized by regular citizens and respected by world leaders for simply being her. "I think Diana would have been enormously touched by the world's reaction," Tilberis added.

Today, and to a whole new generation of young people, her loss still seems incomprehensible. At her funeral, Earl Spencer eulogized that the Princess "needed no royal title to continue to generate her particular brand of magic." The brand of magic he talked about then still resonates as I write this book. In the past few years, since creating my Instagram account @ladydirevengelooks, I've seen teenagers, millennials, and baby boomers adopt and re-create some of Diana's best postdivorce revenge outfits. Her clothes remain forever fresh-looking, while her personal story continues to touch a nerve with anyone who's

ever felt discarded or less than. "It was her innermost feelings of suffering which made it possible for her to connect with her constituency of the rejected," her brother said. That remains true to this day.

As for Prince Charles and Camilla. They made their mistakes and are now happily married, living quietly at Clarence House, irrelevant to most. Charles is still not king. Diana, twenty-five years after her death, continues to connect with people across the world. Just the other day in Los Angeles, when I walked to get a coffee wearing my very own Virgin Atlantic sweatshirt, a young woman, not more than twenty-one, recognized the sweatshirt and stopped me to say: "I love Princess Diana, so, so much."

"At heart she was a woman who championed feminine values rather than simply craving acceptance in a male-dominated world," Andrew Morton wrote in the final chapter of his biography. "Her importance now lies not just in what she did during her lifetime but in the meaning of her life, the inspiration she gave to others, particularly women, to search for their own truth."[155]

What surprises me most is that Diana helped me heal from my own breakup. With every outfit I researched and interpreted—the countless archived articles I trawled through and every piece of old video footage I watched—I found comfort in her style, her sly sense of humor, and her no-bullshit attitude. She became my biggest inspiration, leading me on a journey that showed me not just how to get over a loss, but how to do it with a great outfit, a pointed comment, a wink, and a smile. If Princess Diana could do it, with all of the challenges that she faced, then I had no excuse.

Sometimes, my mind wanders to what Diana might be wearing if she were alive today. Would she have subscribed to Donatella's maximalist vision of Versace, or would she perhaps have leaned more into the sinuous, mellow silhouettes of The Row? I like to think she'd still be prancing along the King's Road in a pair of glistening white sneakers and an oversized sweatshirt, clutching on to a revived Gucci "Diana" tote—showing the Gen Z Sloanes of today how it's done.

If Diana taught me one thing, it's that being able to speak your mind is a privilege, and a skill we must learn and practice. If you're not ready to say it, wear it. Invest in a few ruthless revenge outfits. Play a jolly good game of "Pretend the ball is your ex." Don't let the fuckers get you down. And if all else fails . . . throw a few crusty bread rolls at 'em. That should do the trick.

"Her sympathies went out to the sick, the dispossessed, the dying, the helpless. Ours went out to her when she most resembled us."

—JOAN JULIET BUCK

ACKNOWLEDGMENTS

There are so many people I am indebted to for making this book happen, from the individuals who saw the potential beyond my very first Instagram posts, to the family members and friends who've cheered me on and patiently listened to me harp on about Princess Diana's clothes over the past few years (I promise to move on to another subject . . . eventually!).

First and foremost, I am so grateful to my editor, Elizabeth Beier, for believing in *The Lady Di Look Book*, for loving Diana as much as I do, for endless enthusiasm, and for genius guidance. I was once told that being paired with the right editor is a game of matchmaking—it feels like fate that I was matched with you. Thank you for simply *getting it*. Many thanks to the wonderful Hannah Phillips and Brigitte Dale, for all their work, and the wider team at St. Martin's Press, including Jonathan Bush and Olga Grlic who designed this magical cover, Shubhani Sarkar who designed the beautiful interior pages, Erica Martirano, Michelle McMillian, Brant Janeway, Mary Moates, Lisa Davis, and Lena Shekhter.

Lisette Verhagen, my brilliant "agent queen!" Thank you for taking a chance on me and believing in my writing long before I did. You haven't simply acted as my agent, you've been a mentor, an editor, and primarily, a friend. This book is your baby as much as it is mine. I'll forever remember our first meeting in the West Village over Aperol Spritzes, where we talked love, nightmarish break-ups, books, Diana, and revenge. To say you vastly improved my life is a drastic understatement—you're the best in the biz (also, the most chic, I might add!), and I'm unbelievably lucky to have you—the ultimate joy—represent me.

To the fabulous Becky Wearmouth, thank you so much for your work in making this book happen. Lucy Barry and Antonia Kasoulidou, and all the other members of PFD who've been so brilliant, thank you, thank you, thank you! I am so grateful to Alison Starling at Octopus—it means so much to me that my book will be published on my home soil. England, my heart and home, forever!

To my mum, Kaja, you are my biggest inspiration—every ounce of style, resilience, and wit within me I inherited from you (don't worry, Dad, you're funny too). Thank you for teaching me some of my most important lessons: 1) to always work hard, and never rely on a man for money 2) that shit happens and it always passes 3) there's immeasurable power behind the right outfit 4) to tell the bastards who get you down to "fuck right off." You are my rock, role model, and the person who keeps me going.

To my lovely dad, Wayne—thank you for your endless creative encouragement, for always wanting to read my writing, and for telling me the best stories since I was a little girl. To my brother, Joe, you're the true success of the family—you and Dad are some of the good ones. I love you all immensely.

My grandma Doreen—the powerhouse in our family of strong women—thank you for encouraging my creativity and reading from an early age. I love and cherish you so much and I hope to always make you proud. Don't worry—with any luck I won't be exiled from Britain for writing "#FyouCC".

My talented aunt and godmother, Magda, thank you for your constant encouragement—you're a true legend! To the other brilliant and fearless women in my family—Nanny Margorie, Carole, Leah, Minty, Kitty, Winnie, Freddie, and my niece-slash-god-daughter, baby Juno, thank you for all the love and support.

For the family members no longer here: Grandpa Eric, Grandad Bill, and Aunty Jen: I love and miss you, I wish you could be here to read this, but I hope you get to sneak a read up there in heaven.

My forever friends (and very own "revenge crew") are based all over the world, yet this book could not have existed had it not been for their infinite love, support and encouragement: Kayleigh Snowden, Ramona Jones, Marie-Sophie Lockhart, Lamia Lagha, Kelsey Calandro, Jen Dunlap, Gerry O'Kane, Faye Young, Penelope Strintz, Juan Satizabal, Nicole Robinson, and Harley Chapman. Your friendship has shaped me in ways I couldn't possibly put into words. I will thank each of you in person, but for now: I love you—you all deserve the best, the most, and so much more. And to those who aren't named, you know who you are.

Jacques Azagury, Joanna Osborne, Sally Muir, Gyles Brandreth, and Jackie Harris—endless thanks for speaking to me about Diana and your fascinating encounters with her. Our conversations were some of my favorite moments in my writing process. Thank you to Mauro Carraro, for graciously letting me peer into your magical archive. Your photographs, in my opinion, are some of the most remarkable of the Princess. Fiona Stuart—thank you for indulging me in our endless, daily discussions on clothes. (A note to the reader: If you're in London, make sure to visit Fiona's iconic Notting Hill vintage store, Rellik—you won't be disappointed.)

My friend, Hannah Tindle, thank you for being the first to see the potential in @ladydirevengelooks and for putting it "on the map" with my very first bit of press. James Abraham—AKA @90sanxiety—thank for your support since the early days. To the fans of @ladydirevengelooks—the people who make it worth spending hours of time on Instagram—I wrote this book for you. I hope Diana's revenge looks have helped you as much as they've helped me the past few years. Endless thanks for all the support.

Second to last, but maybe, perhaps least, thank you to all my exes. You've inspired me in ways I had once never thought possible. This book is for you too. Mwah!

Finally, to Diana: thank you for helping me in my own journey of healing. My hope is that if you were alive to read this, you'd get a giggle or two from it (did you know back then of Camilla's taste for chicken Kiev?). I hope that you'd find some comfort in knowing that you have inspired me and a whole new generation of women to be louder, braver . . . and to just go for it.

Long live the Queen of our hearts.

RESOURCES

DIANA'S FAVORITE BRANDS

Some of these brands are still alive and well today! I like to trawl through eBay, Etsy, and other secondhand websites—you'll be surprised by the treasures you can find! So far on my search, I've found the same Polo Ralph Lauren "USA" sweatshirt Diana wore in the nineties, a vintage Canadian Mounties baseball cap, a pristine pair of Escada jeans with horseshoe appliqué, and endless Diana memorabilia (my tea towel and mug collection is unrivaled).

Alexander Gabbay

Amanda Wakeley

Anya Hindmarch

Arabella Pollen

Banana Republic
(Nineties Banana—always!)

Belville Sassoon
(Try eBay or Etsy for
vintage gems, plus old
sewing patterns!)

Bruce Oldfield

Butler & Wilson

Catherine Walker

Chanel

Christian Lacroix

Christina Stambolian

Converse

David & Elizabeth Emanuel

Dior
(Gianfranco Ferré & Galliano
eras)

DKNY

Donald Campbell

Escada
(Margaretha Ley era)

Frederick Fox

Garrard & Co

George Hostler

Gina

Gina Fratini

Giorgio Armani

Gottex

Graham Smith

Gucci

Gyles & George
(Rowing Blazers recently
revived the infamous
"I'm a Luxury" sweater.)

Hachi

Iceberg

Inca

Jacques Azagury

Jan Van Velden

Jasper

Jimmy Choo

K-Swiss

Laura Ashley

Louis Féraud

Manolo Blahnik

Margaret Howell

Marina Killery

Mondi

Moon Boot

Moschino

Murray Arbeid

Nike

Paloma Picasso

Patek Philippe

Paul Costelloe

Philip Somerville

Polo Ralph Lauren

Reebok

Rifat Ozbek

Roland Klein

Salvatore Ferragamo

Sloppy Joe Sweatshirts
(Sloppy Joe still makes the exact same sweatshirt styles that Diana wore to the gym in the nineties.)

Souleiado
(This French brand still makes the signature Provençal totes that Diana favoured in the eighties.)

Tanner Krolle

Tod's

Valentino

Versace

Versus

Victor Edelstein

Warm & Wonderful
(Warm & Wonderful recently revived their classic black sheep sweater with Rowing Blazers, but you can also find knitting patterns on Etsy if you want to take a more economical, slightly more arduous route.)

Zandra Rhodes

DIANA'S FASHION AND WELLNESS CIRCLE

Anna Harvey—
long-time friend and style advisor.

Barbara Daly—
Princess Diana's first make-up artist, who taught her lessons for how to do her own makeup in the eighties.

Bruce Oldfield—
largely responsible for the Princess's best "Dynasty Di" looks, including a sweeping lamé number.

Catherine Walker—
Diana's friend and most trusted designer.

Christina Stambolian—
independent designer responsible for the one-and-only "Revenge Dress."

David and Elizabeth Emanuel—
designers of Princess Diana's fairy-tale wedding dress, with its twenty-five-foot-long train.

Debbie Frank—
Diana's astrologer.

Giancarlo Giammetti and Valentino Garavani—
co-founders of Valentino and summertime acquaintances of the Princess.

Gianni Versace—
credited for the skin-tight dresses and powder-hued suits that upped Diana's sex-factor.

Jacques Azagury—
designer of Diana's "'famous five'" dresses.

Jenni Rivett—
Diana's personal trainer.

Jimmy Choo—
her favorite shoe designer.

Liz Tilberis—
Diana's friend, her New York wing-woman, and editor in chief of *Harper's Bazaar*.

Mario Testino—
legendary fashion photographer who shot the Princess for the 1997 *Vanity Fair* piece "*Diana Reborn*" (and taught her how to catwalk).

Mary Greenwell—
her longtime nineties makeup artist, who first did Diana's makeup on a Patrick Demarchelier shoot for *Vogue*.

Patrick Demarchelier—
fashion photographer who captured some of Diana's most free-spirited portraits.

Richard Dalton—
Diana's eighties hairdresser, responsible for her unforgettable multi-tiered bouf.

Sam Mcknight—
Diana's nineties hairdresser, credited with modernizing her look.

Simone Simmons—
Diana's psychic.

Stephen Twigg—
Diana's life coach, masseur, and teacher of affirmations.

DIANA'S FAVORITE MUSIC

ABBA

Bob Dylan

Celine Dion

David Bowie

Diana Ross

Dire Straits

Duran Duran

Elton John

Genesis

George Michael

John Denver

Lionel Richie
(Diana's favorite song was "*Hello.*")

Paul Simon
(Diana reportedly loved the album *Still Crazy After All These Years*.)

Rod Stewart

The Eagles

Wham!

ESSENTIAL REVENGE LISTENING

LadyDiRevengeSongs
playlist, by me, on Spotify

When Diana Met . . .
hosted by Aminatou Sow for CNN

Royally Obsessed
hosted by Roberta Fiorito and Rachel Bowie

You're Wrong About
hosted by Michael Hobbes and Sarah Marshall (The Diana episodes!)

ESSENTIAL REVENGE WATCHING

Nine to Five

Dynasty

I May Destroy You

Legally Blonde

Shirley Valentine

The First Wives Club

Spencer

Double Jeopardy

Promising Young Woman

Kill Bill I and *II*

Bridget Jones's Diary

Thelma & Louise

Sleeping With the Enemy

Dr. Foster

NOTES

1. "Martin Bashir: Inquiry criticises BBC over 'deceitful' Diana Interview," Francesca Gillett, *BBC News*, 2021.
2. "An interview with HRH The Princess of Wales," BBC *Panorama*, 1995.
3. *Diana: Her True Story—In Her Own Words* (Diana's secret tapes), Andrew Morton, Simon & Schuster, 2017.
4. Ibid.
5. Ibid.
6. Ibid.
7. Ibid.
8. Ibid.
9. Ibid.
10. Peter Settelen Tapes, 1992.
11. Morton, *Diana: Her True Story*.
12. Peter Settelen Tapes, 1992.
13. Morton, *Diana: Her True Story*.
14. Peter Settelen Tapes, 1992.
15. Morton, *Diana: Her True Story*.
16. Ibid.
17. Ibid.
18. "From the Archive: Vogue's Anna Harvey on Dressing Princess Diana," Anna Harvey, British *Vogue*, 1997.
19. Ibid.
20. Morton, *Diana: Her True Story*.
21. Ibid.
22. Ibid.
23. Ibid.
24. Ibid.
25. Ibid.
26. "Living: Shy Di Makes a Daring Debut," Michael Demarest, *Time* magazine, 1981.
27. "The Diana Nobody Knows," *The Daily Express*, 1982.
28 Morton, *Diana: Her True Story*.
29. "The Diana Nobody Knows," Catherine Olsen, *The Daily Express*, 1982.
30. Morton, *Diana: Her True Story*.
31. Ibid.
32. "Diana's Revenge," Anthony Holden, *Vanity Fair,* 1993.
33. Morton, *Diana: Her True Story*.
34. Ibid.
35. Ibid.
36. Ibid.
37. "Dorothy's Ruby Slippers Have a History As a Populist Symbol. Now the Smithsonian Is Asking Us for Help." Rachelle Bergstein, *Forbes*, 2016.
38. Morton, *Diana: Her True Story*.
39. Ibid.
40. Ibid.
41. *Diana: The Untold Story*, "Part Seven: The Fashion Icon," Richard Kay and Brenda Polan, *The Daily Mail*, 1998.
42. Morton, *Diana: Her True Story*.
43. "Princess Diana's London," Ken Wharfe, *The Evening Standard*, 2017.
44. "On the Trail of London's Sloane Rangers," *The New York Times*, 1984.
45. "The Mouse That Roared," Tina Brown, *Vanity Fair*, 1985.
46. *The Official Sloane Ranger Handbook: The First Guide to What Really Matters in Life*, Ann Barr and Peter York, Ebury Press, 1983.
47. "The Mouse That Roared," Tina Brown, *Vanity Fair*, 1985.
48. Ibid.
49. Morton, *Diana: Her True Story*.
50. Ibid.
51. Ibid.
52. Ibid.
53. Brown, "The Mouse That Roared."
54. Morton, *Diana: Her True Story*.
55. *Diana: The Untold Story*, "Part Seven: The Fashion Icon," Richard Kay and Brenda Polan, *The Daily Mail*, 1998.
56. *The Diana Chronicles*, Tina Brown, Anchor Books, 2008.
57. Morton, *Diana: Her True Story*.
58. Ibid.
59. Ibid.
60. Ibid.
61. "An interview with HRH The Princess of Wales," BBC *Panorama*, 1995.
62. Morton, *Diana: Her True Story*.
63. Ibid.
64. *Inside the Crown: Secrets of the Royals*, ITV, Ken Lennox.
65. Morton, *Diana: Her True Story*.

66. "An interview with HRH The Princess of Wales," BBC *Panorama*, 1995.

67. "From the Archive: Vogue's Anna Harvey on Dressing Princess Diana," Anna Harvey, British *Vogue*, 1997.

68. Richard Kay and Brenda Polan, *The Daily Mail*, 1998.

69. Morton, *Diana: Her True Story*.

70. "An interview with HRH The Princess of Wales," BBC *Panorama*, 1995.

71. Morton, *Diana: Her True Story*.

72. "Diana's Revenge," Anthony Holden, *Vanity Fair*, 1993.

73. Peter Settelen Tapes, 1992.

74. "An interview with HRH The Princess of Wales," BBC *Panorama*, 1995.

75. Morton, *Diana: Her True Story*.

76. Ibid.

77. *Diana: The Untold Story*, "Part Seven: The Fashion Icon," Richard Kay and Brenda Polan, *The Daily Mail*, 1998.

78. "The Mouse That Roared," Tina Brown, *Vanity Fair*, 1985.

79. "An interview with HRH The Princess of Wales," BBC *Panorama*, 1995.

80. "The Mouse That Roared," Tina Brown, *Vanity Fair*, 1985.

81. "Princess Diana's London," Ken Wharfe & Alex Gatenby, *The Evening Standard*, 2017.

82. "An interview with HRH The Princess of Wales," BBC *Panorama*, 1995.

83. "Princess Diana brings beauty to the 'battlefield,'" Edward Parker, *YOU Magazine*, 1988.

84. Morton, *Diana: Her True Story*.

85. "Interview with John Travolta," Mario P. Székeli, *Esquire Spain*, 2021.

86. "Royals, for All the Whirl," Elizabeth Kastor, *The Washington Post*, 1985.

87. "The Story Behind Diana's Wedding Gown," Bethan Holt, *The Telegraph*, 2020.

88. "The Mouse That Roared," Tina Brown, *Vanity Fair*, 1985.

89. Morton, *Diana: Her True Story*.

90. *The Daily Express*, 1981.

91. "Shy Di Makes a Daring Debut," Michael Demarest, *Time*, 1981.

92. Morton, *Diana: Her True Story*.

93. "From the Archive: Vogue's Anna Harvey on Dressing Princess Diana," Anna Harvey, British *Vogue*, 1997.

94. Morton, *Diana: Her True Story*.

95. "An interview with HRH The Princess of Wales," BBC *Panorama*, 1995.

96. "From the Archive: Vogue's Anna Harvey on Dressing Princess Diana," Anna Harvey, British *Vogue*, 1997.

97. "An interview with HRH The Princess of Wales," BBC *Panorama*, 1995.

98. "Diana: A Decade On," Suzy Menkes, *Harper's Bazaar*, 2007

99. "Remembering Anna Harvey, the Vogue Editor Who Dressed Princess Diana and Translated the Magazine's Style Across the World," Sarah Mower, *Vogue*, 2018.

100. "'I Will Need a Really Good, Sexy Dress': Jacques Azagury on How He Created a Daring New Look for Princess Diana," Caroline Leaper, *The Telegraph*, 2017.

101. "Squidgygate" Tapes, *The Sun*, 1992.

102. "Diana Reborn," Cathy Horyn, *Vanity Fair*, 1997.

103. *Diana: The Untold Story*, "Part Seven: The Fashion Icon," Richard Kay and Brenda Polan, *The Daily Mail*, 1998.

104. "Diana Reborn," Cathy Horyn, *Vanity Fair*, 1997.

105. "Anya Hindmarch: bag lady with a £20 empire," Roya Nikkhah, *The Telegraph*, 2009.

106. "An interview with HRH The Princess of Wales," BBC *Panorama*, 1995.

107. *Diana: The Untold Story*, "Part Seven: The Fashion Icon," Richard Kay and Brenda Polan, *The Daily Mail*, 1998.

108. "An interview with HRH The Princess of Wales," BBC *Panorama*, 1995.

109. "Diana: A Tribute to a Princess," Liz Tilberis, *Harper's Bazaar*, 1997.

110. *Dressing Diana*, Tim Graham and Tamsin Blanchard, Welcome Rain Publishers, 1998.

111. Morton, *Diana: Her True Story*.

112. "Princess Diana worked out at queer men's gym because she 'really liked gay guys,'" Patrick Kelleher, *Pink News*, 2021.

113. Jenni Rivett, *YOU Magazine*, 1998.

114. "Rollerblading, step aerobics . . . gym was a real tonic for Princess Diana, says her personal trainer," Sebastian Shakespeare, *The Daily Mail*, 2021.

115. "Diana's Relics," Joan Juliet Buck, *The New Yorker*, 1997.

116. "An interview with HRH The Princess of Wales," BBC *Panorama*, 1995.

117. "Diana's Revenge," Anthony Holden, *Vanity Fair,* 1993.

118. "Squidgygate" Tapes, *The Sun,* 1992.

119. Morton, *Diana: Her True Story.*

120. "Diana's Revenge," Anthony Holden, *Vanity Fair,* 1993.

121. "Diana: A Decade On," Suzy Menkes, *Harper's Bazaar,* 2007.

122. "Princess Diana's former hairstylist on the joys of working with her for seven years," *The Telegraph,* 2020.

123. "Diana's Revenge," Anthony Holden, *Vanity Fair,* 1993.

124. *The Diana Chronicles,* Tina Brown, Anchor Books, 2008.

125. "From the Archive: Vogue's Anna Harvey on Dressing Princess Diana," Anna Harvey, British *Vogue,* 1997.

126. Ibid.

127. An interview with HRH The Princess of Wales," BBC *Panorama,* 1995.

128. Ibid.

129. Morton, *Diana: Her True Story.*

130. "Diana's Revenge," Anthony Holden, *Vanity Fair,* 1993.

131. Morton, *Diana: Her True Story.*

132. Ibid.

133. *Diana: The Untold Story,* "Part Seven: The Fashion Icon," Richard Kay and Brenda Polan, *Daily Mail,* 1998.

134. "From the Archive: Vogue's Anna Harvey on Dressing Princess Diana," Anna Harvey, British *Vogue,* 1997.

135. Ibid.

136. An interview with HRH The Princess of Wales," BBC *Panorama,* 1995.

137. "Last Christmas," Wham!, 1984.

138. "Diana's Impossible Dream," Sarah Ellison, *Vanity Fair,* 2013.

139. "Diana film's cruel lies about our love . . . ," Hasnat Khan, *The Daily Mail,* 2013.

140. Ellison, *Vanity Fair,* 2013.

141. Ibid.

142. Morton, *Diana: Her True Story.*

143. "An interview with HRH The Princess of Wales," BBC *Panorama,* 1995.

144. *Diana: The Untold Story,* "Part Ten: Landmines and Love," Richard Kay, *Daily Mail,* 1998.

145. Ellison, *Vanity Fair,* 2013.

146. "Princess Diana's London," Ken Wharfe and Alex Gatenby, *The Evening Standard,* 2017.

147. Morton, *Diana: Her True Story.*

148. Ibid.

149. "Diana Reborn," Cathy Horyn, *Vanity Fair,* 1997.

150. Morton, *Diana: Her True Story.*

151. "Diana Cleans Out Her Closet, And Charities Just Clean Up," Elisabeth Bumiller, *The New York Times,* 1997.

152. Cathy Horyn, *Vanity Fair,* 1997.

153. Morton, *Diana: Her True Story.*

154. "Diana: A Tribute to a Princess," Liz Tilberis, *Harper's Bazaar,* 1997.

155. Morton, *Diana: Her True Story.*

PHOTO CREDITS

Alan Davidson/Shutterstock: p. 167

Alpha Photo Press Agency Ltd: p. 295

Antony Jones/Getty Images: pp. 162, 203, 225 (right), 265

Anwar Hussein/Getty Images: pp. 28, 29, 39 (far right), 68, 80, 81, 103, 137 (bottom right), 137 (bottom left), 140 (left), 144, 150 (top left), 150 (top right), 150 (bottom left), 197, 221 (right), 225 (bottom left), 231, 236, 284, 298

AP/Shutterstock: pp. 128–129

Bob Thomas/Popperfoto/ Getty Images: pp. 30, 31

Brendan Beirne/Shutterstock: pp. 52, 53, 69, 194 (left), 195, 198 (left), 206, 207 (left), 209, 219 (top left), 240, 252

Carl Bruin/Sunday Mirror/ Mirrorpix/Getty Images: p. 5

Cassidy and Leigh/ Shutterstock: pp. 260–261

Clive Postlethwaite/ Shutterstock: pp. 263 (left), 263 (right)

Dave Benett/Hulton Archive/ Getty Images: pp. 175, 234

David Hartley/Shutterstock: pp. 207 (right), 243 (bottom right), 258, 262, 267 (bottom right)

David Levenson/Getty Images: pp. 56, 82, 87, 97, 113

Daily Mail/Shutterstock: p. 253

Eddie Boldizsar/Shutterstock: p. 150 (bottom right)

Eugene Adebari/Shutterstock: p. 15

Georges De Keerle/Getty Images: p. 98

Hulton Royals Archive/ Getty Images: pp. 13 (left), 14,

16–17, 35, 64 (right), 84, 95, 107, 111, 112, 114, 116, 117, 122–123, 133 (top right), 141 (bottom left), 142 (left), 161, 183, 210, 220, 237, 266, 267 (top right), 273

Joanna Osborne and Sally Muir "Warm & Wonderful" Archive: pp. 32, 33

Johnny Eggitt/AFP/Getty Images: p. 191

John Shelley Collection/ Avalon/Getty Images: p. 115

Julian Parker/Getty Images: pp. 83, 143, 167 (left), 171, 177, 211, 221 (left), 250, 259 (right), 274–275

Justin Goff/Getty Images: p. 217

Justin Sutcliffe/Shutterstock: p. 294

Kypros/ Getty Images: pp. 18, 94

Lynn Hilton/Mail on Sunday/ Shutterstock: p. 214

Mark Cuthbert Archive: p. 193

Mark Cuthbert/UK Press/ Getty Images: p. 179 (right)

Mauro Carraro Archive: pp. 36, 39 (bottom), 41, 54, 55, 101, 104

Michel Dufour/French Select/ Getty Images: pp. 296, 300

Mike Forster/Daily Mail/ Shutterstock: p. 293

Mike Hollist/Daily Mail/ Shutterstock: p. 251

Mirrorpix/Getty Images: pp. 147, 199 (left), 208 (right), 235, 254, 264, 276, 277

Mitchell Gerber/Getty Images: p. 233 (left)

New York Daily News/Getty Images: p. 187

News Group/ Shutterstock: p. 226

News Group/ Shutterstock: p. 226

News UK Ltd/Shutterstock: pp. 181, 248

Nikos Vinieratos/ Shutterstock: p. 208 (left)

Nils Jorgensen/Shutterstock: pp. 137 (top left), 267 (left)

PA Images/Getty Images: pp. 59, 72–73

Paul Currie/Alpha Press/ MAXPPP Newscom: p. 45

Paul J. Richards/AFP/Getty Images: p. 299

Peter Brooker/ Shutterstock: p. 66

Picture Alliance/Getty Images: p. 243 (bottom left)

Richard Young/Shutterstock: pp. 39 (top), 215

Pool/Tim Graham Picture Library/Getty Images: pp. 178, 282, 283

Ron Bell/PA Images/Getty Images: p. 133 (left)

Ron Galella/Getty Images: p. 172

Rose Hartman/Getty Images: p. 185

Shutterstock: pp. 11, 58, 120, 135 (right), 166, 168, 213, 218, 224, 238, 241, 261

Stephane Cardinale-Corbis/ Sygma Premium/Getty Images: pp. 302–303

Steve Eichner/WireImage/ Getty Images: p. 182 (bottom)

Steve Wood/Shutterstock: p. 13 (left)

Today/Shutterstock: p. 67

Tim Graham/Getty Images: pp. ii, 10, 27, 37, 40, 42, 46, 48–49, 50, 64 (left), 70, 71, 74, 75 (top left, top right, bottom left, bottom right),

86, 96, 99, 105, 118, 121 (right), 130 (far left) 130-131 (left), 133 (bottom right), 134, 135 (left), 136, 137 (top right), 138, 146, 148, 154, 165, 170, 173 (top), 173 (bottom, 174, 179 (left), 180, 182 (top), 184 (left), 205, 212, 216 (top left), 216 (bottom left), 219 (right), 222 (left), 222 (right), 225 (top left), 228, 229, 243 (top right), 243 (top left), 271, 272, 285, 297

Tim Ockenden/PA Images/ Getty Images: p. 239

Tim Rooke/Shutterstock: pp. 176, 199 (right), 219 (bottom left), 232, 233 (right), 255, 256, 259 (left)

Times Newspapers/ Shutterstock: p. 249

Tom Stoddart Archive/Getty Images: p. 12

Tom Wargacki/WireImage/ Getty Images: pp. 119, 142 (right)

Tony Harris/PA Images/ Getty Images: p. 194 (right)

UK Press/Hulton Archive/ Getty Images: p. 196

UK Press/Shutterstock: p. 169